SPECTACULAR HOTELS

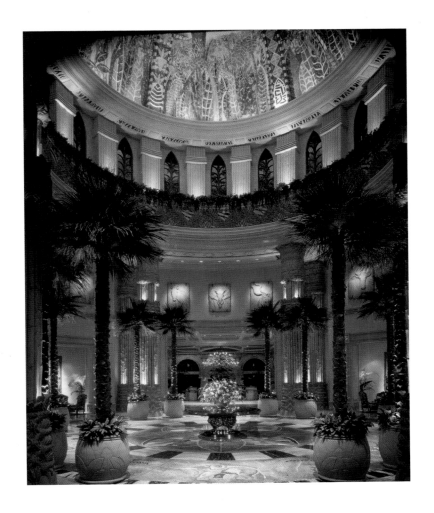

THE MOST REMARKABLE PLACES ON EARTH

by Trisha Wilson

Second Edition

For the children.

Published by

SIGNATURE
PUBLISHING GROUP

13747 Montfort Drive, Suite 100
Dallas, Texas 75240
972-661-9884
Fax: 972-661-2743
www.spgsite.com

Publisher: Brian G. Carabet
Designers: Derrick Saunders & Emily Kattan

Distributed by Independent Publishers Group
800-888-4741

PUBLISHER'S DATA

Spectacular Hotels: The Most Remarkable Places on Earth

Library of Congress Control Number: 2007932331

ISBN 10 (First Edition) : 0-9745747-1-6
ISBN 10 (Second Edition) : 0-9792658-0-0
ISBN 13 (Second Edition) : 978-0-9792658-0-8

Second Edition 2007

10 9 8 7 6 5 4 3

On the Cover:
The formal Tea Lounge at the Four Seasons Hotel Cairo is a
sophisticated blend of French and Egyptian traditions.
See page 52. *Photo by Robert Miller.*

Previous Page:
The dramatic domed lobby of The Palace of the Lost City has stories
of the ancient civilizations woven into the hand-laid tiles on the floor
and ceiling.
See page 12. *Photo by Peter Vitale.*

This Page:
The infinity edge melds pool into ocean at Las Ventanas Al Paraiso.
See page 60. *Photo by Michael Wilson.*

Endsheets:
Relaxation is a priority at The Grand Hotel a Villa Feltrinelli.
See page 174. *Photo by Ottavio Tomasini.*

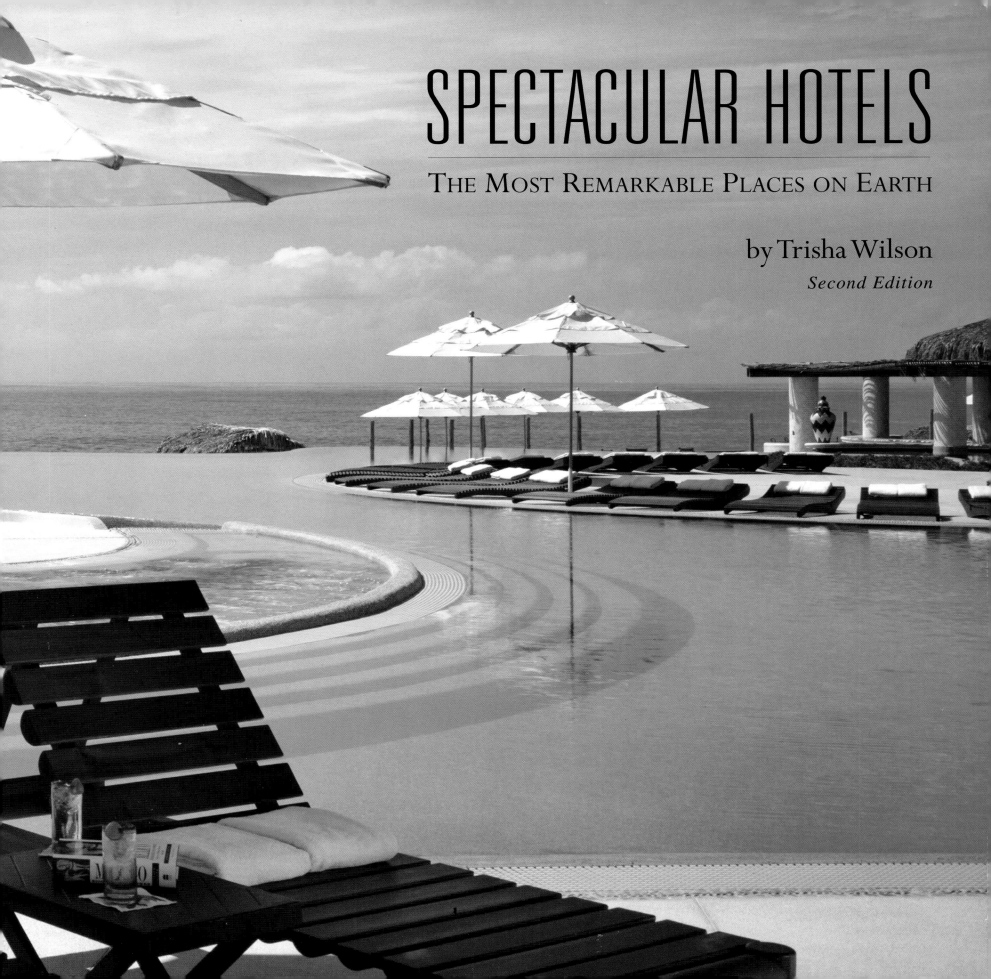

SPECTACULAR HOTELS

THE MOST REMARKABLE PLACES ON EARTH

by Trisha Wilson

Second Edition

Foreword

Trisha Wilson is the dean of international interior design. She defines beauty and style around the world. Since Trisha appeared on "Lifestyles of the Rich and Famous" for her work on The Palace of the Lost City Hotel in South Africa, I have come to know the luxury of her designs in hotels all over the world. Now, you can travel around the world to the most opulent palaces on Earth in the pages of this book.

Spectacular Hotels: The Most Remarkable Places on Earth is Trisha Wilson's selection of the most spectacular hotels in the world – the créme de la créme, catering to the international elite. She shows you these fabulous places like no one else can.

Trisha will take you on a guided tour of a world only the richest and luckiest of travelers have ever seen. From the most luxurious hotels of Europe – where guests are treated like kings – to the mysterious, exotic game reserves of Africa, Trisha Wilson reveals her treasure trove of beauty.

Each gorgeous photograph is a feast for the eyes. These are the palaces of modern-day jet-set kings and queens. Imagine yourself in each of these opulent settings and you'll know how today's international royalty lives.

Robin Leach
"Lifestyles of the Rich and Famous"

Introduction

I have been lucky enough in both my career and personal life to have visited, worked on and stayed at some of the world's most remarkable hotels. From tropical paradise to urban high-rise, from sparkling seaside to desert interior – these are my all-time best.

There is an intangible quality that makes a hotel stand out above its peers. It is not necessarily the location, the architecture, the interior design or the service alone that brings the magic, but rather a strange alchemy of all these elements that produces that special something. The hotels I have chosen to share with you have a character all their own, they produce that magic as you walk in the door. More than just elegant places to stay, these hotels have that magic, that intangible quality that makes you truly happy. These are places that transport you, and take you away from the everyday reality of life to that fantasy world where everything is perfect. Often this feeling is backed by a romantic history – a rich cast of characters and fascinating events that weave their way into the relaxation and luxury to create a once-in-a-lifetime experience that stays with you forever.

This is the experience I would like to share with you. I have carefully chosen each of these hotels as the places one never tires of. Most of them are perennial in their station at the top of the hospitality world, some of them are beautiful or interesting newcomers, all of them radiate that aura of luxury and look as magnificent in real life as they do on the printed page. I hope you get as much pleasure from that beauty as I do, and I hope you get the chance to visit and experience these spectacular and very special crown jewels of the world's hotels.

Bon voyage,

Trisha Wilson

P.S. I love to enjoy a really good book when traveling; therefore, I have included a book selection at the end of each article that is appropriate to each hotel.

the wilson
FOUNDATION

"The employees of Wilson Associates, our clients, vendors and service consultants, travel the world for business. We are fortunate that our work involves creating places of beauty and luxury in some of the most exotic locations on earth. Yet, with every step, we must be mindful of how blessed we are. I believe we all have a responsibility to give back to others who are less fortunate and to provide opportunities for a healthier, more productive life." -Trisha Wilson

Inspired by the contrast between privilege and poverty all over the world, Trisha Wilson established The Wilson Foundation in 1997 as a 501(c)(3) public charity. The mission of The Wilson Foundation is to make a difference *one child at a time*. It is our vision that one child, provided with a quality education, health care, and a stable home environment, can help to change the world.

Through her travels in Africa, Trisha became aware of the crippling effects of HIV/AIDS, poverty and lack of education on the children in rural South Africa. She launched programs to improve the quality of education for schoolchildren in rural South Africa, many of whom attend schools without electricity or running water. She then helped conceptualize and fund the building of a private school, the first of its kind for that region.

Working with leading area pediatrician Dr. Peter Farrant and other local community leaders, Trisha became involved in efforts to address the issue of HIV/AIDS and its devastating effects on children and their families as well as on the entire socioeconomic structure of the region.

The Wilson Foundation was created through Trisha Wilson's passion to improve the lives of underprivileged children. The Foundation has since grown and evolved, focusing its support on education and health care programs in and around the Waterberg region in the Limpopo Province of South Africa. In an area with only a few nonprofit organizations to meet social service needs, The Wilson Foundation has become an active and involved partner in the efforts of these organizations to educate children and to expand the availability of health care services to the underprivileged and underserved. Examples of the Foundation's support include:

Health Care
- Care and counseling for children and family members affected by HIV/AIDS
- Administration of anti-retroviral treatment for HIV/AIDS patients
- Programs to train community volunteers in home-based care
- Funding for clinic nurses to oversee health care and counseling programs
- Funding to transport ill patients from their homes to the hospital 1½ hours away
- Support for a prevention of Mother-to-Child Transmission (PMTCT) program to help prevent the transmission of AIDS from HIV+ expectant mothers to their babies
- Support for efforts to bring U.S.-trained physicians to South Africa to expand the delivery of health services

Education
- Private school tuition, uniforms and books for disadvantaged students
- Support for public elementary and high schools
- Funding for teacher salaries, teacher training programs and after school tutoring

Community Outreach
- After school art & music programs for area youth
- AIDS prevention and drug/alcohol prevention programs taught in area schools

As a public charity, The Wilson Foundation depends upon the support of individuals, corporations, private foundations, and public grants to support its work. Thanks to the worldwide reputation of Wilson Associates, The Wilson Foundation has received tremendous support from companies throughout the design industry, and continues to attract other donors all over the world who share a concern for the plight of the children of South Africa.

Thank you for purchasing a copy of *Spectacular Hotels*. A portion of the proceeds from the sale of these books will benefit The Wilson Foundation and its education and health care programs in South Africa. For more information on The Wilson Foundation, please call 214-521-6753 or visit www.thewilsonfoundation.org.

Top Left: Trisha Wilson with the children of the youth after-school program.

Top Right: A member of the youth group performs in a dance program for the community.

Proceeds from the sale of this book benefit The Wilson Foundation

www.thewilsonfoundation.org

Acknowledgements

Albeit trite, I really could not have produced this book without the help and dedication of some very talented folks. I am indebted to Signature Publishing's Brian Carabet (for the vision, leadership and tenacity), and Derrick Saunders (for his artistic eye and layout genius).

Fond gratitude to my Wilson Associates team for making this second edition of *Spectacular Hotels* a reality.

To Connie Campbell, who makes everything in life fun, deep gratitude for your creativity, wisdom and ability to keep us all anchored and focused. Connie, you are one of those rare and special friends that come along once in a lifetime and I appreciate you deeply.

As a designer, I will admit that my visual senses are finely honed, but my writing skills are sadly lacking. Rachel Long and Will Taylor did an excellent job of transcribing my travel logs, notes, articles and thoughts and organizing them into coherent, readable descriptions.

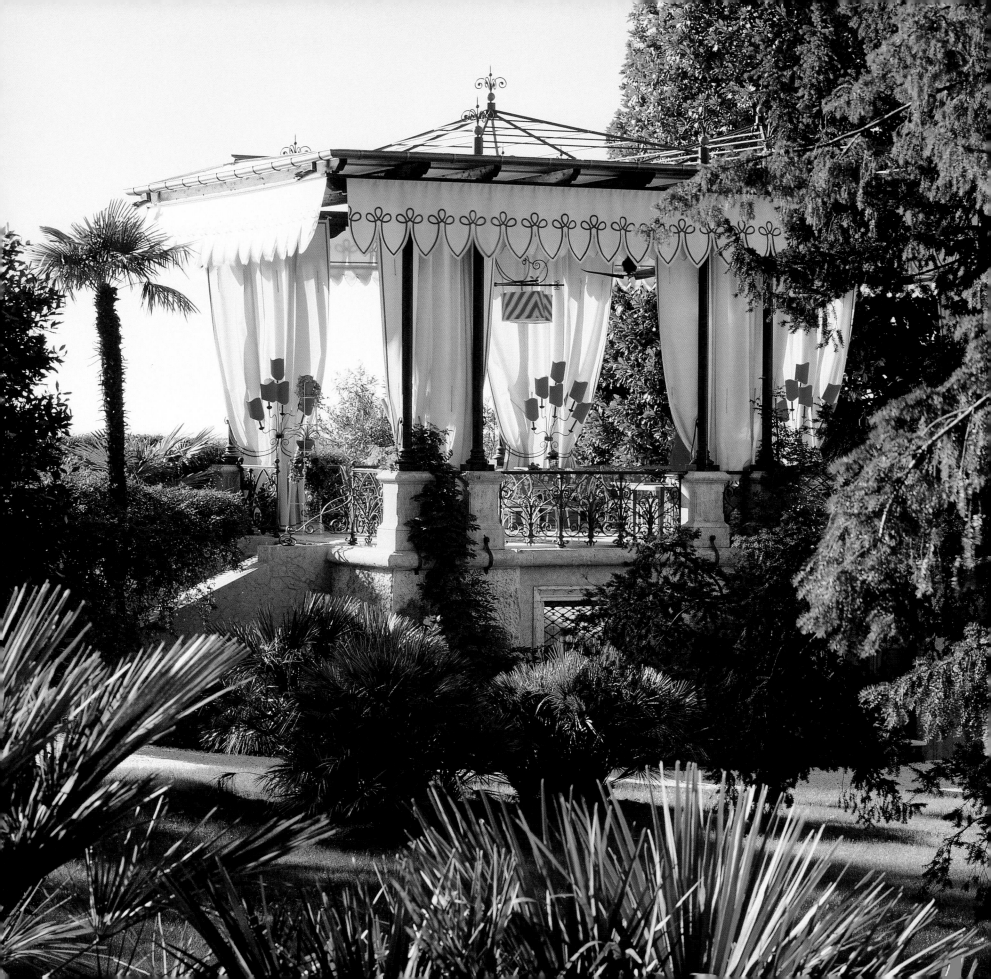

Contents

Left: Dining pavilion in the Villa Feltrinelli gardens in Italy.

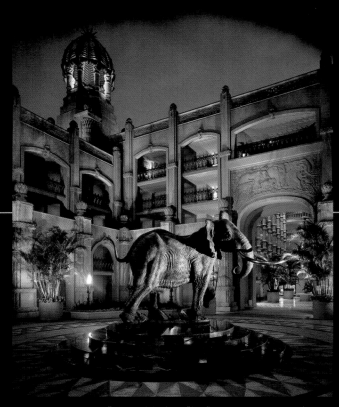

Palace of the Lost City, Page 12

Africa

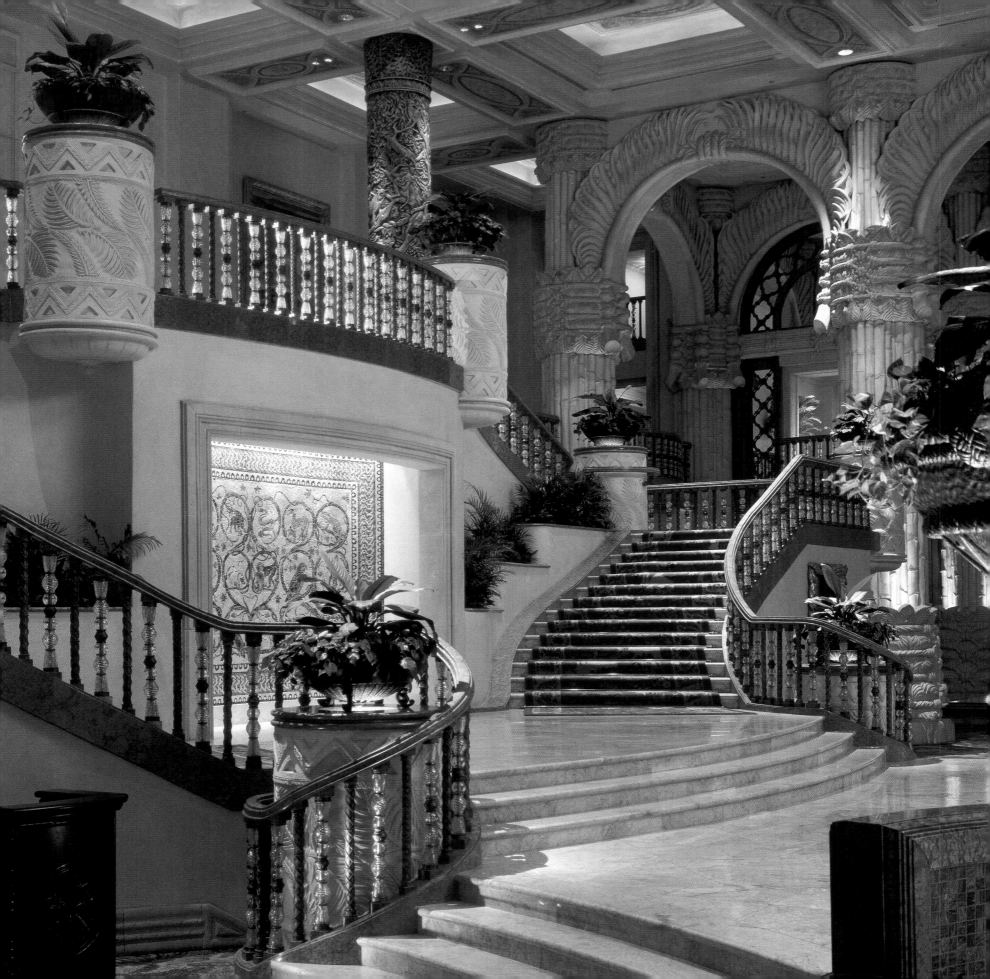

THE PALACE
OF THE LOST CITY

Sun City, South Africa

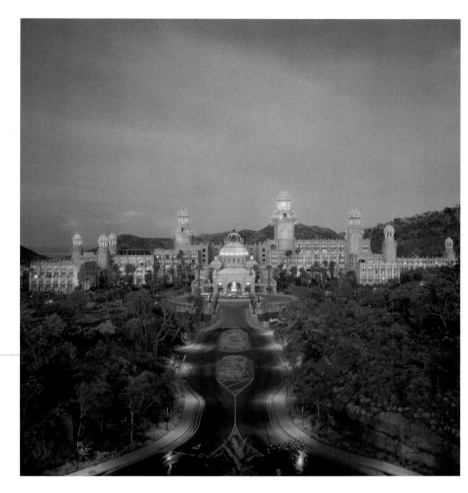

Left: The grand staircases lead from the domed lobby to the Crystal Court. Fine craftsmanship is in every detail.

Right: The spectacular Palace of the Lost City is undoubtedly one of the finest buildings in the world. Magnificent in its setting in an African valley, the building is at its most beautiful in the early evening sunset.

*I*t is the architecture of palaces: sweeping stairways, elaborately carved moldings, richly grained and highly polished marble. It is also the art of the theatrical: an enormous rotunda rising six stories, huge tusk-like sculptures, a grand entrance flanked by elephant statuary. Credit renowned hotelier and gaming czar Sol Kerzner with the vision to create a legend. Though I helped weave its tale and make it reality, I am still captured and awed by the grandness of scale and detail of theme. The Palace will always be indescribably special to me because it represents a pivotal moment in my life. This project was my introduction to Africa, which is now my second home, and I met my wonderful husband while working on this three-year labor of love!

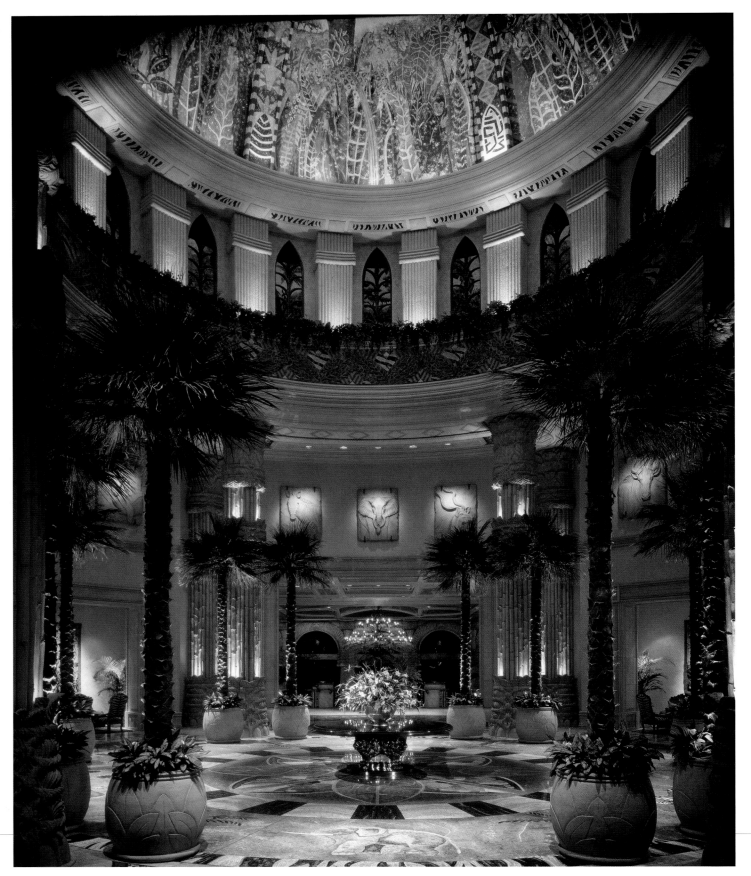

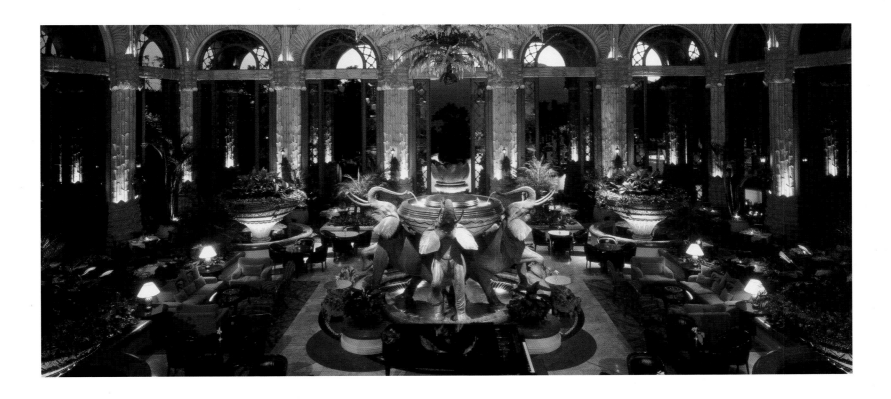

In Sun City, South Africa, imagine a mythical civilization, a tribe whose culture blended architecture, hospitality, and love of nature. The fabric of Sun City and its Palace of the Lost City is woven of the tale involving the Valley of the Sun, an ancient volcanic crater where an earthquake ruined the magnificent city, forcing its villagers to flee. Its discovery and restoration by nomadic tribesman became The Lost City at Sun City.

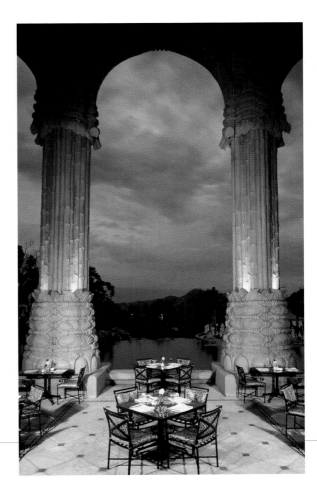

Left: The dramatic domed lobby of the Palace has stories of the ancient civilizations woven into the hand-laid tiles on the floor and ceiling.

Above: The elephant fountain graces the center of the Crystal Court, a marvelous place to relax or enjoy a meal.

Right: Pillars on the Crystal Court veranda frame a moody African sky.

For the design team, the challenge became that of creating a new design vocabulary, one that could have existed centuries ago, yet transformed into modern-day luxury. The vocabulary must envelop and engage contemporary travelers, yet convey the essence of legend. This magical realm relies on rich African color with monumental detailing, at home thanks to the larger-than-life scale of the buildings. Ornamentation and handicraft take on enormous importance. The hotel's domed roof, 25 meters high, includes a naif jungle, painstakingly painted, with a rotunda floor containing more than 300,000 individual mosaic pieces.

The Palace of the Lost City includes countless must-see details. Enter the Crystal Court and you'll traverse a grand double staircase accented by a rock crystal and bronze balustrade, topped with hand-carved marble. At the base of the stair, a 10,000-piece mosaic depicts local animal and plant life in 30 different types of semiprecious stone. Under 5,000 pieces of crystal in the chandelier, you'll find an incredible fountain supported by four trumpeting elephants in aged copper.

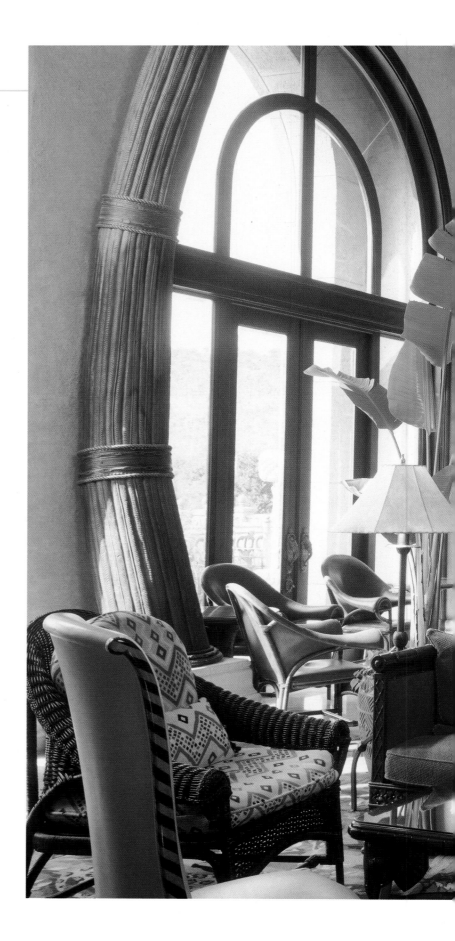

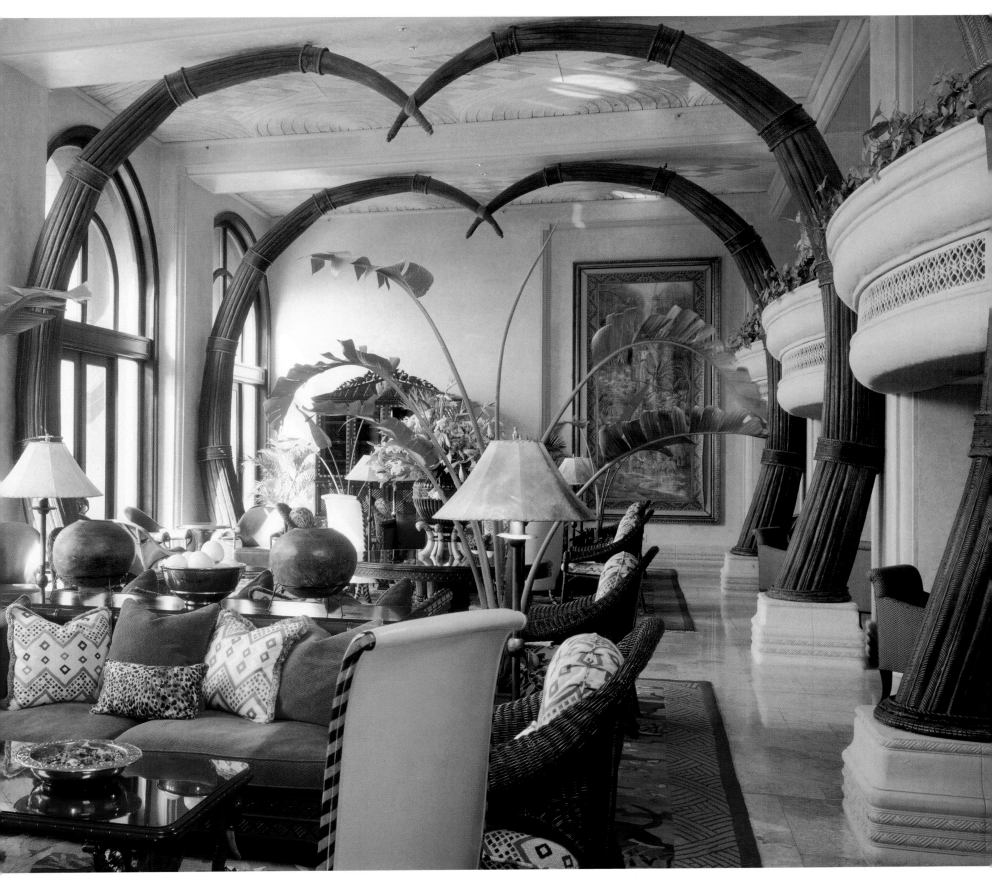

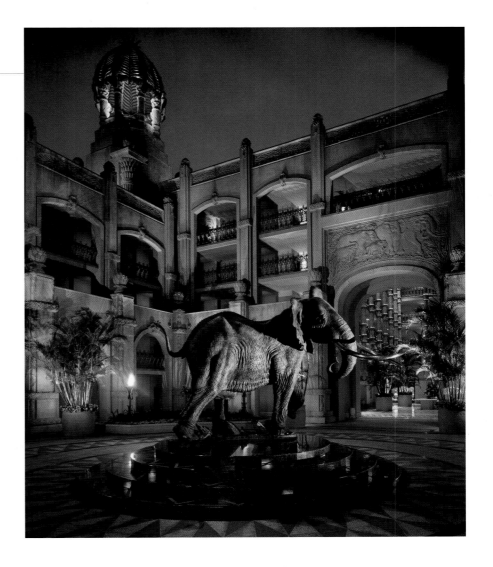

The fantasy of the Lost City places a water park among the so-called remnants of ancient temples. The landscaping includes rock carvings and pavers — 20 million bricks and counting! South African sculptor Danie de Jager has crafted a life-size bronze of Shawu — the largest of the Kruger Park's legendary Magnificent Seven. These were seven elephant bulls carrying some of the most massive ivory recorded in Africa's history. Appropriately, Shawu now reigns over the world's most magnificent mythological kingdom.

BOOK TO PACK:
July's People by Nadine Gordimer

THE PALACE OF THE LOST CITY

P.O. Box 2
Sun City 0316
South Africa
Tel: 011 27 14 557 1000
www.suninternational.co.za

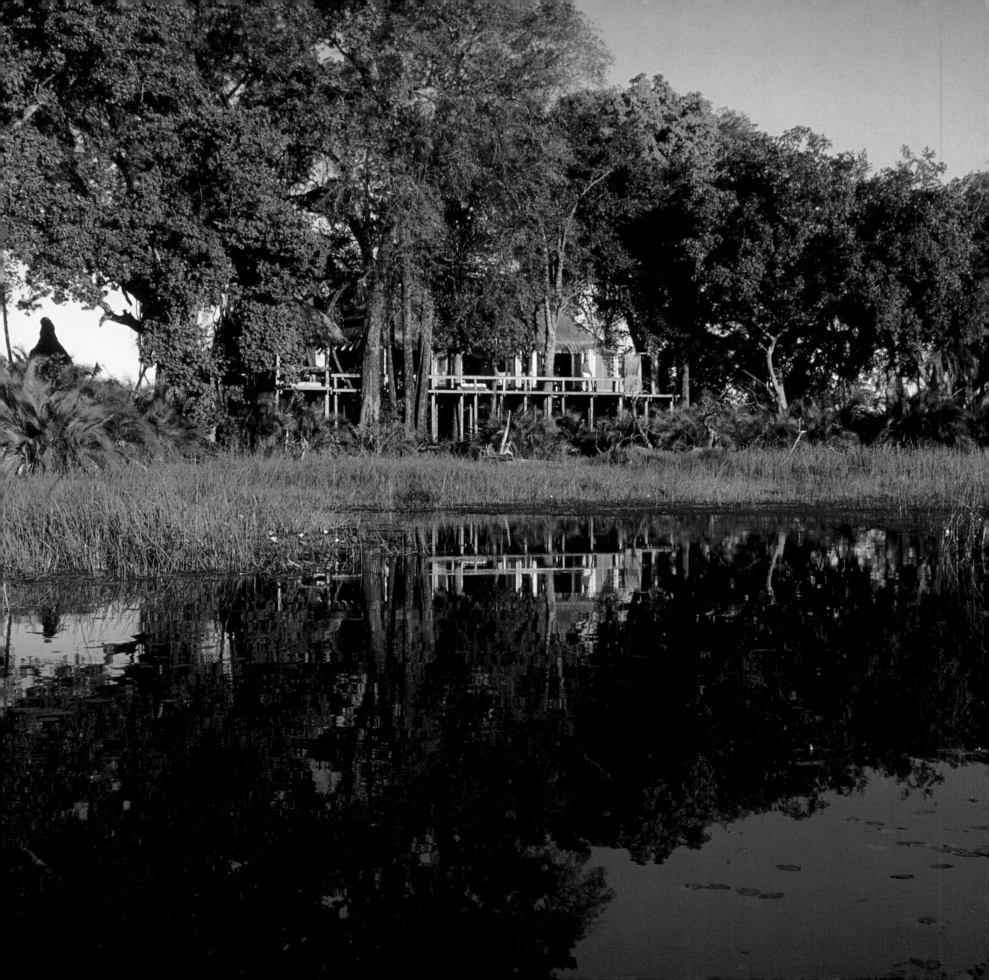

JAO CAMP

Okavango Delta, Botswana
Southern Africa

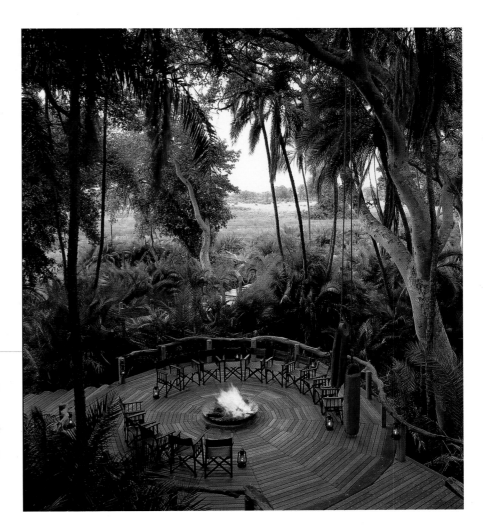

Left: A thatched guest tent reflects in the clear water of the Okavango.

Right: The teak fire pit deck at Jao welcomes guests back from their game drive.

*W*hen I first came to Africa, I didn't realize what a profound impact this continent would have on my life. But the instant I stepped out into the open air of the South African bush and looked out across the vast spaces and open skies, I felt as if I had come home. I have been lucky enough to spend a lot of time on photographic safaris throughout Africa, and have stayed in many camps, but my first visit to Jao literally took my breath away. For me, it combined perfectly my two greatest passions, the wilderness of the African bush, and the beauty and comfort of great architecture, coupled with perfect design.

Botswana is a huge country, and one of its treasures is the Okavango Delta, a massive stretch of pristine wetland, that teems with animals and birds. Jao is situated on an island in the middle of this paradise, and is quite simply magnificent.

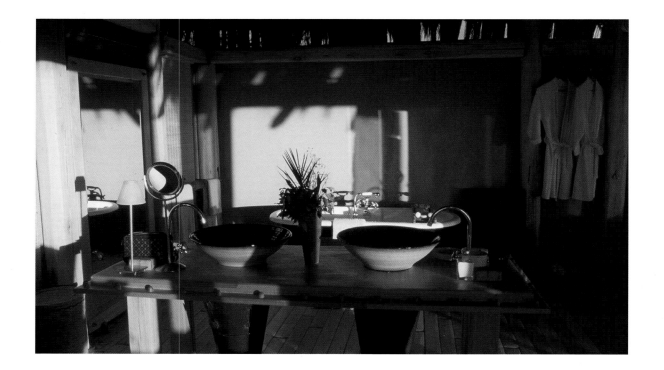

Dave and Kathy Kays are the owners of Jao, and it was their vision that was to change the face of hospitality in wild places forever. They are a remarkable couple with deep roots in the African bush, Dave is a fourth-generation Botswanan, and Cathy hails from the Limpopo province of South Africa. The Kays' passion for the wild, coupled with a vision of creating a camp that elevated being in their favorite part of Botswana to a never-to-be-forgotten experience, led them on their adventure. They hired the husband and wife team of Silvio Rech and Lesley Carstens to design their dream, and with input from Colin Bell of Wilderness Safaris, who were to market the camp, they set out on their journey.

The result is so much more than the label attached to it – Jao is not a camp, it is an experience.

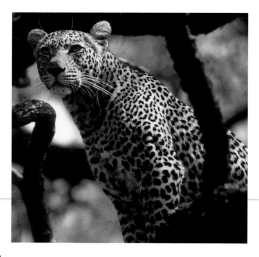

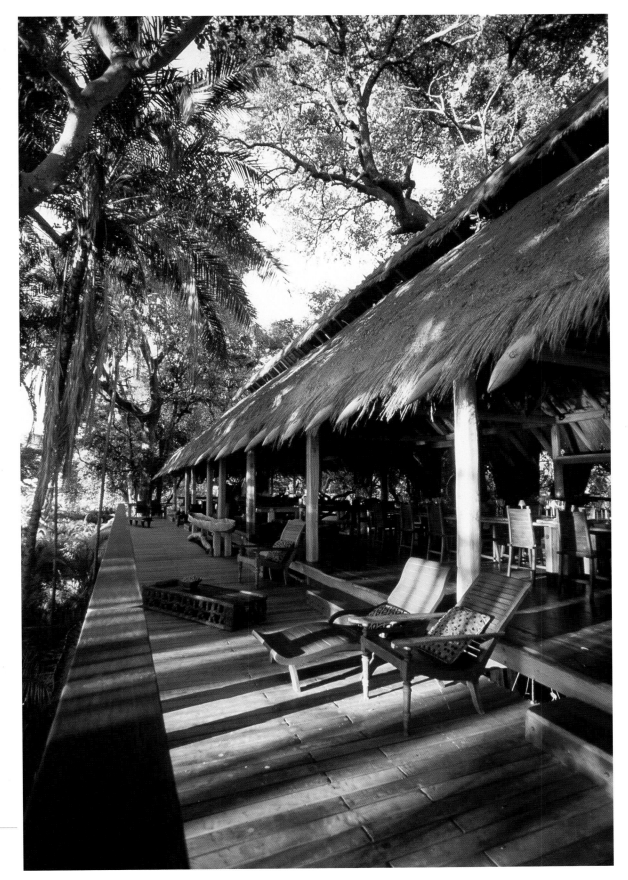

Facing Page
Top: The bathrooms inside the tents are spacious and elegant.

Bottom: Game viewing is sublime at Jao Camp, and offers the perfect opportunity to practice my hobby... photography.

This Page:
The most splendid venue for evening cocktails anywhere in the world.

It's open-air, it's earthy, yet it's beautifully crafted. Rech is, after all, a craftsman; his wife is a designer. And their work is what I've heard Rech refer to as "adventure architecture." It shows none of the stuffiness of earlier lodges in the area; at Jao Camp there are no pretenses.

After getting over the feeling of having landed in a Robinson Crusoe meets jungle tree-house dream world as I stepped off the boat and onto the dock in front of Jao, I started noticing the brilliance of the design. I was amazed at the efficiency of its structure and layout. There are nine guest suites accommodating 18 guests in all, connected by raised, meandering, wooden walkways. The entire camp is raised off the ground below, giving one the feeling of being up in the air, suspended in the canopy of huge riverine trees, on eye level with the naughty troops of vervet monkeys, who will quite happily relieve you of anything you may leave lying around on your deck. More than the feeling though, is the practicality of being raised. It keeps guest above the predators and dangerous game, and also has no environmental impact on the ground below. Not one tree was removed when Jao was built. The area allows for both land and water activities, and has spectacular concentrations of game, including huge herds of red lechwe antelope, and one of the healthiest lion populations on the continent! This suits me, as lions are another passion!

I'm drawn to Africa for, among other things, its art and artifacts, and that is one thing that best differentiates Jao Camp from other buildings. Rech has chosen carefully from, and lent his own inventiveness to, local craft, art, and technique to initiate what borders on a new architectural vernacular. With thatched roofs and primitive-style furniture in the mix, the remaining elements of style have great influence on the overall look. I like the woods used throughout — leadwood as a stair rail, distressed rosewood on the floor. It reminds me that elegance doesn't have to mean fussiness and decoration. The Kays were involved in collecting furniture and artifacts from as far afield as Bali, and in fact primitive Balinese, long house design dominates the architecture.

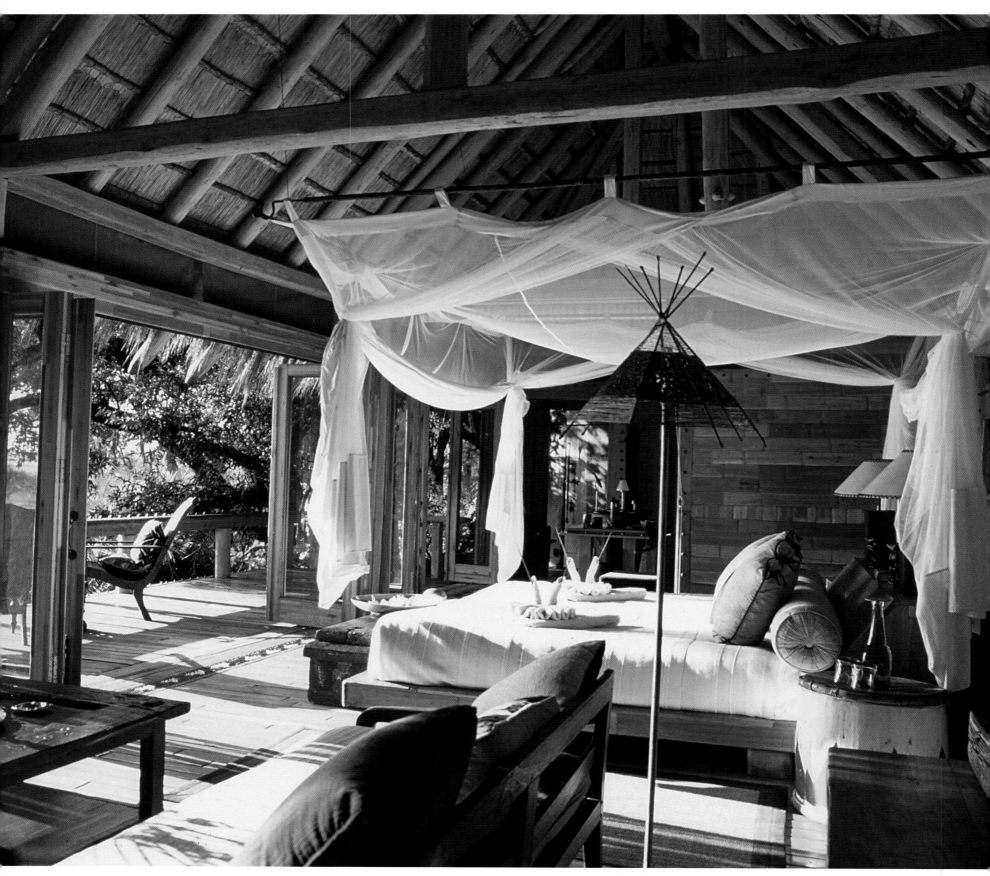

The two-story common space, gracefully connected by a simple staircase (with a connecting carved snake motif winding from one space to another), includes a sitting area and a library with polished tree trunks for sitting on. The spaces are filled with hand-worked metal lighting and decorative objects that intensify the feeling of fantasy and entice the eye to look around at the detail. The lower level leads to an outdoor deck, complete with swimming pool. The outside dining deck becomes a treetop aerie, beautiful in its simplicity – letting the view be the show.

The rich, rustic guestrooms – tents in name only – are like cocoons: mosquito netting drapes over the beds, the decks feel utterly private. By choosing artifacts and handicraft as accents – a drum for the bedside table, a handmade lampshade of metal – the designers give the feel of local flavor and culture. Its wood and canvas paneling give it a sanctuary-like effect. For inspiration and quiet I sit out on my private deck, which is open to the air completely. Connected to the deck is a thatched daybed, or sala, where I spend afternoons reading and bird watching, and which has remained one of my favorite places in the world to be.

Jao is inspirational and magnificent – and that is before you have even been out on a game drive!

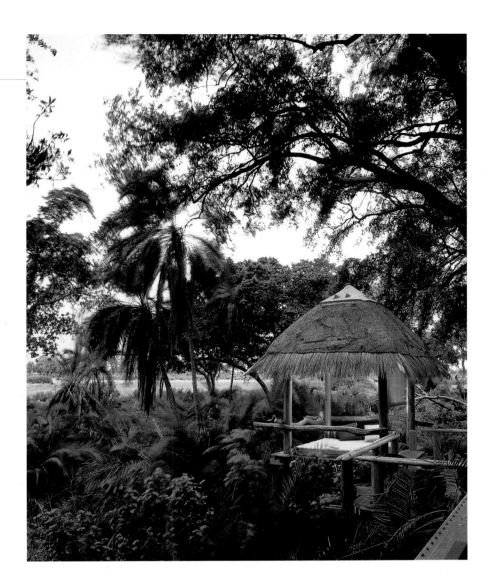

BOOK TO PACK:
The Kalahari Typing School For Men
by Alexander McCall Smith

Hand-carved hardwood floors set off the sumptous comfort of the rooms.

JAO CAMP

Wilderness Safaris
3 Autumn Street
Rivonia, Southern Africa 2128
Tel: 011 27 11 807 1800
Fax: 011 27 11 807 2110
www.jaocamp.com
www.wilderness-safaris.com

ROYAL LIVINGSTONE

Zambia, South Africa

Left: A view of the lobby from the river shows all the elements of colonial style.

Right: A chandelier hangs from the "monkey tree" with the Zambezi River in the background.

Because Africa is one of two continents I call home, working on a project as distinct and romantic as the Royal Livingstone holds special meaning. We wanted to exceed guest expectations and hint at adventure. We wanted to embrace the ruggedness of the surroundings without compromising a single comfort. As with many of the world's most spectacular hotels, this one starts with an incredible site. In fact, the site of the Royal Livingstone may be the most spectacular piece of real estate on the face of the planet. Consider that your room is only yards from the banks of one of the world's greatest rivers, where hippopotamus, crocodile and elephant abound, fish eagle calls ring out from the skies and graceful bushbuck and other antelope trip delicately by on manicured lawns. Add to this the fact that 200 meters downstream is probably the most spectacular of the World's Seven Natural Wonders, the Victoria Falls. The Falls dominate the experience of your stay here, as all day long the distant thunder reverberates through your feet, and at night lulls you to sleep.

The Royal Livingstone occupies a prime location within Mosi-oa-Tunya National Park on the southernmost edge of Zambia, bordering Zimbabwe. Mosi-oa-Tunya, which translated means "the smoke that thunders," is the local name for the Falls, derived from the heavy shroud of mist that rises out of waters falling 300 feet (100 meters) into the Batoka Gorge. It is not only the height of the falls, but their incredible length — over a mile and a half — that make them so spectacular.

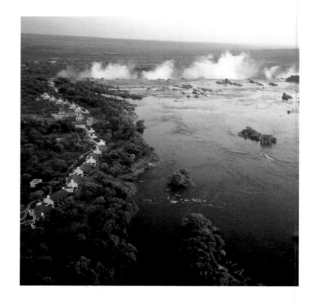

For design ideas for the Royal Livingstone, we looked no farther than the resort's doorstep and our own imaginings of an era when great explorations were afoot. We took inspiration from accounts of the hotel's namesake, Dr. David Livingstone. A Scottish missionary, Livingstone deemed the Zambezi River "God's highway" to the Indian Ocean, and on a hellish, fever-addled river journey from 1852 through 1856 became the first white man to see Victoria Falls, naming the cataract for his British queen. I tried to imagine Livingstone's excitement upon making such an incredible discovery. He did so on the 22nd of November 1855, creeping on his belly to the edge of the falls on Livingstone Island, a magical place where today the hotel can take you to have breakfast at the most spectacular table in Africa. Here Livingstone beheld "scenes so beautiful they must have been gazed upon by angels in flight."

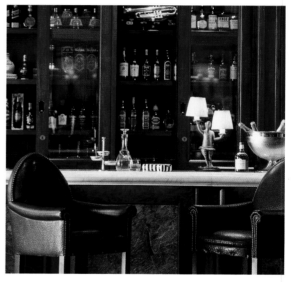

While modern conveniences have forever altered the Africa Livingstone encountered, the pace of life and spectacular scenery within Mosi-oa-Tunya can conjure images of an area untouched by technological progress. Working closely with the architectural firm Stafford Associates, we designed the hotel for the luxurious tradition befitting Sun International's resort collection, crafting site, space, and furnishings within to recall a bygone era. Sun International's president, Peter Bacon, closely guided our progress, making suggestions that lent local flavor and kept the focus on creating a low-impact, but high profile, resort that would be welcome in Mosi-oa-Tunya. (It is, after all, the only five-star resort in a Zambian national park.)

Top: Aerial view of Royal Livingstone and Victoria Falls.

Middle: The bar transports one back to the era of Victorian exploration.

Bottom: The pool feels like an extension of the river.

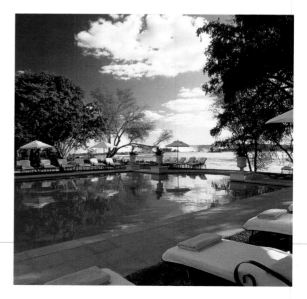

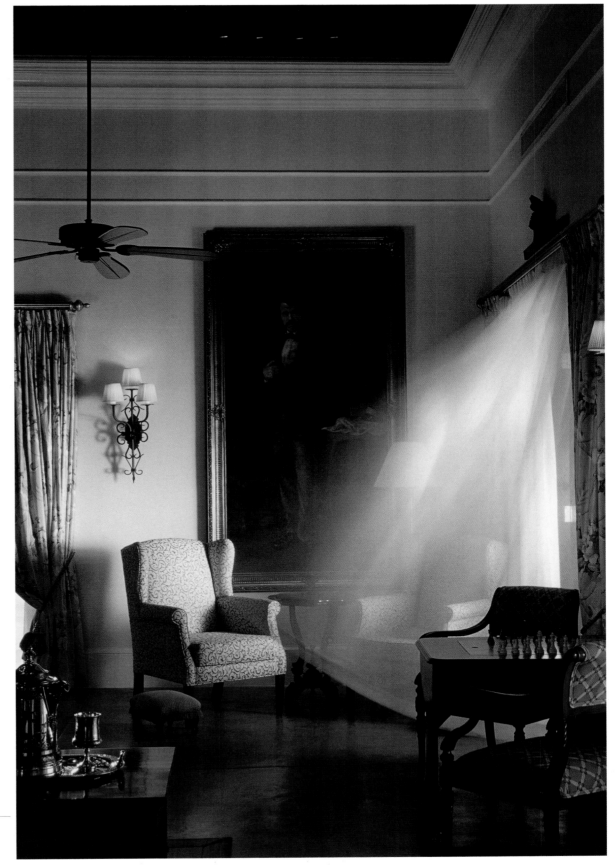

Luxury and classical ambience in the bar.

There are no words to describe the power and beauty of this wonder of the natural world.

The complex is every bit a retreat, with huge shaded verandahs protected by tall shutters and cooled by fans overhead. In the central lounge, which is open to the view, low ottomans and comfy armchairs were de rigueur, making the space suitable for afternoon high tea or port and cigars in the evening. It is possible to order global delicacies in the hotel restaurant, so our designs reflect the elegance of a sophisticated, international flair balanced by locally crafted furniture and natural color. The transition among spaces establishes a magical effect of a colonial estate — areas are separate but harmonious, and the placement and selection of accessories and furniture, museum-like in their quality, literally transport guests back to that romantic time.

In keeping with plantation vernacular, guest quarters mimic centuries-old, grand estate houses, each containing 10 rooms in two stories with balconies or terraces that overlook the stunning river view. It is, most definitely, a backdrop for romance and adventure — tropical wood furniture enhanced by creamy white mosquito netting, upholstery fabric, and linens. Roofs are an eclectic mixture of thatch and tin, another throwback to colonial days, and the pool is nothing short of magnificent.

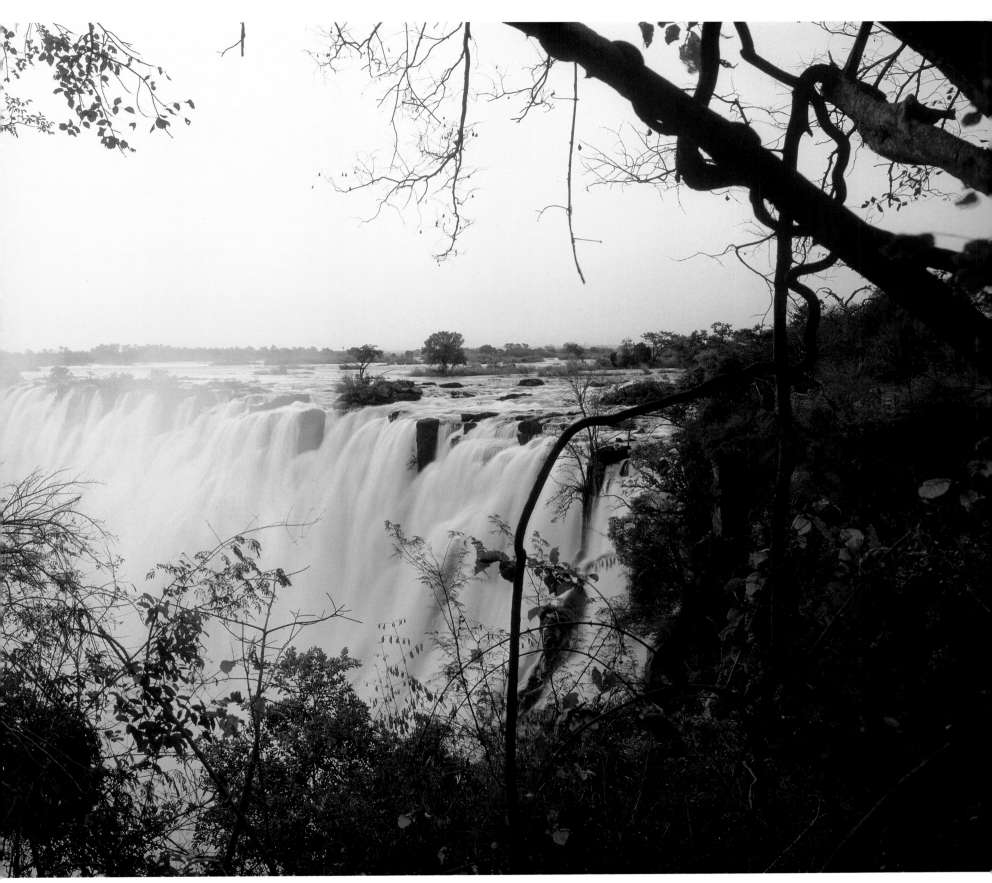

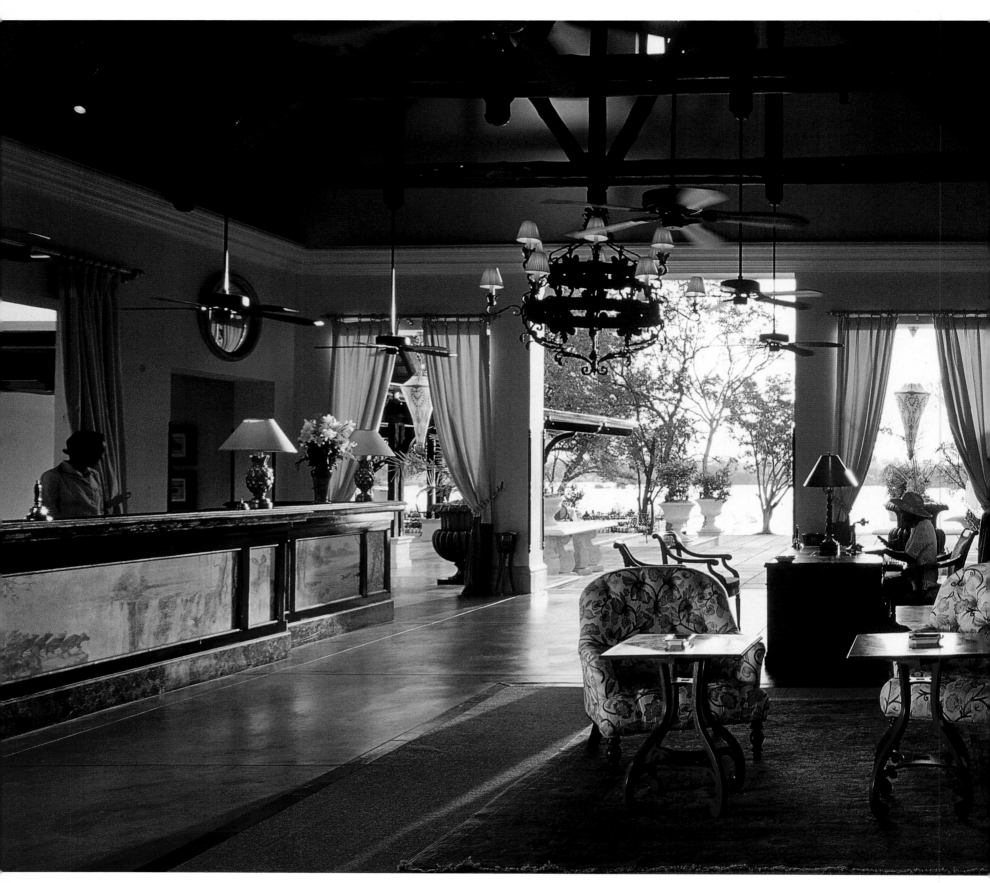

The Verandah offers a heavenly place to read or sip a cocktail.

I have two rituals for my visits to the Royal Livingstone (famed bungee-jumping nearby is not among them!). One is to book a massage under the mosquito-netted white pavilion on the banks of the Zambezi, and the other is probably my favorite thing to do in the world: to eat dinner under the monkey tree with family and friends. In the grounds of the hotel, this magnificent tree, replete with chandelier hanging from branches hundreds of years old, is set with heavy white linen, lead crystal and silver, candles and hurricane lamps. The staff is immaculately turned out white-gloved waiters, who represent their nation true to form because the Zambians of Livingstone are the friendliest, proudest and most courteous people I have come across on this beautiful continent.

BOOK TO PACK:
North of South by Shiva Naipaul

The reception lobby and concierge desk with spectacular views.

ROYAL LIVINGSTONE

Sun International
Mosi-Oa-Tunya Road
Livingstone, Zambia
Tel: 011 260 332 1122
Fax: 011 260 332 1128
www.suninternational.co.za

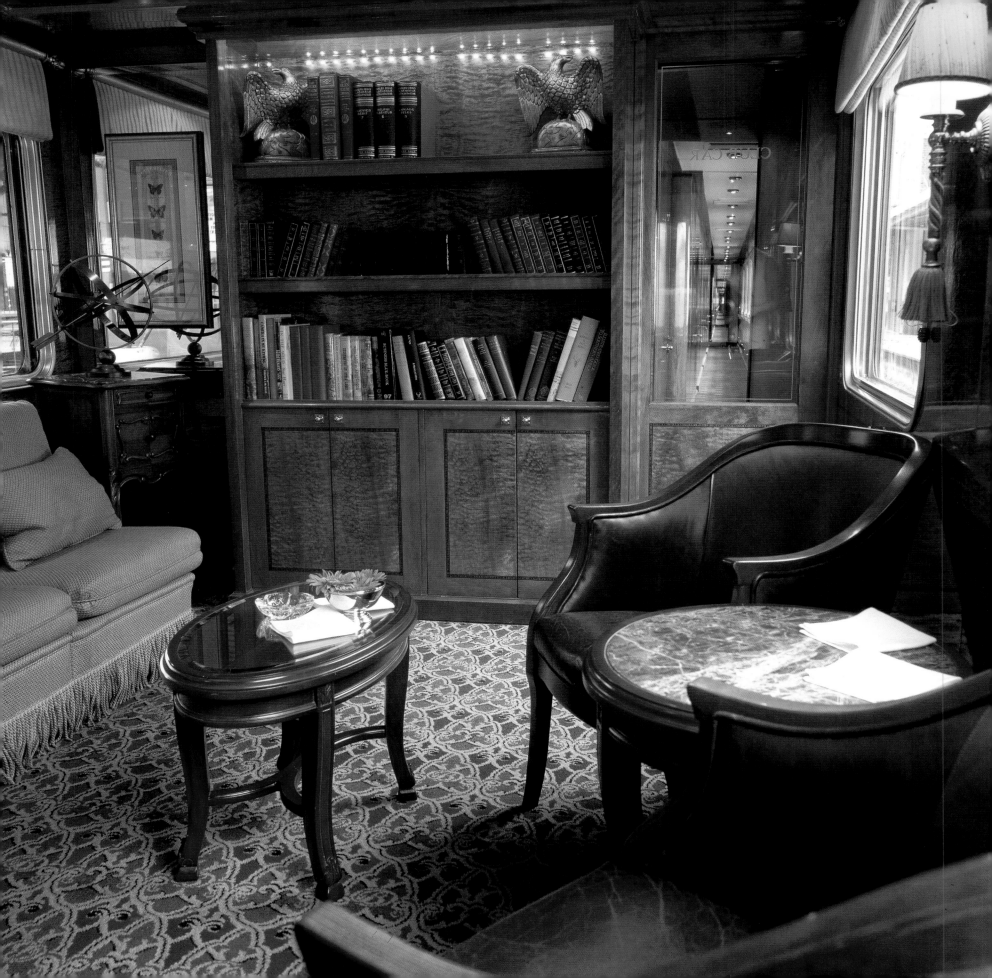

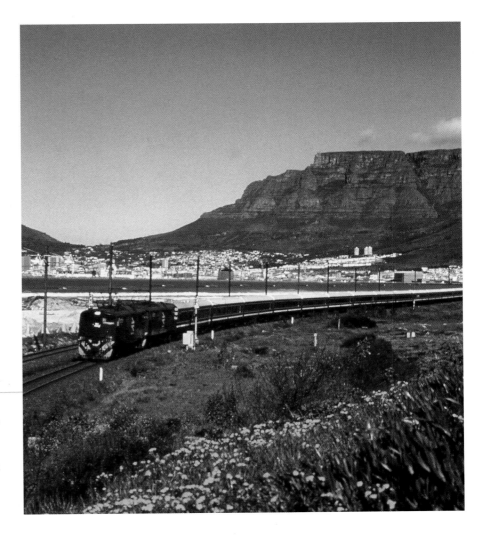

THE BLUE TRAIN
South Africa

Never has more luxury been layered into such compact space, nor square footage so efficiently engineered for comfort. The Blue Train — with its 18 carriages, 84 passengers, 30 staff members, round-the-clock butler service, and laundry — is indeed a five-star hotel on wheels. In the manner of the world's grandest hotels, The Blue Train is not without history and tradition. My firm's charge as the interior architectural design consultant was to inject updated style and glamour to a classic.

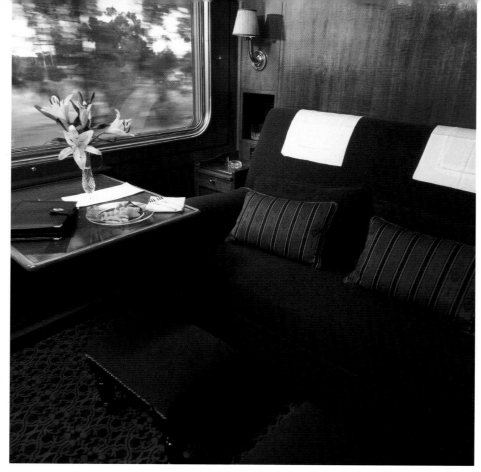

Top: Deluxe accommodations include choice of twin-bed suite with a shower or a double-bed suite with a three-quarter-size bath. Far Right: Made-up single bed in twin deluxe suite.

South Africa's Blue Train has its earliest roots as the Zambezi Express — a luxury line with oak-paneled gaming rooms and a library of leather-bound volumes, that linked Bulawayo with Cape Town. The gold and diamond rush heralded three opulent trains of the Victorian era — Diamond Express, Imperial Mail and African Queen — all gone. In 1923, the Johannesburg-to-Cape Town trip was eased by the debut of the Union Limited (labeled the Union Express on its return). Called "those blue trains," the name stuck. With the arrival of 12 all-steel, air-conditioned sleeping coaches from England in 1939 and two lounge cars, two dining cars, kitchen cars, and luggage vans in 1940, the trains continued for just two years of service due to economic fallout of World War II.

Below: Details abound on this luxury express.

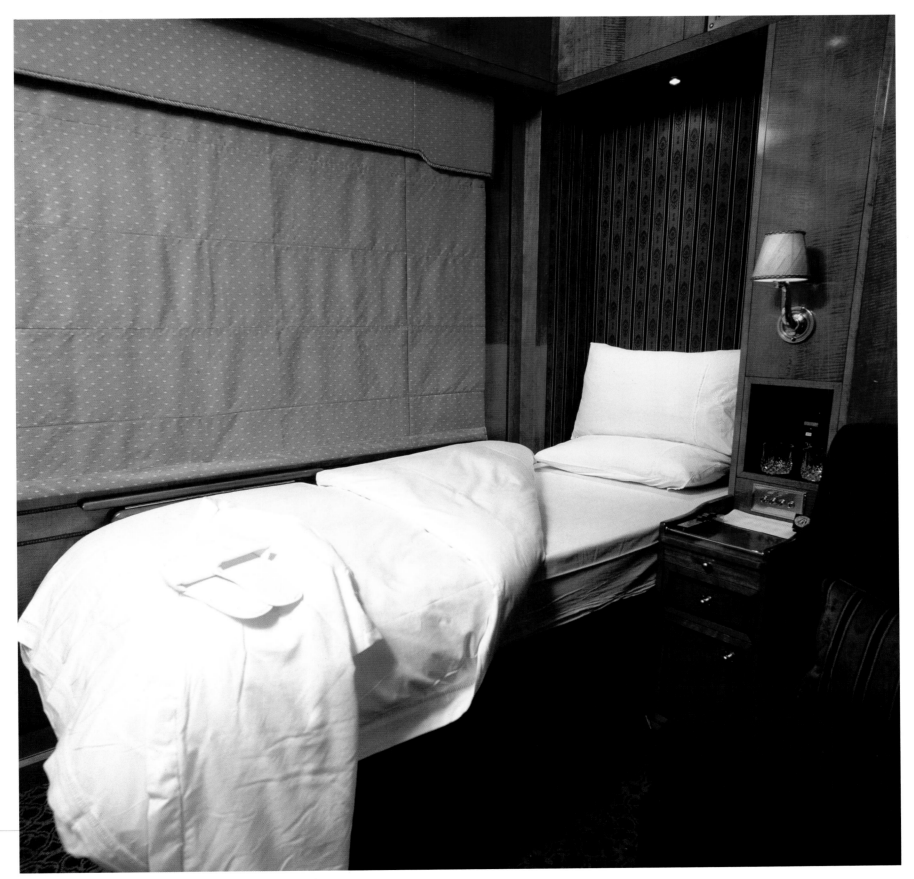

Back on the rails in 1946 and officially renamed The Blue Train by the Minister of Transport, the luxury accommodations have been rolling ever since. Two new trains were built in the early 1970s, but two decades later their look appeared dated, and the world of service had moved on while South Africa languished during the dark years of Apartheid. However, the soul of this amazing country and its historical traditions of excellence made it easy to resurrect this truly remarkable traveling experience true to the essence of The Blue Train. New lavish refurbishment meant squeezing rich appointments and full amenities into narrow rail coaches – imagine just two inches of clearance for elegant door handles! The design team, undaunted by the process and its inherent restrictions, was managed by Shiree Darley and included Michael Crosby, whose father had designed the previous "new" Blue Train launched in 1972.

From the signature "B" emblazoned in gold on white-detailed blue cars, to richly grained woods and marbles, impeccable and sumptuous details mark each coach. Michael Crosby took elements of what whizzes by outside the windows into each and every piece of design. Look at the inlaid woods of the paneling in the coaches, you will pick out the windmills, iconic of the great interior desert of the Karoo, through which the train sweeps on its way north. Look for the dark wood flat topped hills set into the light wood of the surrounding plains. Even the bathing compartments have full tubs and showers.

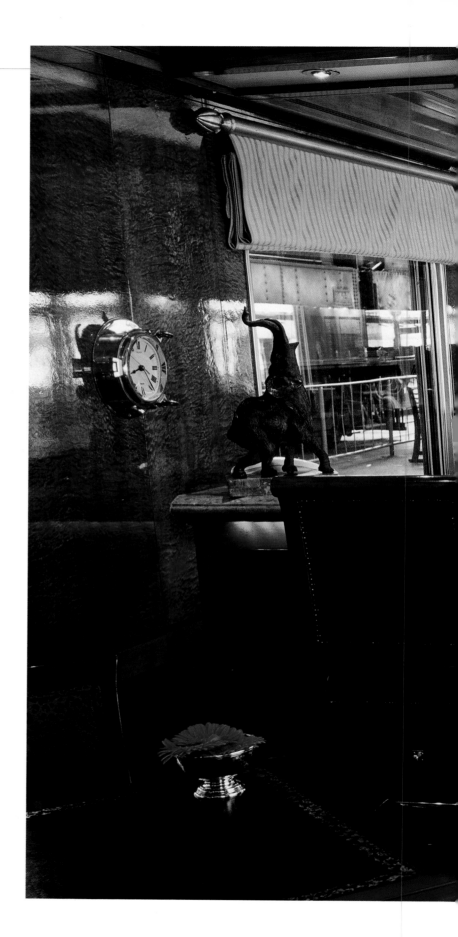

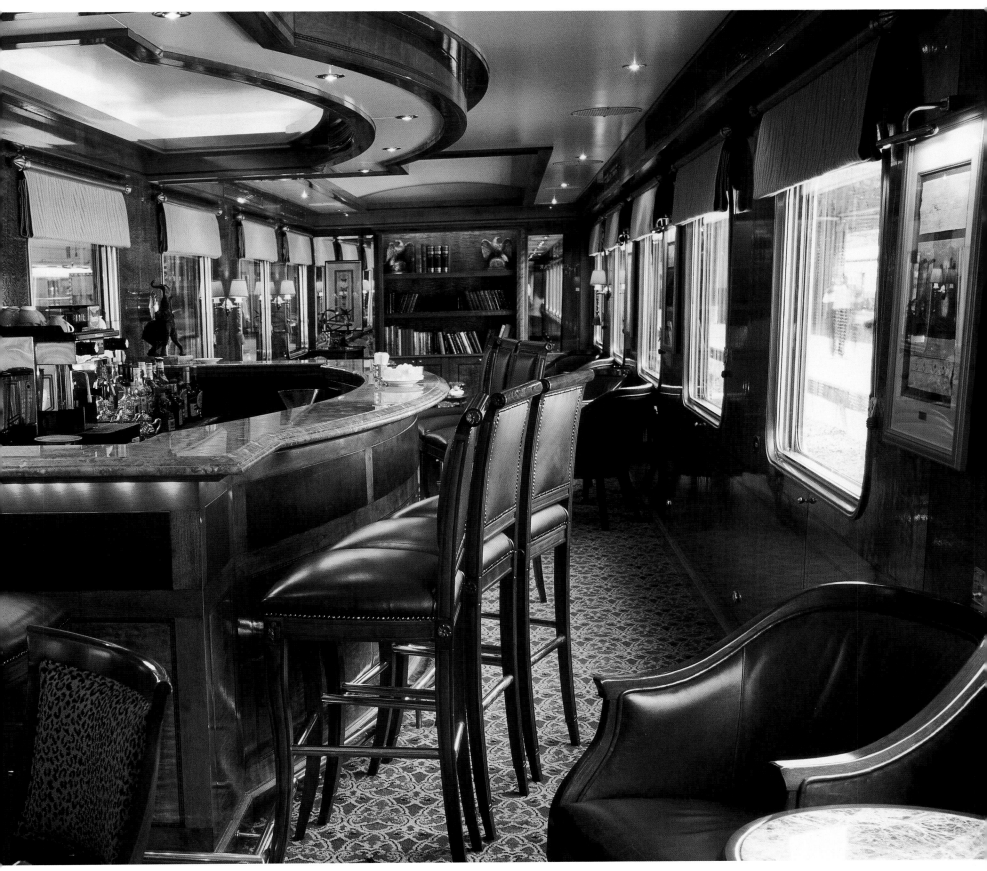

Bathrooms are small but elegant.

Though The Blue Train recalls the golden age of train travel, it is positively 21st century in technological engineering. Interior video monitors show live front-of-train views; guests have CD players and international fax capabilities. Coaches contain special air cushions that provide passengers with the feeling that the landscape is moving, not the train, as it pulls away from the station. And then there are your own private butlers. When we helped design the train, we also suggested a complete overhaul of service staff training and helped the owners, Spoornet, to choose the best facilitators in the world.

Traveling over 994 miles from Pretoria to Cape Town through the Karoo Desert and Kimberley diamond fields, or covering the 992 miles from Pretoria to Victoria Falls, The Blue Train offers timelessness, romance, the exotic excitement of Africa, and elegance singular to the rails.

BOOK TO PACK:
Story of An African Farm by Olive Schreiner

THE BLUE TRAIN

Suite 1608
39 Wolmarans Street
Braamfontein
Johannesburg, South Africa 2044
Tel: 011 27 11 773 7516
Fax: 011 27 11 773 7519
www.bluetrain.co.za

Luxury accommodations include a full-size bath with hand shower, CD players and video machines.

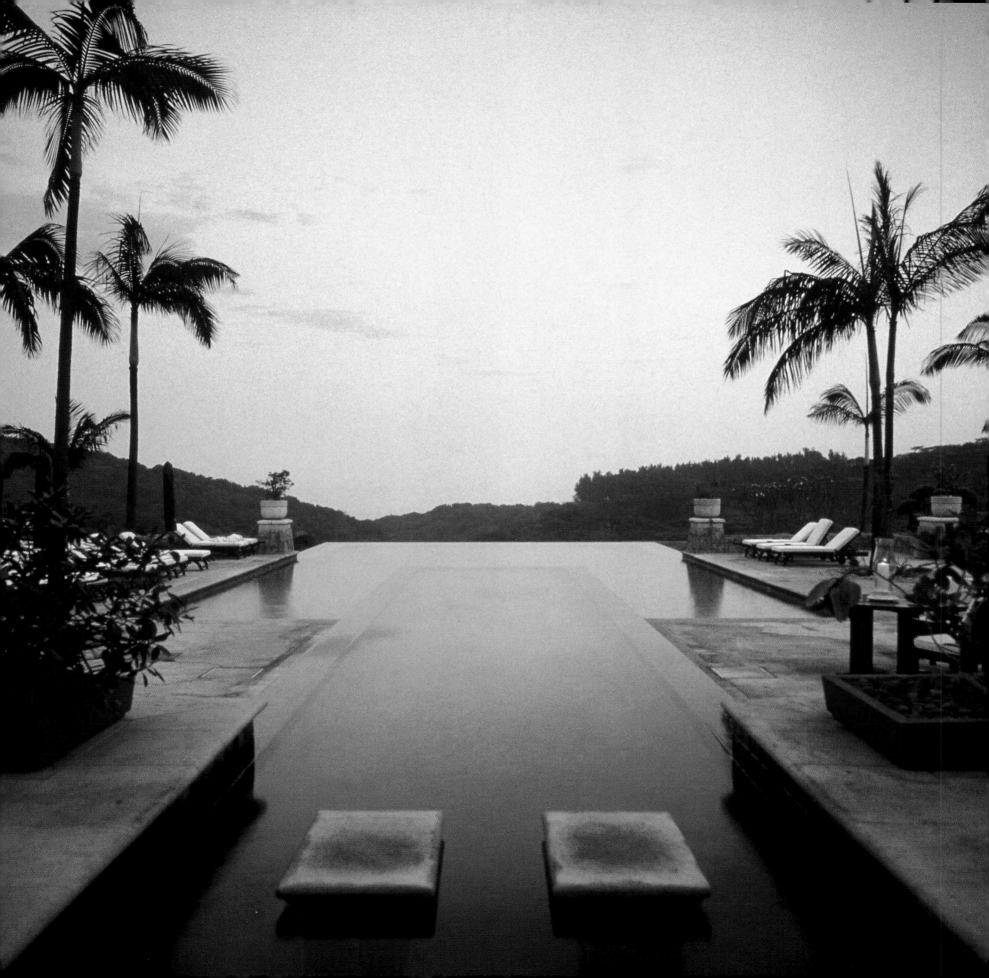

ZIMBALI LODGE

Umhlali, South Africa

*I*n Zimbali, which is Zulu for "Valley of the Flowers," the landscape is a lush, protected environment of lakes and wetlands, home to some of the most magnificent butterflies, birds and trees you will see anywhere. It is the sort of place where anything man-made might seem an intrusion, yet, where the sensitively built environment could become one with nature, putting guests in a resort setting beyond imagination.

This is my haven between more rustic forays into the African bush. Our travel party generally takes two or three days at Zimbali Lodge to rest and regroup – for ultimate pampering and relaxing – before we strike out on another safari experience.

For starters, Zimbali Lodge had to be small and exclusive to fit in at all. It's just 76 guest rooms in a series of lodges set on stone stilts reminiscent of a treehouse. North of KwaZulu Natal's capital city of Durban, Zimbali Lodge fronts Africa's Dolphin Coast, with the waters of the Indian Ocean just beyond. Painstakingly designed stone walls perfectly blend with the natural landscape, with terraced platforms nestled on the sloped site, affording the eight guest lodges magnificent views of coastal forest, a carefully planned golf course, and the blue ocean beyond.

The hotel's furnishings are evocative of both English and African traditions.

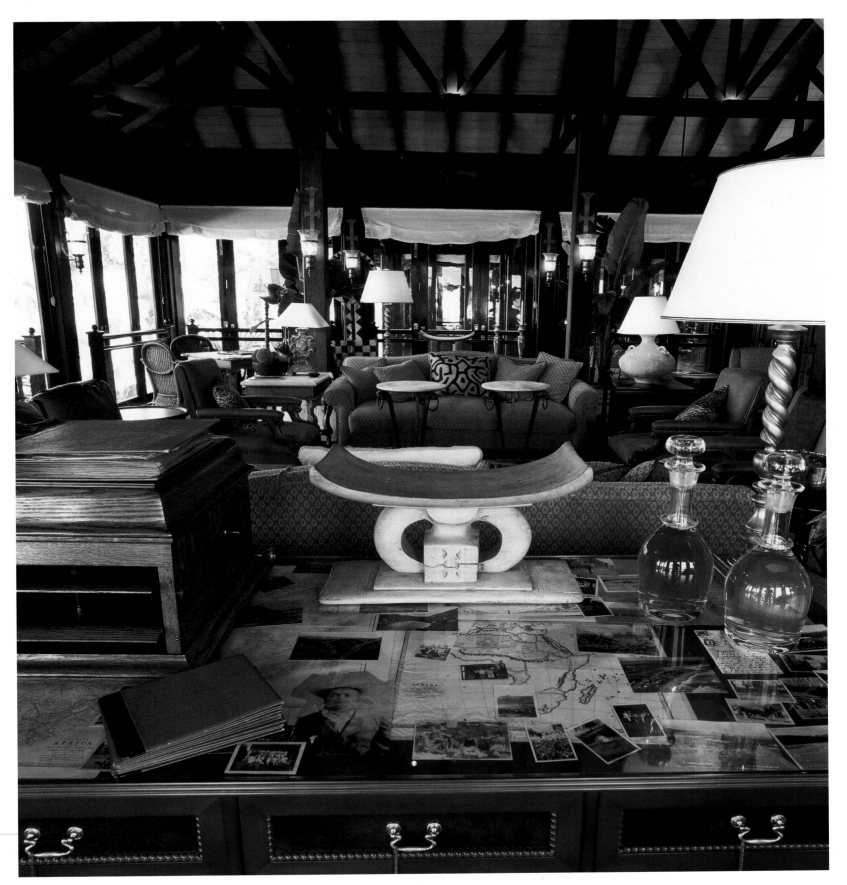

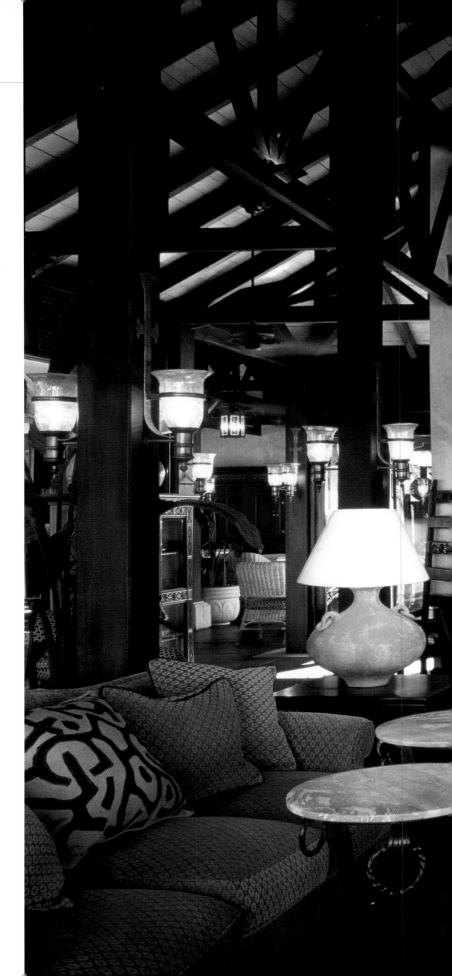

The stone chimney is central to the main lounge with warm and comfortable furniture to help a guest relax.

Embracing the natural setting while creating surroundings reminiscent of the local, baronial homes of sugar magnates required creative vision. I am proud that our design team collaborated on this special retreat. The result is what I call "time travel," the essence of Victorian detailing and classical African elements that lends unparalleled romance and transports you back to a grander era.

Outside, note the simplicity and orderly disorder of cottage gardens, manicured and contained close to home, gone shaggy and wooly beyond. Inside, revel in a huge Victorian claw-footed tub, sleep under mosquito netting, nap in hand-carved furniture from Zanzibar. The effect would not be complete without butler's trays, hand-forged chandeliers, hand-carved basins and marble slabs in the baths. Even the carved grills over the air vents depict traditional African scenes.

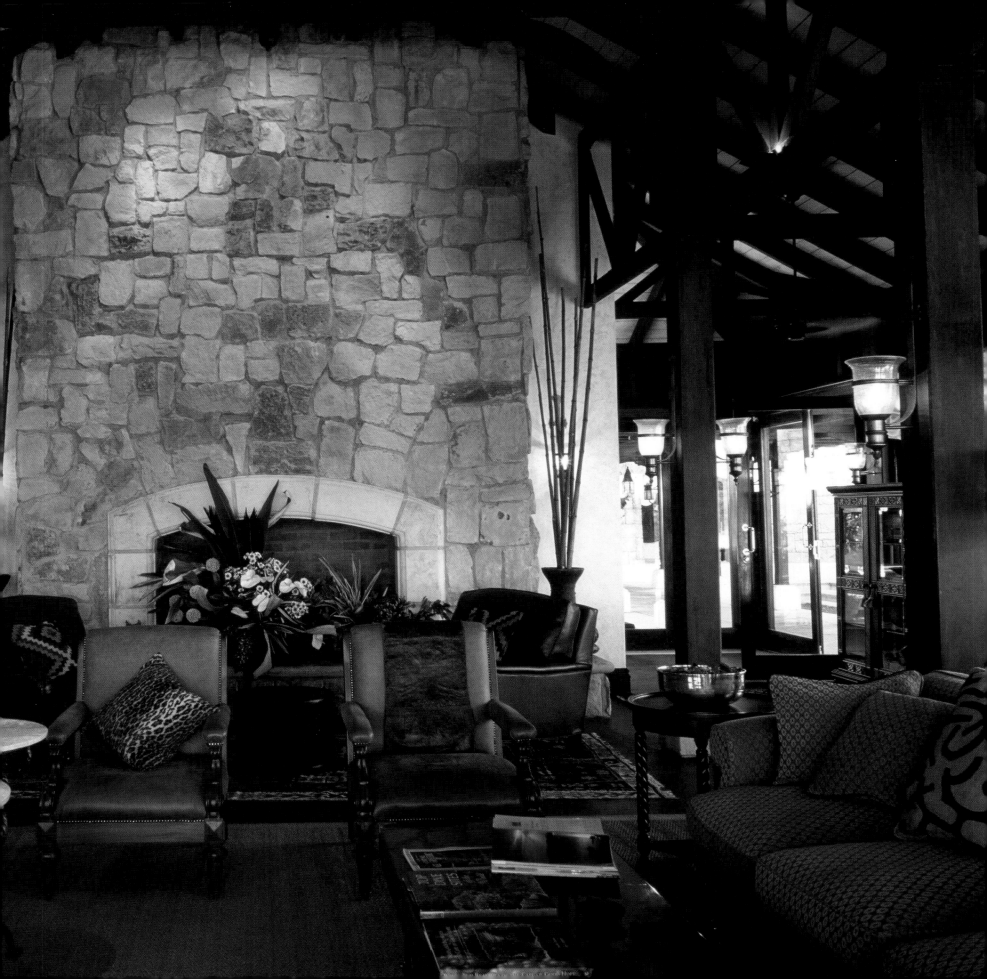

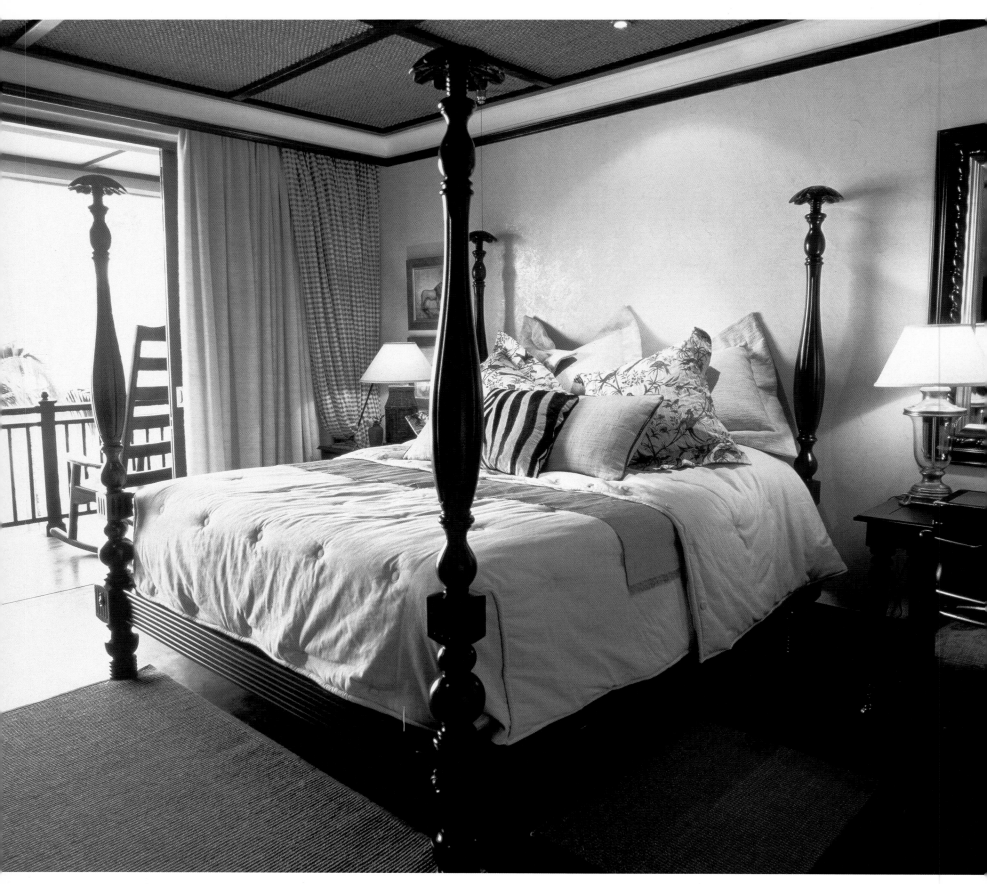

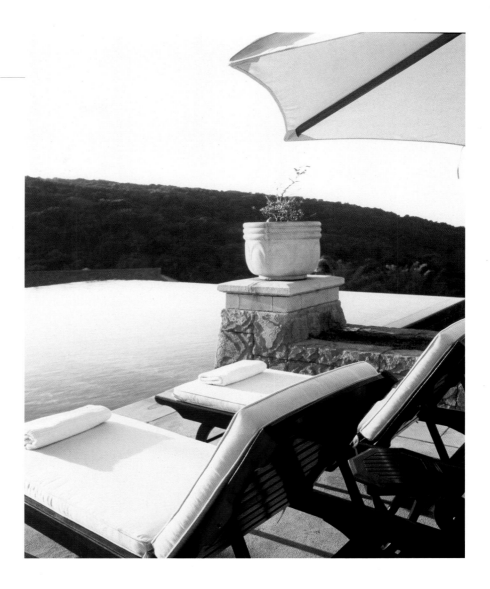

Outside, the magnificent golf course beckons to those who want
to experience the feeling of playing in a tropical paradise, or
there are the beaches, for long walks next to the wild Indian
Ocean at sunset.

Like the pools of my dreams, the infinity-edge pool waters at
Zimbali Lodge appear to drift into the Dolphin Coast and the
Indian Ocean. To be one with nature while being so perfectly
pampered – that's Zimbali Lodge.

BOOK TO PACK:
Cry The Beloved Country by Alan Paton

The suites at Zimbali Lodge feature hand-carved four
poster beds with soft textured fabrics to add to the
peace and comfort.

ZIMBALI LODGE

P.O. BOX 404
Umhlali 4390
Tel: 011 27 32 538 1007
Fax: 011 27 32 538 1019
www.suninternational.co.za

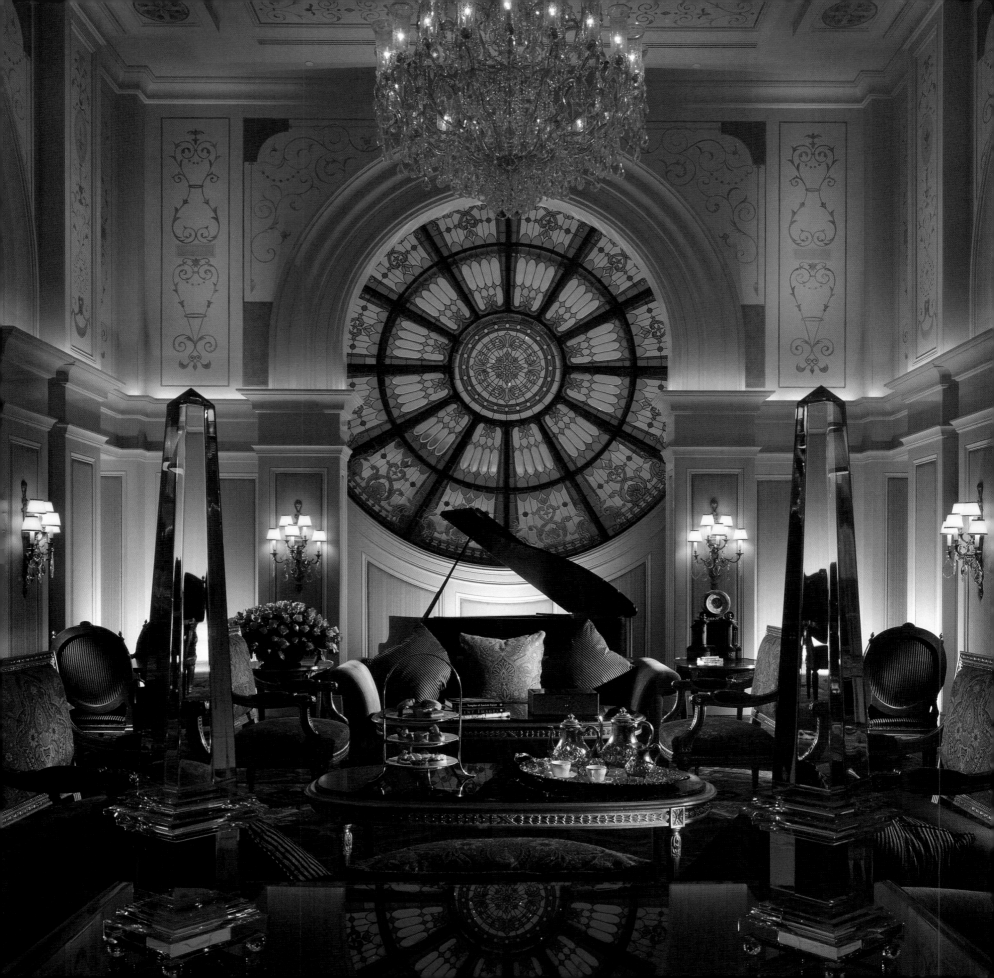

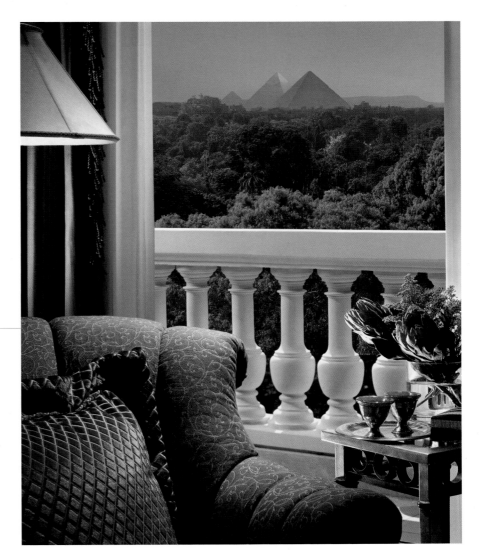

FOUR SEASONS
HOTEL CAIRO
AT THE FIRST RESIDENCE
Cairo, Egypt

There is no place in the world where the past and the present collide like they do in Cairo. Variously called the Jewel of the Orient, the Triumphant City, the melting pot of Ancient and Modern – it is a place that can literally take your breath away – sometimes for the wrong reason!

To the east of the city stands evidence of 2,000 years of Islamic, Christian Coptic and Jewish culture; to the west the ancient Egyptian city of Memphis, or Giza, as it is more commonly known. This is the site of the pyramids, the only surviving member of the Seven Wonders of the Ancient World.

Left: The formal Tea Lounge is a sophisticated blend of French and Egyptian traditions.

Right: A captivating view of the pyramids from a deluxe room.

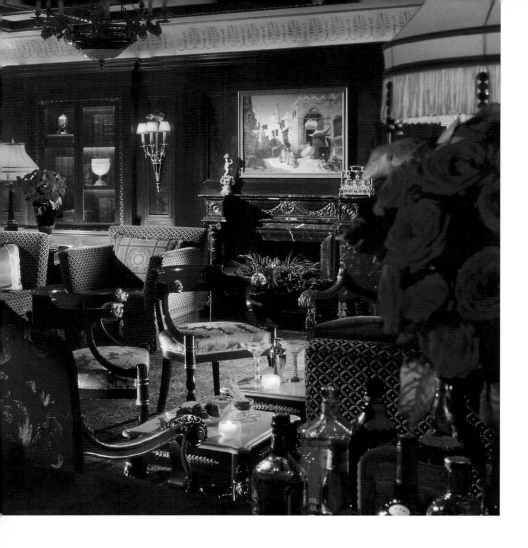

The Four Seasons Hotel Cairo at the First Residence is a modern haven nestled in this ancient world. Situated on the west bank of the Nile in Giza, it is a serene and gracious sanctuary in a teeming, bustling, sometimes hot and dusty, but always exciting metropolis. In the cool comfort of my room, I remember looking out of my window at the great pyramid of Khufu, probably the world's most famous monument, and the Nile River. It was almost overwhelming as stories from my childhood came rushing back to me, and there I was in the land of the pharaohs.

The hotel itself is truly enchanting. In a land where kings' tombs are layered with gold, where the focus is on masterful antiquities and historic context, re-creations ring hollow. When we were designing the hotel, we simply focused on the needs of the traveler. What sounds best after a dusty day of trekking ancient burial sites or suffering through jetlag in an eight-hour business meeting? I like to relax in the soaking tub in a pristine room, indulge in a spa treatment, and turn in early to rest up for another day's events.

Top: The Library Bar is welcome relief following a day of sightseeing.

Bottom Left: Suites are luxuriously appointed and artfully detailed.

Bottom Right: Seasons Restaurant offers beautiful surroundings and stunning views, as well as epicurean delights.

Facing Page: French furnishings and architectural details in the foyer.

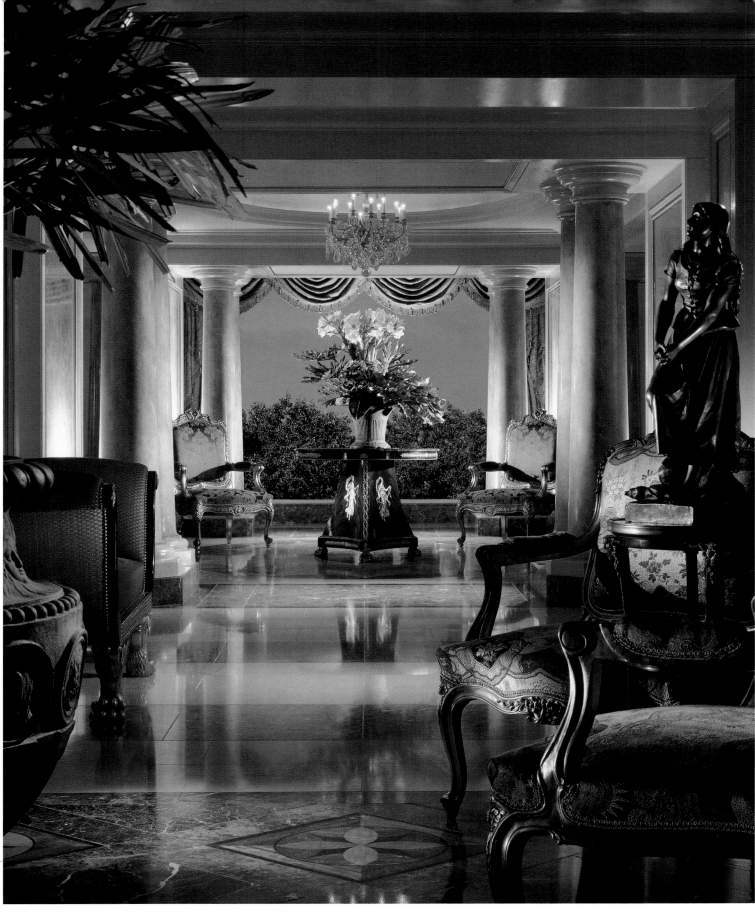

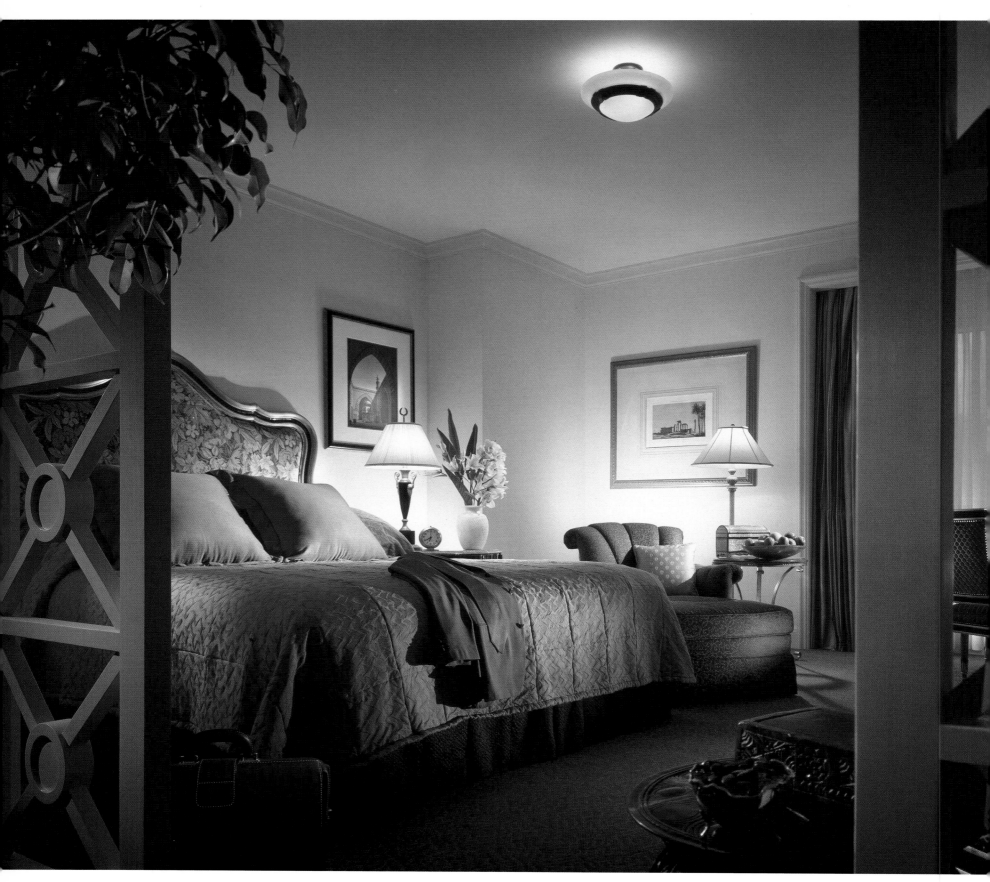

The fourth-floor pool deck is a true oasis in the desert.

We concentrated on Egyptian sensibilities, rather then Egyptian themes. For example, the finest fabrics in the world, especially cottons, have for centuries come from this land. Handwoven pieces, fine paintings and sculpture added authentic Egyptian elements to a refined and understated interior. Comfort, softness and a sense of being enveloped in luxury in a hard land is the effect I think we achieved. Add to this the pampering – no request is too much trouble for the staff whose service is exceptional and always charmingly delivered. The cuisine too is wonderful – largely Mediterranean, with influences from North Africa, Lebanon, Morocco and Italy.

One day, I rode on a camel with an enchanting guide to view the pyramids and visit museums, and was completely overawed by the beauty and antiquity of everything I saw. On return to the hotel I visited the Spa where I had the Dead Sea Salt massage and treatment – this is a must. Cleansed and invigorated I reflected on the fact that ancient Egyptians were known for their refinements in domestic life. The wealthy appreciated the aroma of myrrh ointments and the luxury of fine linen clothing. They liked to surround themselves with elegant objects and furniture. I think they would approve of the Four Seasons.

BOOK TO PACK:
Ramses The Son of Light by Christian Jacq

The deluxe guestroom offers ample space for relaxing and planning tomorrow's agenda.

FOUR SEASONS HOTEL CAIRO

35 Giza Street
Giza, Cairo, Egypt 12311
Tel: 20 (2) 573-1212
Fax: 20 (2) 568-1616
www.fourseasons.com

Four Seasons Hotel New York, Page 92

The Americas

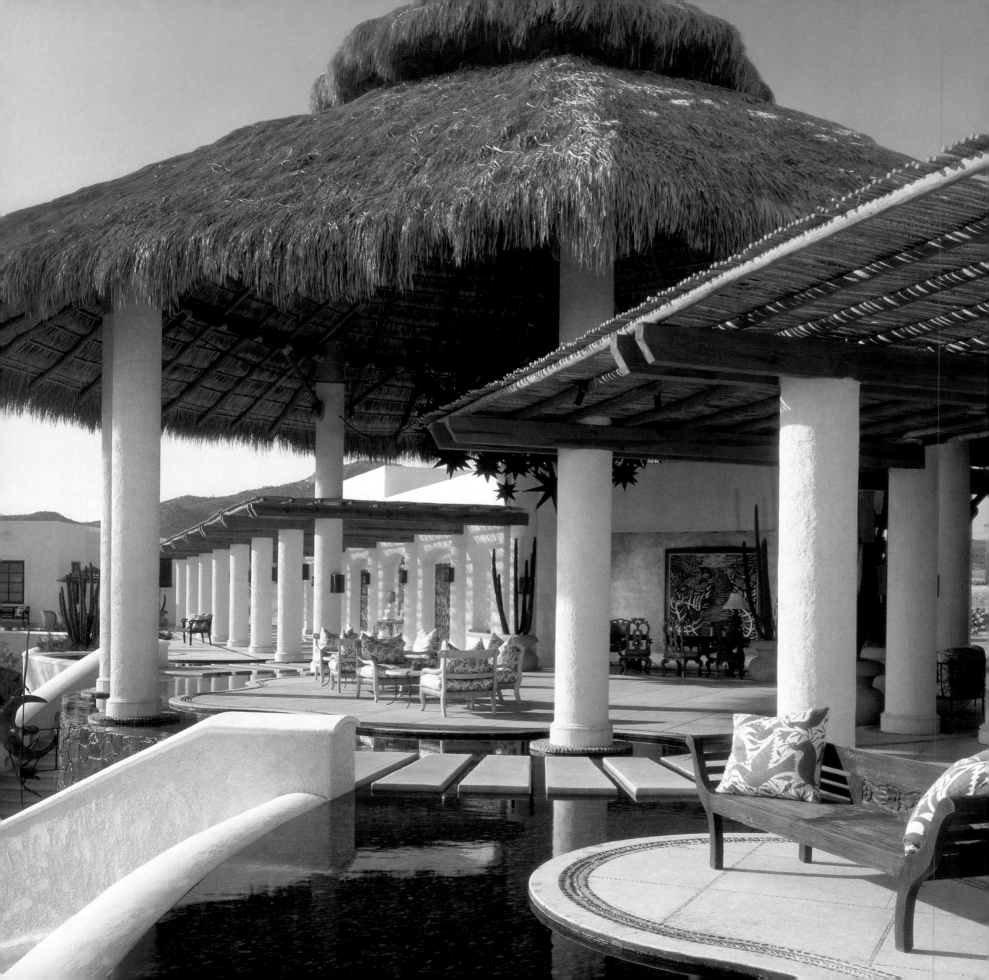

LAS VENTANAS
AL PARAISO

Cabo San Lucas, Mexico

os Cabos, with an incredibly beautiful 20-mile stretch of pristine white sand beaches between San Jose del Cabo and Cabo San Lucas, averages 350 days of sunshine per year, which makes getaways to Las Ventanas all the more perfect. Las Ventanas Al Paraiso, a Rosewood Resort, lies at the tip of the Baja Peninsula, in an area known as Los Cabos (The Capes).

The resort's layout is a series of stucco buildings and open-air patios with the focus always on powerful views.

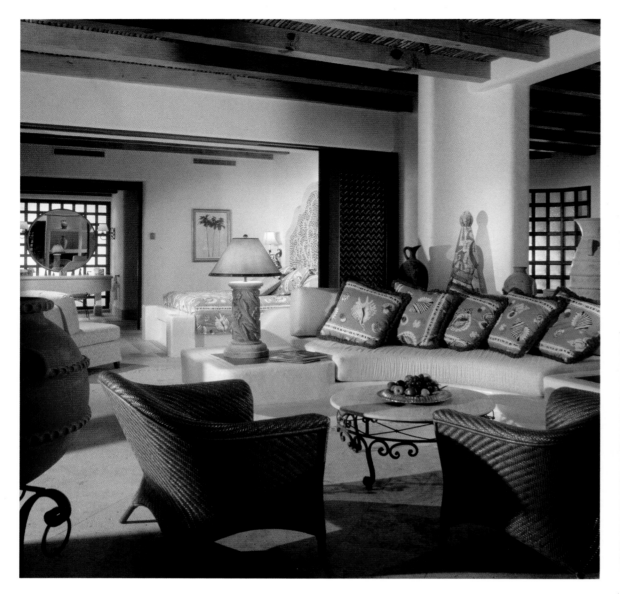

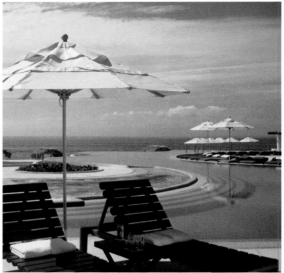

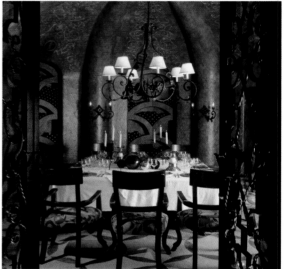

Las Ventanas is a resort of choice for celebrities – a getaway replete with comfort and luxury. I love sitting by the pool, combing through a stack of magazines, and sighting movie stars. It's obvious why the cognoscenti love Las Ventanas. Here, they want for nothing, as even guests' dogs are indulged and pampered with special canine treats and amenities!

The spa treatments are nothing short of fabulous – there's a lengthy menu for body and skin experiences. You can choose something new and different every day, which I have been known to do.

Top left: Suite sitting area.

Top right: The infinity edge melds pool into ocean.

Bottom right: Dining in the wine grotto.

Facing page: Open-air lobby bar with spectacular "estrella" chandelier.

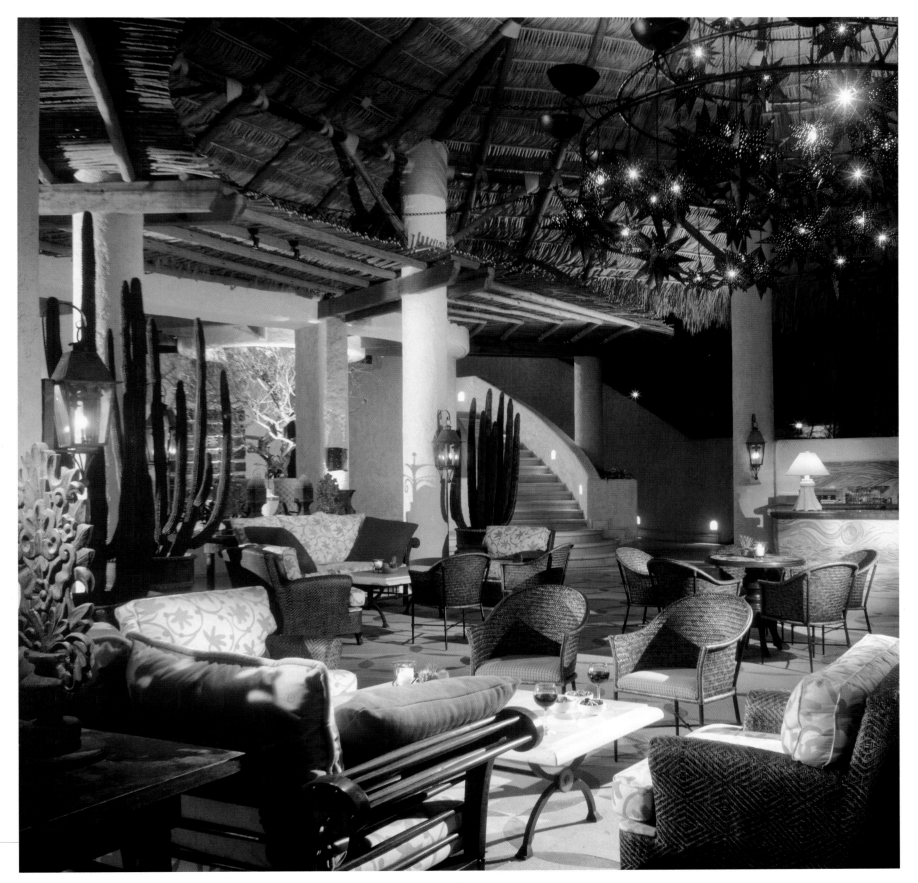

At Las Ventanas, the emphasis is simultaneously on luxury and the outdoors. When my husband and I asked the concierge to arrange a private dinner on the beach, the result was absolutely spectacular. We were just six feet from breaking waves, in our own candlelit palapa.

The beauty of the resort comes both from what's visible and what's hidden. I love that maintenance, grounds, and delivery crews crisscross the resort in underground tunnels, keeping what should be behind the scenes out of sight. That frees what's visible to delight the eye and engage the senses.

I luxuriate in the idea of enjoying my fresh-squeezed morning juice while relaxing in my private terrace splashpool. Guest suites open fully onto terraces, eliminating boundaries and cultivating outdoor access that captures a breezy resort style. Second-floor rooms have roof terraces, which make great settings for starlight dinners to capture an amazing view of the ocean and twinkling lights.

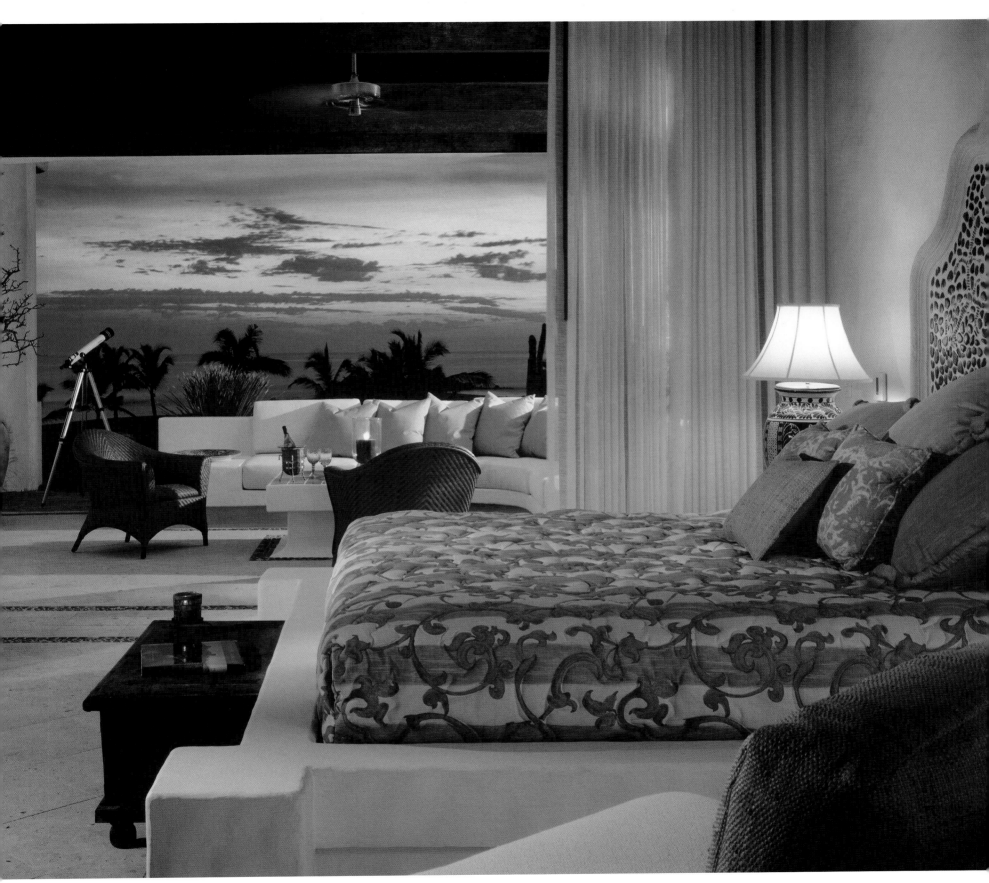

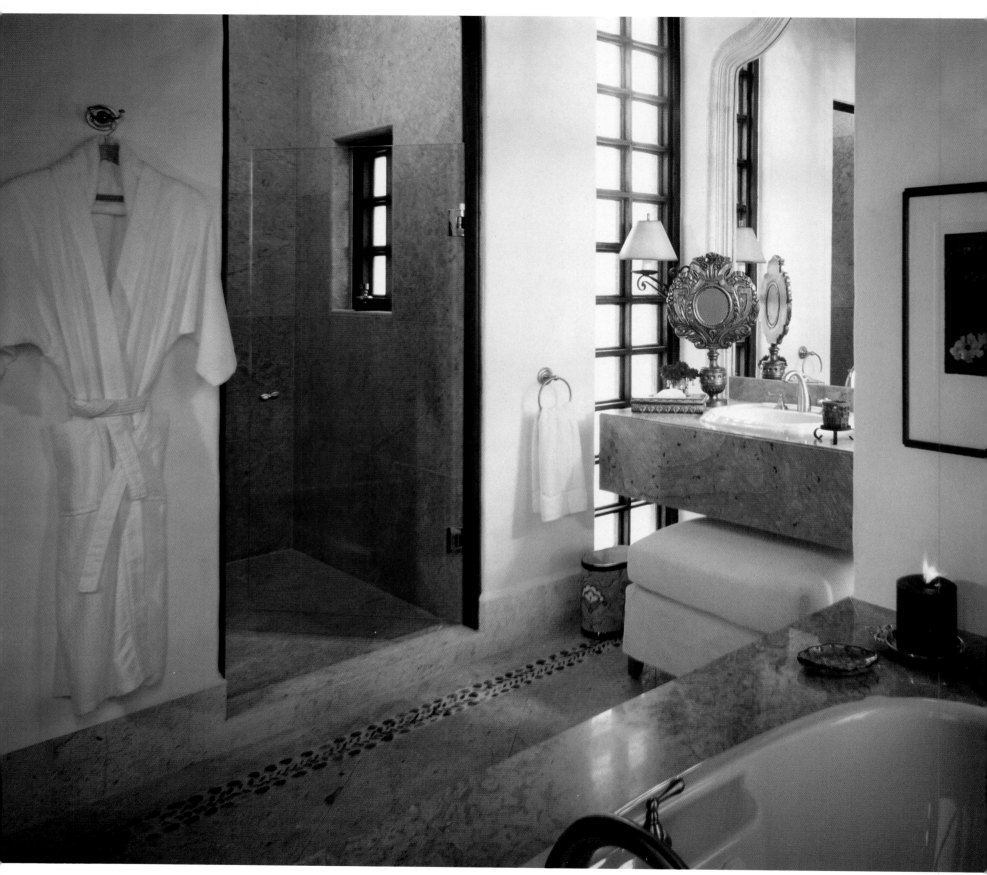

In the quest for simplicity and local flavor, we kept furnishings purposefully sparse, decorative only as regional craft dictates. On the floor, cool conshevela (limestone) pavers are studded with hand-tiled stone; decorative motifs take cues from ocean and desert colors and local materials.

From the hand-hammered lanterns to rough-hewn beams to the creamy, shapely adobe walls, Las Ventanas is perfect in a not-too-perfect way. What's perfect here is the effect of nature blending seamlessly with the built environment. There's a telescope in every room for a reason. You won't want to miss the view, day or night.

❧

BOOK TO PACK:
Best Stories of Baja by Larry Stanton

Luxury abounds in the spa-style bathrooms accentuated with hand-crafted Mexican amenities.

LAS VENTANAS AL PARAISO

KM 19.5 Carretera Transpeninsular
San Jose del Cabo
Baja California Sur 23400, Mexico
Tel: 52 624 144 2800
Fax: 52 624 144 2801
www.lasventanas.com

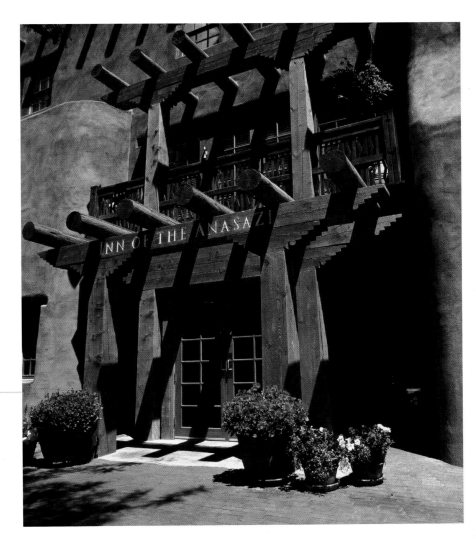

INN OF THE ANASAZI

Santa Fe, New Mexico U.S.A.

Left: Massive hand-carved doors open into the elegantly comfortable reception area where guests receive a warm welcome.

Right: The Inn's location, just steps away from the historic Plaza, is perfect for exploring Santa Fe.

When we started to design the Inn of the Anasazi, we understood the importance of representing the spirit of the desert southwest. It is an aura that is at once cultural and historic, yet natural and artistic. Santa Fe is the oldest state capital in the Union, but its history and heritage go back even further than political time – it is the beating heart of ancient tribal America. Like no other city in the United States, it deftly blends creativity in the arts (200 art galleries and five museums) with rugged beauty in materials and surroundings, all couched in an almost inexplicable sense of peace and belonging.

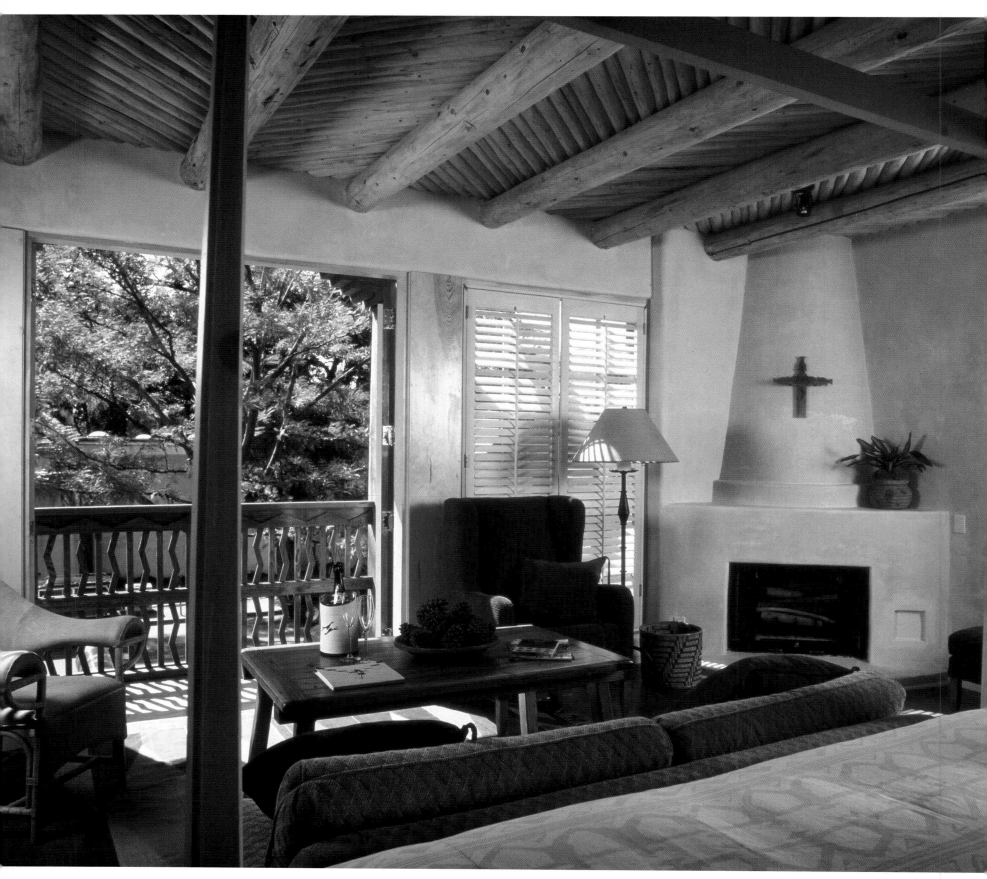

In design we were guided by the history of the area. The Anasazi refer to Native Americans as the ancient inhabitants of the Four Corners Region where New Mexico, Arizona, Utah, and Colorado meet. The name itself is Navajo for "the ancient ones." So our charge was to design an Inn that would celebrate not only the art and artistry, but also the spirituality of the tribe's everyday life, which flourished 700 years ago and is still explored in archeological sites and ancient ruins. Such sites illustrate that the Anasazi understood how to live in harmony with one another and with nature, building complex pueblo villages, including their largest, Chaco Canyon, with 5,000 inhabitants. The tribe had founded the essential center – economic, political, religious – for the entire southwest, though it eventually abandoned its dwellings in search of more reliable water sources.

Spaniards began their exploration of the area in the 16th century, establishing La Real de la Santa Fe de San Francisco, the City of the Holy Faith, or Santa Fe, in 1609. For them, the center of commerce and city life was the plaza, mimicking European and even pueblo planning. The Inn of the Anasazi occupies a prime location within the plaza, across the street from the oldest public building in the United States, the Palace of the Governors. (For me, it puts Santa Fe's history in perspective to think that this Palace of the Governors was built nearly 100 years before the Palace of Governors in Williamsburg, Virginia.)

When the Inn of the Anasazi was designed in the late 1980s, the architectural team at Aspen Design Group studied the adobe-and-timber construction of Santa Fe's Palace and similar structures. Obviously, their rendition is a building in keeping with the materials and styles of centuries past. Architecturally, the Inn of the Anasazi matches the practicality and ingenuity of the area's original settlers. The adobe construction owes its simple grace to chunky-smooth walls of sun-dried clay, used in place of scarce wood. The mud is punctuated by vigas, the heavy, protruding wooden beams that provide support for walls and roof. I am notorious for being a fine detail person, and I love and admire the simplicity of adobe. The architectural starkness of the adobe ceiling is offset by the vigas and the exquisite geometry of their shadows casting patterns on plain facades.

The guestrooms are designed to blend luxury and culture with gas fireplaces, handcrafted furnishings and fabulous linens.

Creative, authentic decorations create the feeling of entering a prehistoric ruin brought into modern times.

The Library houses books on Southwestern art and culture and makes a perfect meeting spot for small groups.

Everywhere at the Inn of the Anasazi, we complemented the thickness of the adobe walls with massive detailing. I applaud the design genius of Jim Rimelspach throughout the interiors. He purposefully sought the textures and tradition of rough-hewn, hand-carved elements in furniture, fixtures, and embellishment. For lobby spaces, he kept things sparse: stone flooring, drystack sandstone walls (laid up in the same way the Anasazi did centuries ago), and viga-and-latilla ceilings. Decorative ornamentation comes in the form of woven textiles richly patterned with geometric, simple metal sculptures, period Indian baskets and pottery.

The Inn's restaurant encompasses the culinary roots of the Southwest and has become a destination for both guests and locals to discover unique traditional tastes with a contemporary flair. Design wise, I refer to the restaurant space as "from the earth" since we mixed art and pattern with simple, rough-hewn tables and bancos. It is a space reflective of the organic, natural bent of the restaurant's kitchen.

In each of the 59 guestrooms, we took a simple approach, staying faithful to local and regional simplicity in design while catering within this paradigm to the luxury expected by today's discerning traveler. It is a comfort-meets-southwest-aesthetic with rich fabrics and textures, gas lit kivas (or fireplaces), viga-and-latilla ceilings, and Indian-style rugs. We even found bath amenities created locally with native cedar extract.

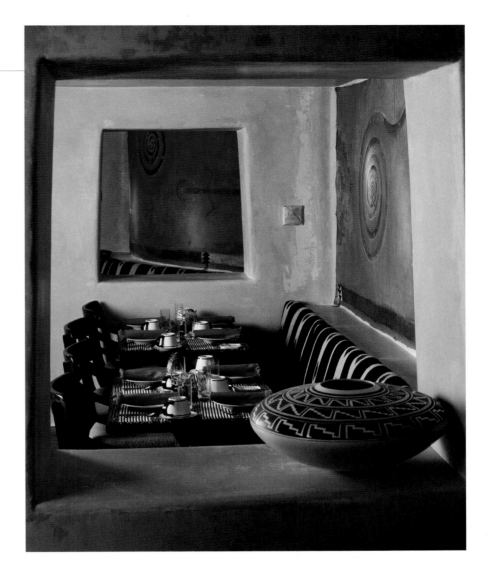

While we knew we were creating a very special project, we never
could have fathomed the communion among guests at The Inn of the
Anasazi. Many return annually or even several times each year, and
tell us the Inn reflects the spirit of ancient cultures and represents
an escape from ordinary pressures and modern trappings. Again, I
think of our mission to impart the aura of the Southwest. To wake
up to the still village-like sounds of Santa Fe, with that famed New
Mexico light feeling its way across soft brown adobe walls, wrapped
in the comfort of a high bed with perfect cotton sheets, is to expe-
rience true relaxation.

For the entire project, we found inspiration in the words of Chief
Seattle: "This we know: The earth does not belong to man, man
belongs to the earth. All things are connected like the blood that
unites us all: Man did not weave the web of life, he is merely a strand
in it. Whatever he does to the web he does to himself."

BOOK TO PACK:
In Search of the Old Ones by David Roberts

INN OF THE ANASAZI

113 Washington Avenue
Santa Fe, New Mexico 87501
Tel: 505-988-3030
Fax: 505-988-3277
www.innoftheanasazi.com

[75]

THE MANSION
ON TURTLE CREEK

Dallas, Texas U.S.A.

*I*t's simply impossible to imagine Dallas without The Mansion. It must be true that things improve with age because The Mansion gets somehow better each year. On my frequent visits, I find architectural features and exquisite little details that I've never noticed.

Left: The motor court elegantly marks the entry.

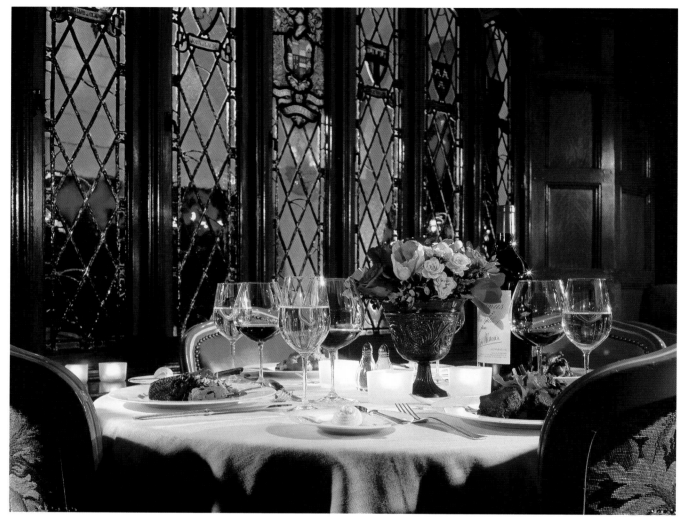

Private dining area, offering an intimate, elegant setting to enjoy conversation and fine cuisine.

It took a visionary to recognize the potential of an Italian Renaissance villa as hotel, a perfect gem crafted at the skilled hands of tradesmen. It is such a rich heritage of craftsmanship that renders The Mansion unique. After all, this was no ordinary millionaire's mansion, even by Texas standards. It began in 1925 with local limestone bedrock carved onsite to create an underground silver vault for owner Sheppard King, a cotton magnate. On that foundation, craftsmen built a showplace, hammering in ornately carved ceiling panels, mouldings and details. Contractors from Denver and St. Louis arrived to witness the building of the unique, cantilevered marble stairway, an engineering feat in its day.

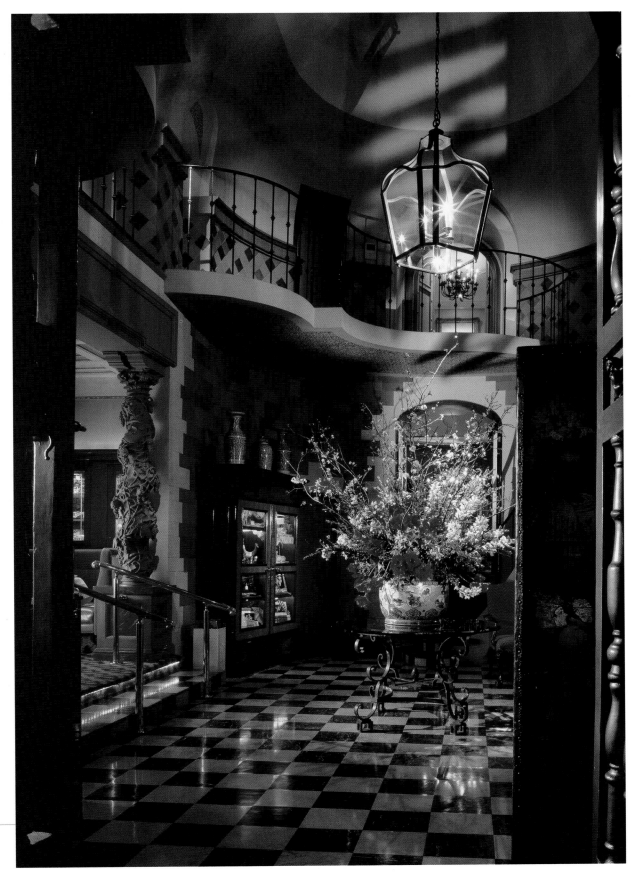

One of my favorite views is the entrance to the world renowned restaurant. This is part of the original Sheppard King home.

Main dining room with views to Turtle Creek.

In 1979, Rosewood Hotels set a new standard for historic restoration, preservation and adaptive reuse. That standard is perfection, heralding an era of residentially styled hospitality luxury in the United States. Part refinement, part reinvention, The Mansion exceeds expectations in service, in food, in quality, in enthusiastic artistry and flair for orchestrating occasions and their details. Ironically, The Mansion is at once the perfect escape and the perfect see-and-be-seen experience. It's become a local destination of Dallas society types, the venue of choice for the midnight cocktails of the tuxedo and ballgown crowd.

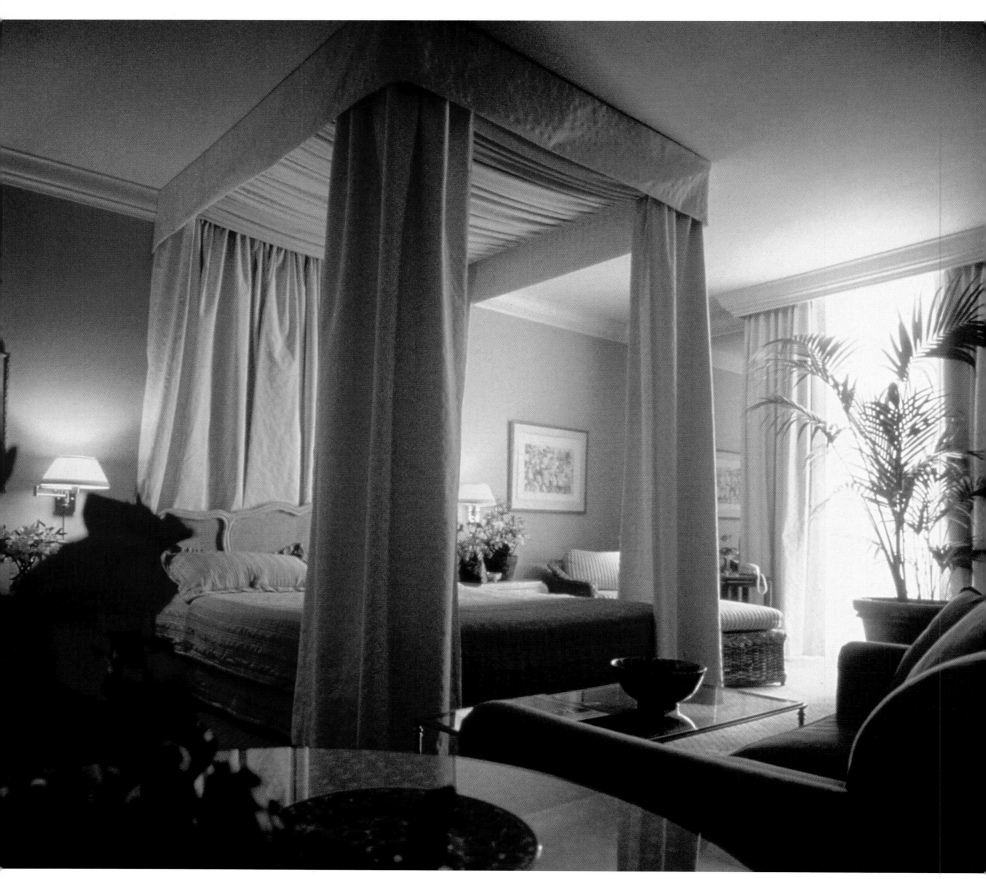

The incomparable, romantic Mansion Bar.

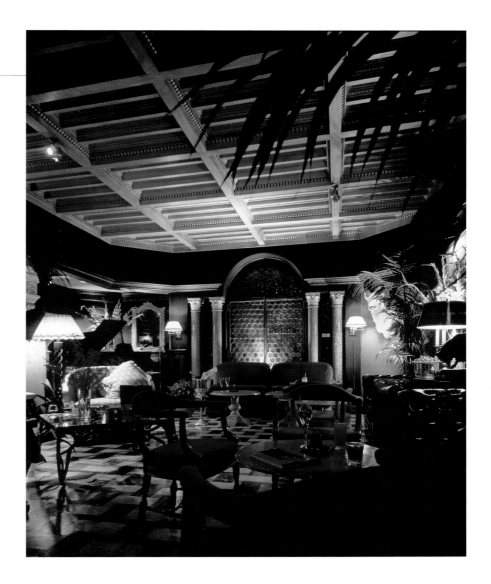

I marvel at The Mansion's deft mix of experiences. What was once the silver vault is now the Wine Cellar, reserved for intimate private dining. And perhaps no hotel dining room stateside can rival The Mansion's extraordinary architecture, dramatic entrances and incredible cuisine. The room's ornate ceiling, incorporating thousands of pieces of inlaid carved wood, is among its many intricate marvels. Credit the unparalleled aesthetic of French architect M. Jacques Carre, uncompromising in detail and precision. For culinary inventiveness, chef Dean Fearing has earned star status. My "musts" at The Mansion include his signature dishes: Tortilla Soup, ladled from a tureen tableside and garnished to my preference, and the warm Lobster Taco, an indescribably rich and savory combination. Mansion regulars know that Fearing's unmatched crème brûlée is always worth the splurge.

BOOK TO PACK:
The Last Picture Show by Larry McMurtry

Luxury abounds in every guestroom and service offered at the hotel.

THE MANSION ON TURTLE CREEK
2821 Turtle Creek Boulevard
Dallas, Texas 75219
Tel: 214-559-2100
Fax: 214-528-4187
www.mansiononturtlecreek.com

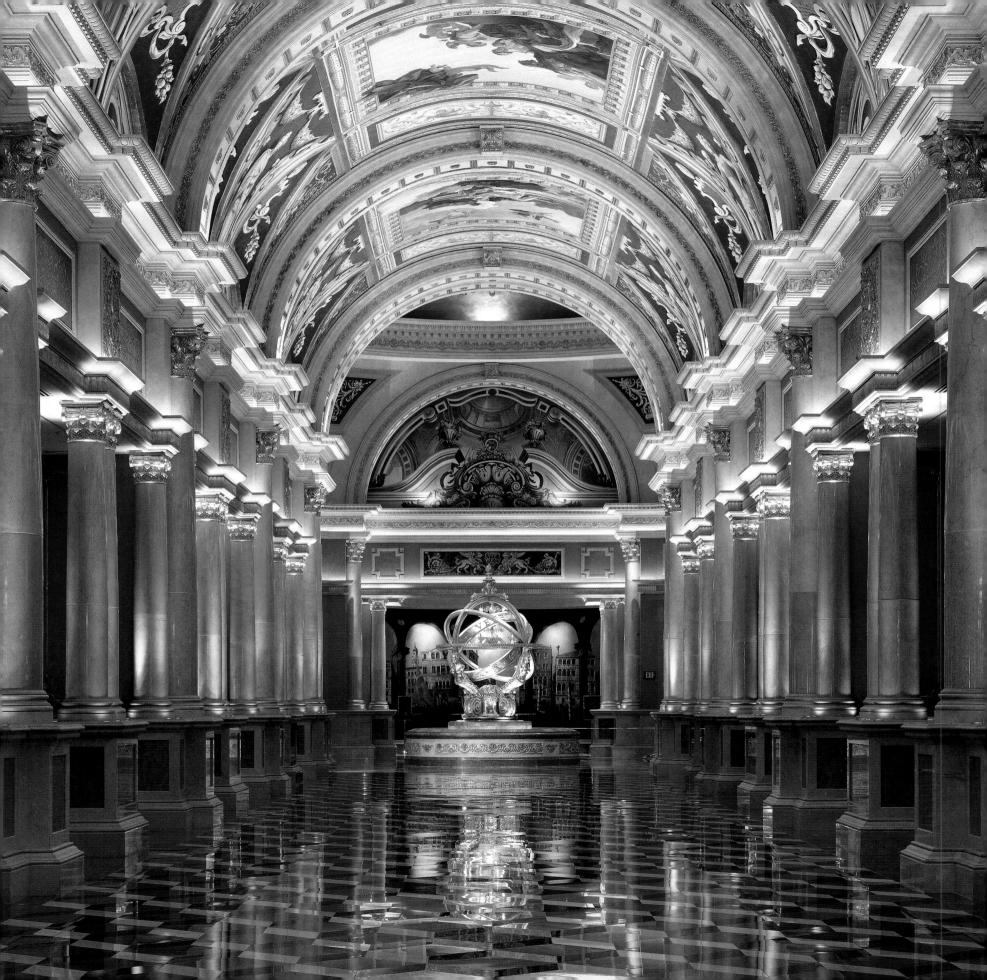

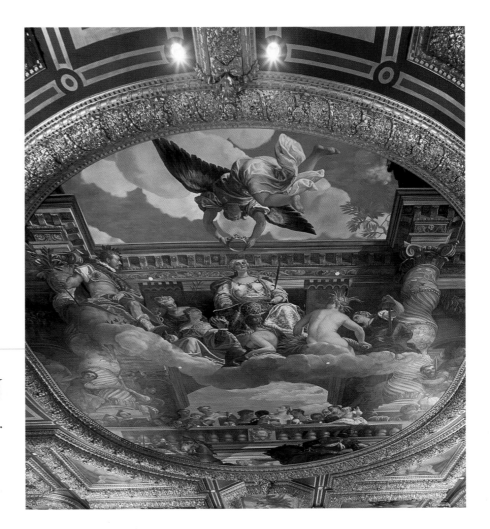

THE VENETIAN

Las Vegas, Nevada U.S.A.

W hen the old Sands Hotel imploded in 1996, the face of Las Vegas would change forever. What would take its place, however, was beyond anyone's imagination. As I listened to owner Sheldon Adelson talk about his vision for recreating the Italian city of Venice in the desert, I realized we were about to make hotel history, designing and building the world's largest hotel, casino, and convention project. And, with a total budget of $1.5 billion, the possibility existed to make it truly remarkable.

The grand scale and opulence of Doges' Palace awes guests at the entrance to The Venetian.

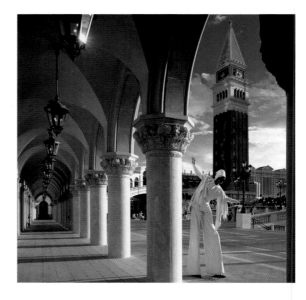

Jim Rimelspach and the design team all agreed on one thing: The Venetian would not be a gimmicky incarnation of its namesake city. This project would require the highest level of craftsmanship to make a believable reproduction of world-class architecture in a singular setting. And Mr. Adelson didn't want a few facades. His singular vision and remarkable acumen, gathered over years of making so many different businesses work, armed him with the confidence to turn the Las Vegas hotel business on its head. The Venetian would encompass all that makes Venice itself so remarkable — piazzas and squares, campanile and canals — all stunningly, exquisitely, and painstakingly recreated.

No hotel project has been this huge and that meant forging new ground in architecture and way-finding. But, above all, our mission was to impart the splendor, beauty, power, romance, and passion of one of the world's most fabled cities. I find the results enchanting in the mesmerizing way they transport one to another world, and another era.

The journey begins — where else — on the Las Vegas Strip, where the Venetian's gondoliers are center stage and where you're likely to find the doormen singing operatic verse. Thanks to the majestic architecture of the Doge's Palace and the Rialto Bridge, plus a campanile that rises 315 feet, the streetscape for Venice is set immediately.

The similarites to the "original Venice" are absolutely astounding along the canal.

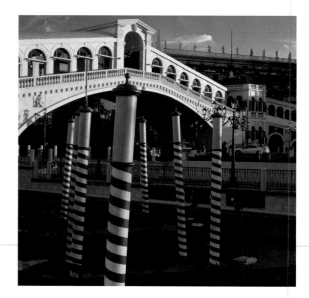

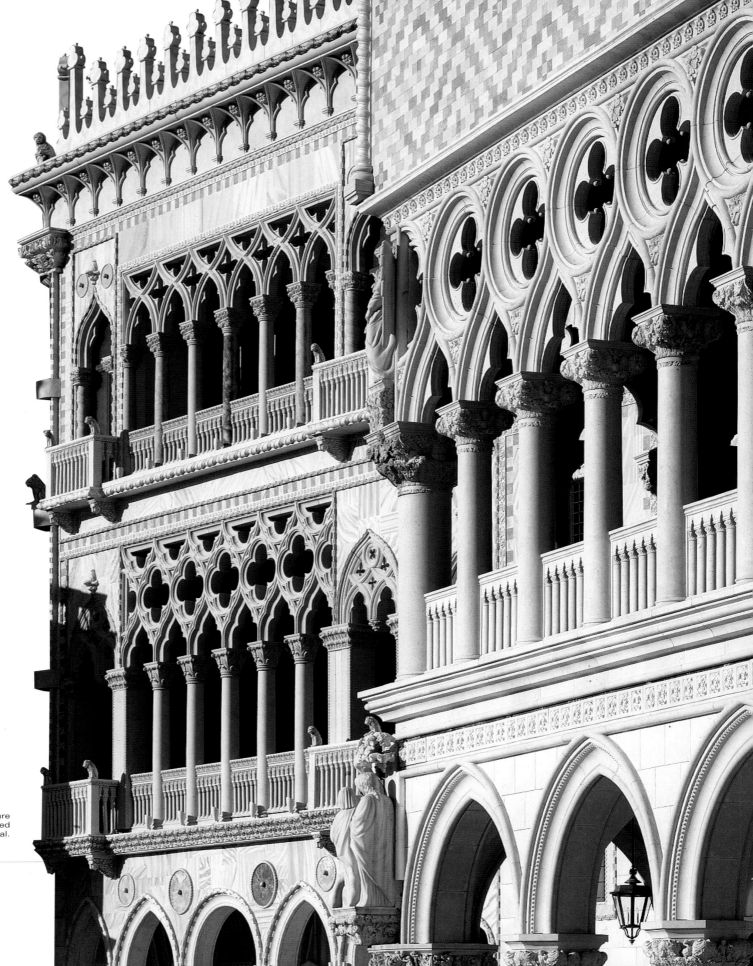

The 14th and 15th century architecture of Venice was respectfully re-created along the canal.

Luxurious Italianate furnishings in a suite.

On my trips to Venice, Italy, I can barely take in all the color and vibrancy that give the city its bustle. Maybe it's the constant movement of water and watercraft throughout the city, maybe it's the centuries-old sun-soaked facades that seem to change with their reflected light. Certainly, it's the squares, a constant mix of café-goers, shoppers, and street performers eager to stage their talents. In Venice Las Vegas, as I call it, our goal was the same high-spirited vibrancy, a city pace with Old World flair, a place where you could become part of the scene or sit back, sip a cappuccino, and take it all in.

By sheer numbers, the Venetian is grand: more than 6,000 guest suites (each more than 700 square feet) over two phases; casinos with more than 200,000 square feet of gaming space; 1.6 million square feet of meeting space in the adjacent exposition center; an 80,000 square-foot grand ballroom; nearly 750,000 square feet of exclusive retail space; two unique venues for entertainment and theatre; a 65,000 square-foot version of the Canyon Ranch luxury spa in an Italianate garden setting; plus world-class museums – the Hermitage and the Guggenheim – and countless restaurants and cafés.

Lounge seating located at the reception area.

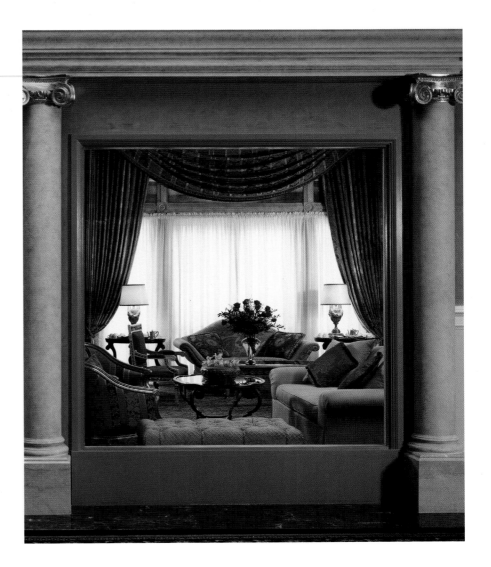

To fill the space appropriately we relied on detail, detail, and more detail. Consider the craftsmanship with which we started: even the canal walls were finished by hand, layer-by-layer. The Venetian's incredible facades demanded spectacular interior spaces. Owner Sheldon Adelson wanted a dramatic fresco at the grand entrance, so we developed and moulded his idea into a magnificent muralled ceiling throughout the entry arcade, creating the drama and beauty that begins the guests' relationship with the Venetian and takes away any sense of pretense. The entry is so dramatic and breathtaking that you are immediately transported, and that is the idea.

BOOK TO PACK:
Dead Lagoon by Michale Dibdin

The sitting room within a Luxury Suite designed to convey a true villa feeling.

THE VENETIAN

3355 Las Vegas Blvd South
Las Vegas, Nevada 89109
Tel: 702-414-1000
Fax: 702-414-1100
www.venetian.com

[91]

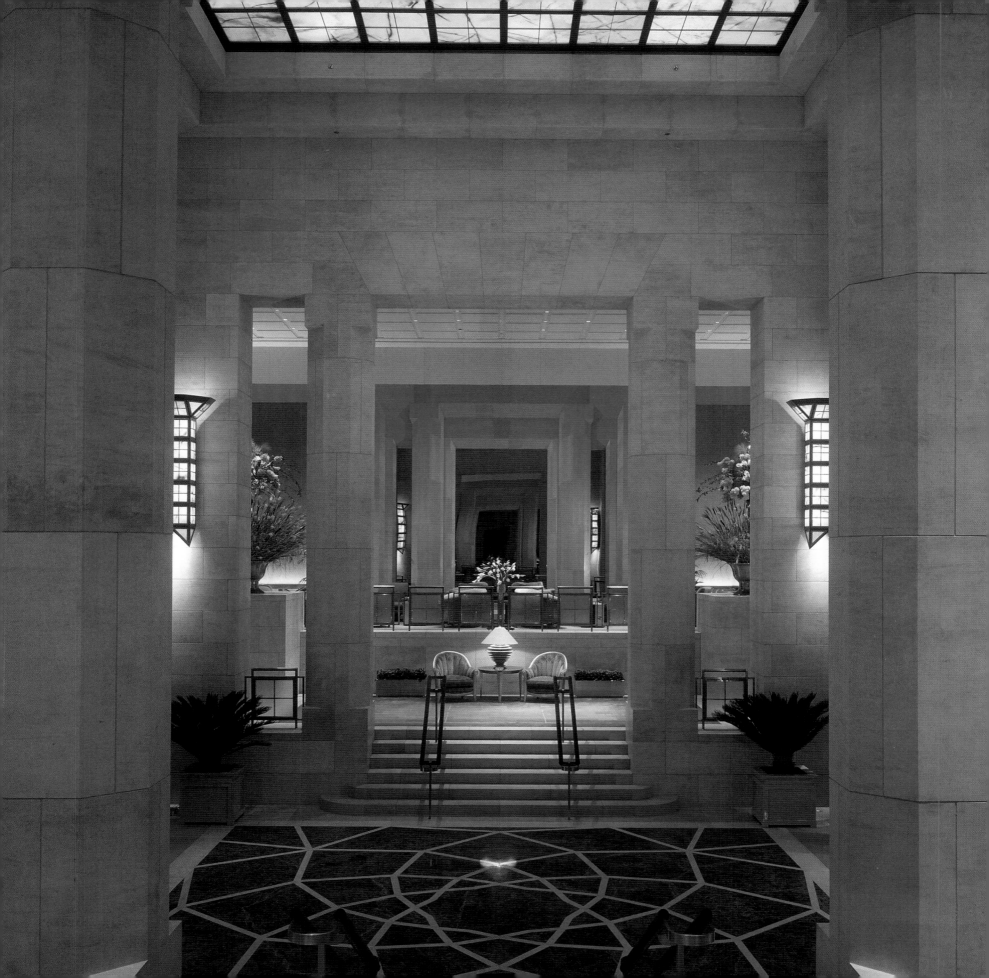

FOUR SEASONS HOTEL
NEW YORK

New York, New York U.S.A.

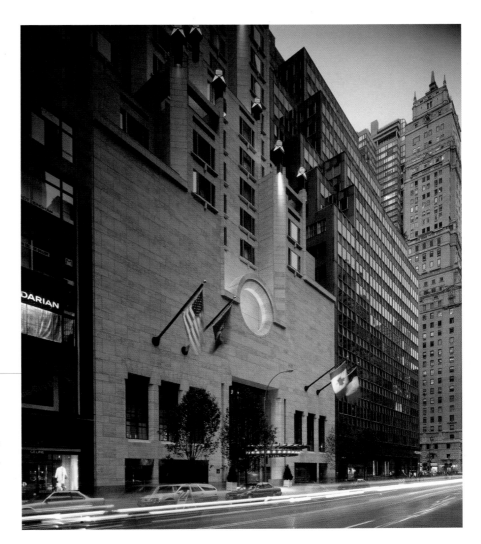

Left: The limestone walls of the hotel's Grand Foyer soar 33 feet on massive columns to a backlit onyx ceiling suspended over a marble floor. The Foyer's center features a rotunda elevated above the street level and circled by eight pillars.

Right: The Four Seasons Hotel New York is located on 57th Street between Park and Madison. Rising 682 feet into the city, the urban landmark is Manhattan's tallest hotel.

The world of design, in all spheres, has its share of legends, and architect I.M. Pei is one of them. So when Pei himself was commissioned to add a 57th Street hotel tower to the New York City skyline in the late 1980s, I was euphoric about the potential for a dramatic end result. The hotel industry simultaneously netted a spectacular structure and a new standard for luxury high-rise properties. With this building, Pei has fine-tuned hotel design, creating spaces that are at once grand and inviting for both guests and those who serve them. This is a stately property with staying power.

If location is everything, this project got off to a perfect start. I adore Manhattan, and, for me, nothing could be more desirable than a midtown location between Park and Madison Avenues, with immediate access to everything — particularly, New York's penultimate shopping. When Pei Cobb Freed & Partners and associate architect Frank Williams & Associates unveiled plans for the new hotel, Pei called the location "one of the few prominent sites remaining in the heart of the city." Therefore, his appropriate design response would be what he called "classic elegance that transcends time and fashion."

For the gracefully stepped facade of this 52-story building, Pei chose the same Magny limestone from France that worked so beautifully on his project at The Louvre in Paris. The stone's density and character — its subtle veining and sumptuous, almost honeylike, color — creates a rich, beautiful exterior worthy of a world-class tower. Exquisite window detailing and the grand oculus of the building's base contribute to the facade's depth and articulation. The progressive vertical setbacks and terraces of the tower provide a residential appeal uncommon for such a grand building.

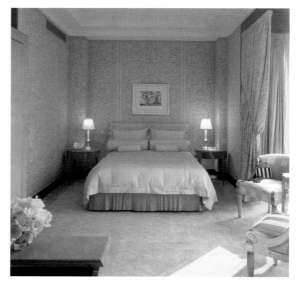

Understanding the potential for nighttime drama, Pei positioned 46 lanterns, each 12-feet high, to light the building's setbacks, and crowned the entrances on both 57th and 58th Streets with outdoor marquees of glass and bronze. I often hear the Four Seasons New York Grand Foyer referred to as monumental, and it is — the proof is in its 33-foot-high, backlit onyx ceiling anchored by floor-to-ceiling columns and appropriately punctuated by a stunning rotunda. The space unfolds in a sequence of columns, terraces for conversations and dining, and elaborate floral displays. It is eye candy of the best variety, exactly the sort of environment that indicates you've arrived.

All 370 guestrooms and suites feature spacious dressing rooms paneled in English sycamore, with mirrored walk-in closet and built-in drawers beneath a spacious covered luggage bench. The suites feature a variety of different design schemes and artwork.

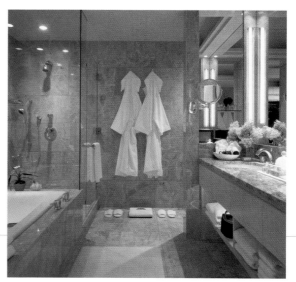

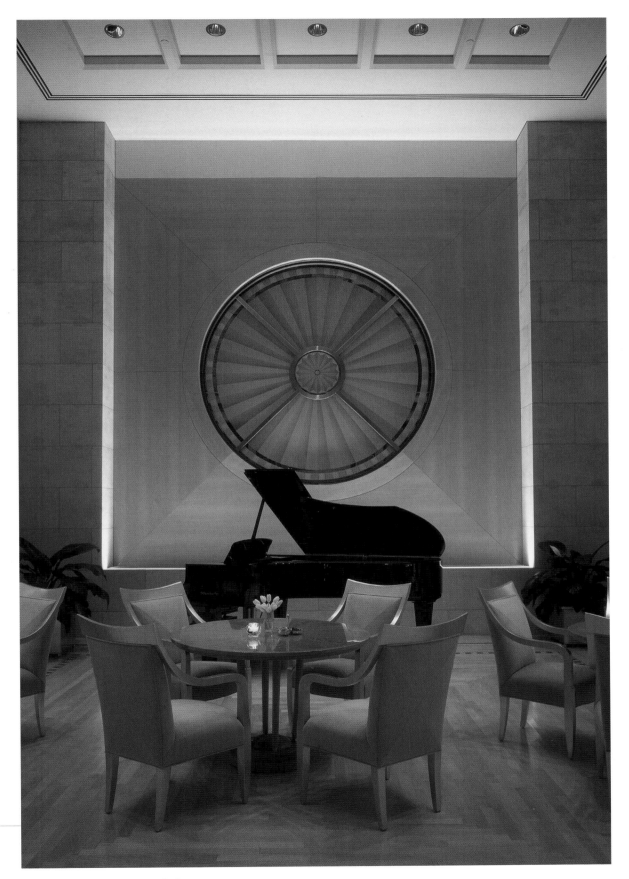

Between the hotel's bar and Fifty Seven Fifty Seven restaurant is a large glazed circular window framed in Danish beechwood. This same circular pattern is reflected in three 14-foot high handcrafted Italian Scagliola panels which hang in the restaurant.

I'm so taken with the public spaces in this hotel, I find it quite apparent that the interior design team worked beautifully with the architectural team on seamless spaces, and on meshing furniture and finishes with the architect's ideal for the space. For interiors, Chhada Siembieda Remedios took a rather minimalist approach to design. The décor is somewhat understated, but far from bland. I find the neutral woods, soft color palette, and rich fabrics a simple, but perfect, adornment for and complement to the massive architecture.

The goal was to establish a restful setting as a backdrop to the stunning views. I, for one, appreciate it and, judging from the popularity of the hotel's Fifty Seven Fifty Seven Restaurant and Bar, I am not alone. I like to meet clients and friends in the bar, with its streetscape views through six 18-foot windows overlooking 58th Street. The bar's informality creates a comfortable, lively atmosphere — not at all stuffy. In response to Pei's circular window on the north facade, which separates cocktail and dining spaces, the restaurant walls are furnished with three, handcrafted, Italian Scagliola panels, each 14-feet high. It is such precise detailing that marries architecture and interior design for spectacular outcome.

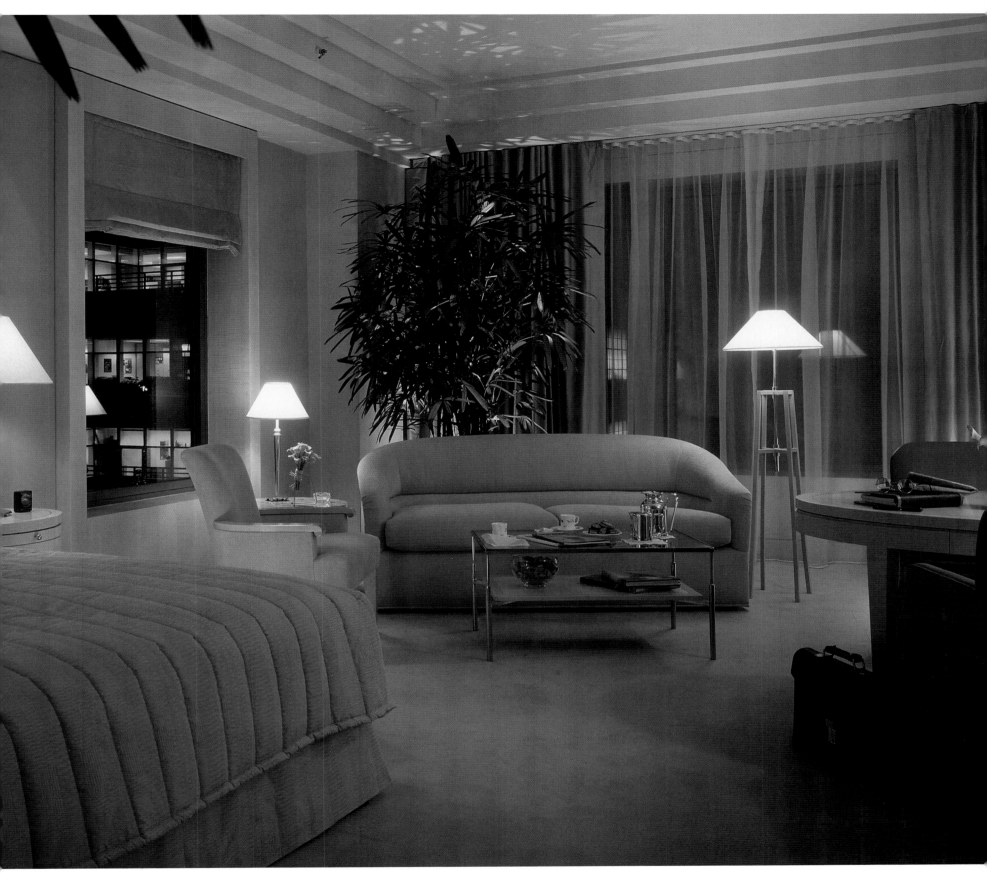

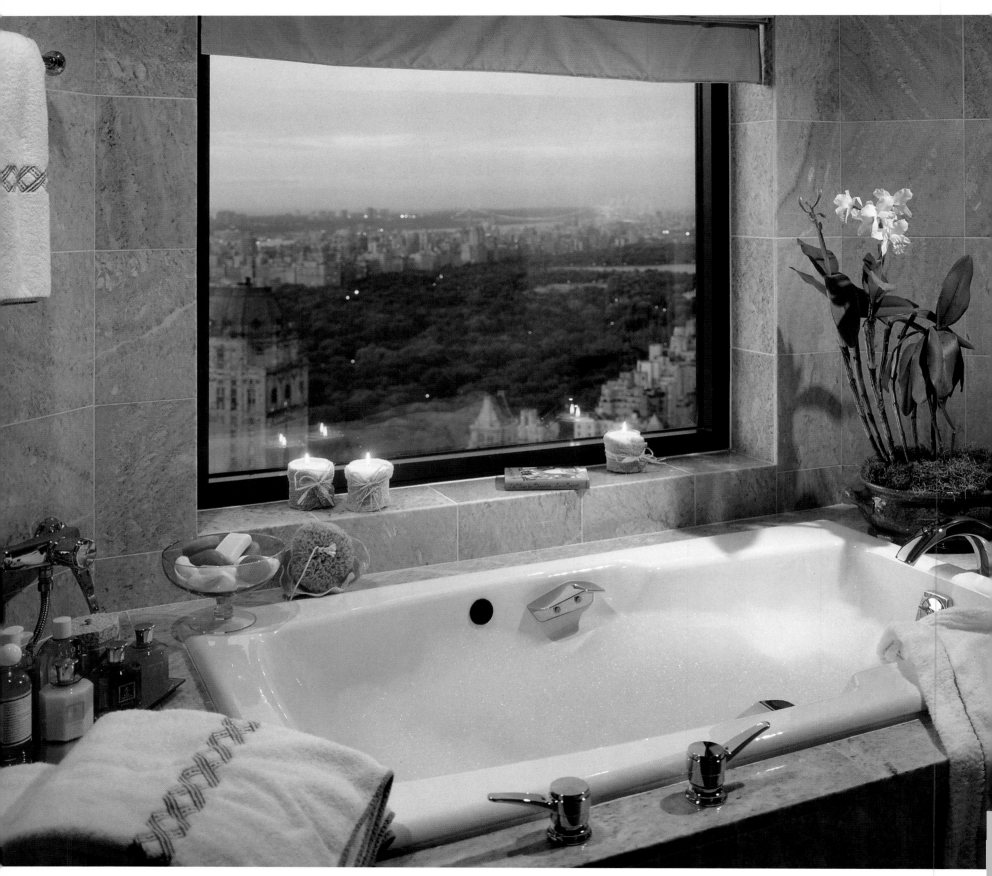

Located on the top floors of the hotel are several
grand suites with panoramic views.

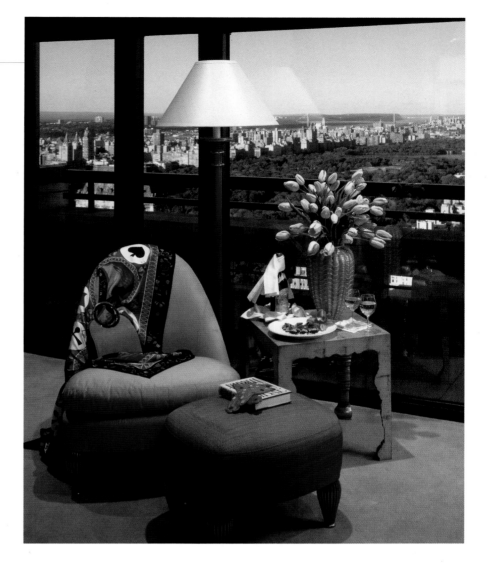

Located on the top floors of the hotel are several
grand suites with panoramic views.

The attention to detail continues in the guestrooms where fine English sycamore used in wide mouldings and furniture echoes the rich, creamy palette of the limestone facade. Pei's dramatic 10-foot-3-inch ceiling height in the guestrooms lends added spaciousness to an already generous 600-square-feet, creating the largest standard guestrooms in the city. I love the fact that each guestroom has a foyer (again, there's that sense of having arrived), a separate dressing area, a walk-in closet, and a marble bathroom. I also admire the art, which includes carefully selected exclusive, limited-edition pieces from 1900–1950, a period known for the birth of modernist design, and so fitting for this setting.

When I stay at the Four Seasons New York, I always try to book a one-bedroom suite with a terrace (the 51st floor suites have dramatic, sweeping views). From my terrace I can listen to the street noise below – the jumble of taxi horns and traffic – or I can cocoon indoors, surrounded by serene colors. I am one of those people energized by big-city crowds and bustle. I am also invigorated by spectacular retreats. Here, I have found the perfect combination.

᙭

BOOK TO PACK:
The Alienist by Caleb Carr

Among the many unique features of the hotel's specialty
suites are breathtaking views from luxurios bathrooms,
overlooking both Central Park and the city skyline.

FOUR SEASONS HOTEL NEW YORK

57 East 57th Street
New York, New York 10022
Tel: 212-758-5700
Fax: 212-758-5711
www.fourseasons.com

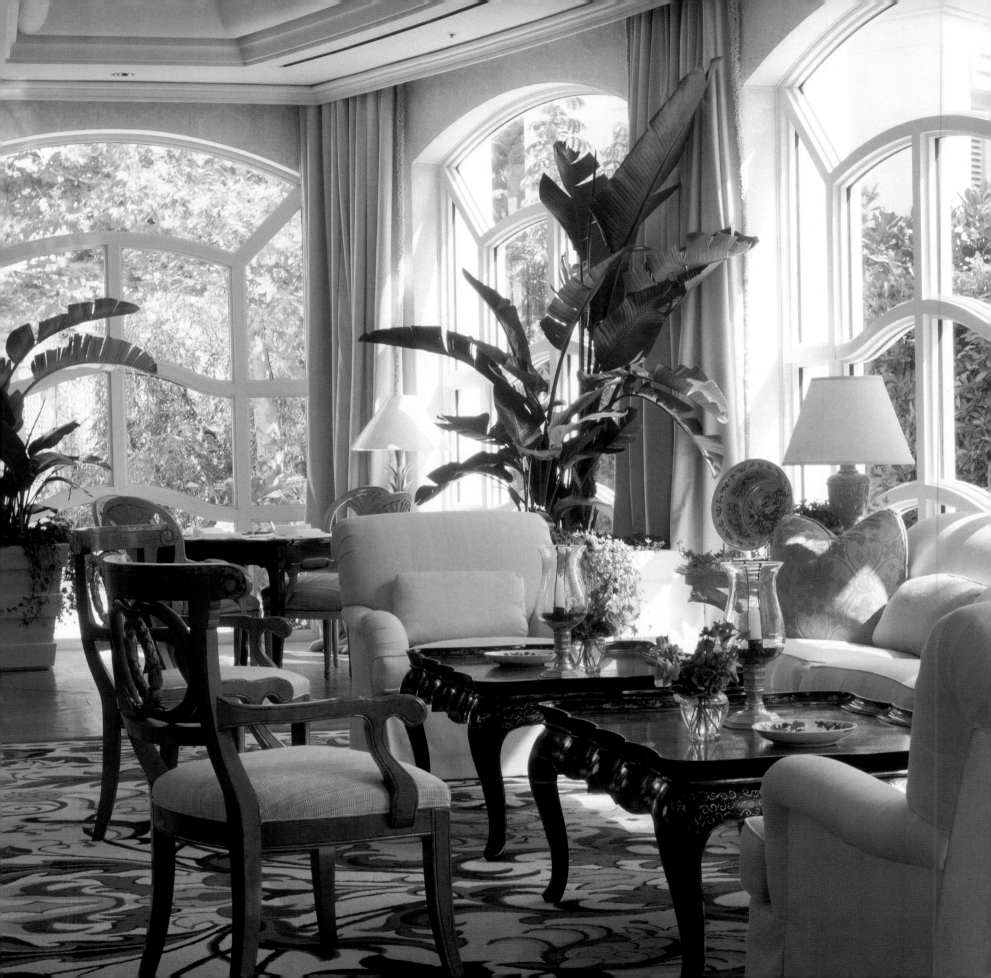

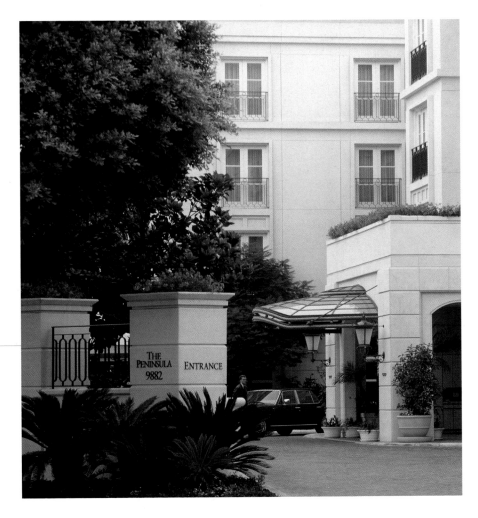

THE PENINSULA
BEVERLY HILLS

Los Angeles, California U.S.A.

Left: The Living Room, open, airy, warm, inviting, with over-sized couches and big roaring fireplaces, is the perfect place to enjoy afternoon tea.

Right: Grand circular drive welcomes guests to The Peninsula Beverly Hills, designed after an 18th-century French Country Villa.

The Peninsula, in the heart of that celebrity city known as Beverly Hills, is always going to be an incredibly special property to design. It has the feeling of an enclave, a safe haven for people who live a life of fame, it is glamorous, and it feels like a grand residence — getting these three things right was a special challenge.

Worldwide, it seems celebrity *is* the new currency. (I can't resist a thrill at seeing the glitterati, and am a self-confessed star watcher!) My good friend, Jim Northcutt, designed The Peninsula Beverly Hills for the famous — offering an undisturbed retreat from everyday pressures — but also for discerning travelers and executives who appreciate the extraordinary. That meant devoting attention to fine-tuning every detail, including state-of-the-art systems for security and worldwide communications.

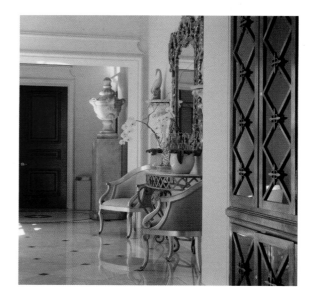

The owners, seeking inspiration for design, turned to their flagship sister property in Hong Kong, one of the grandest hotels ever built and an international hallmark of service standards. The differences came in marrying traditional Peninsula style to the climate and aesthetic of sunny Southern California. It is a union of opposites: Old World appeal and 21st-century convenience. Yet as is my personal experience (you can ask my husband), marriages of opposites work brilliantly, quite complementary of strengths and shortcomings.

On the exterior, the massing and facades of The Peninsula Beverly Hills take a Parisian, street-friendly scale with recognizable rhythm and form. Surprise comes in the details: clean, contemporary, sophisticated lines and style keep the hotel from being yet another historic rehash. What works here especially is the way the hotel is scaled as a residence. It's one thing to take a grand residence and modify it as a hotel. It's another thing entirely to take a hotel and build it to rival a private estate.

Overall, the progression of spaces give way to one another, with guests proceeding from entry foyer to living room as they would in a fine home. The layout and its corresponding décor create an intimacy rarely found in public spaces.

Top: Accessories and decorative details are dramatic and impressive throughout the hotel.

Middle: The Belvedere Restaurant

Bottom: The Club Bar, reminiscent of a handsome den with beautiful California birch paneled walls and gleaming brass details and sconces.

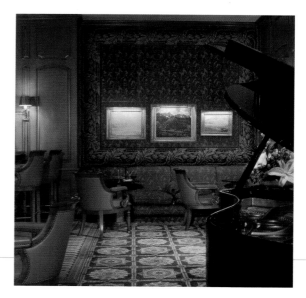

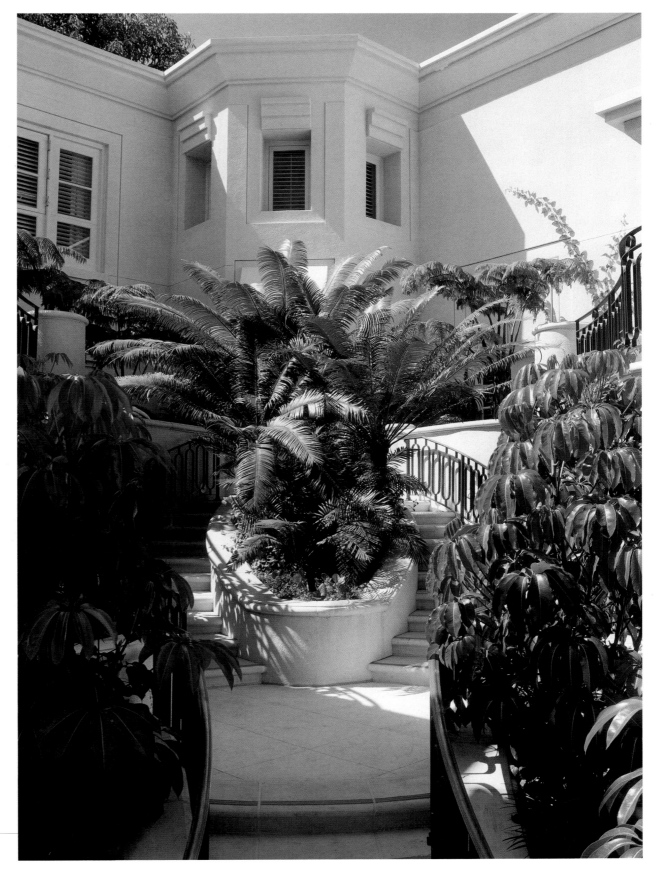

Lush gardens add residential splendor
to the Peninsula.

Jim's design team began designing at the front door, planning your walk from entrance to check-in to the Living Room, which is where everybody gathers. He wanted comfort, elegance, and international influence. Note the French parquet flooring pattern, the handwoven rug interpreted from a Portuguese needlepoint design, and tea tables adorned with gold chinoiserie. It makes a perfect salon space for afternoon tea. For the adjacent dining room, the walls were upholstered in light-colored fabric with strong-hued accents including 18th-century Nymphenburg porcelain, which I think is graceful and stunning. Look for peacocks featured in artworks — they are emblems of the developer's family. A private terrace with garden courtyard frames the entire room and is one of my all-time favorite places for lunch *al fresco*. (Order the gazpacho and a Cobb salad.)

Just off the foyer, the secluded bar mimics a residential library space outfitted in warm tones with English, Regency-style furniture. I love the counterpoint of plein air style paintings from California artists of the 1920s and '30s. A museum-quality collection was assembled for the hotel's bar to represent the California landscape and to establish an overall motif. For every guestroom, original art from new painters working in the same style were commissioned, which lent continuity between public space and private guest quarters.

Throughout the project, art and objets d'art play a starring role. The goal was to collect original pieces that looked great on their own, knowing they would end up fitting in, just as the things we admire and cherish most find perfect places in our homes. In addition to the plein air paintings, several works and decorative panels were commissioned of local artists, keeping with the emphasis on California. Yet there are also pieces from all over the world — 17th-century Italian embroideries, Meissen porcelain from Germany, and French and Japanese needlework. A stunning mix of both aesthetic quality and cultural variety.

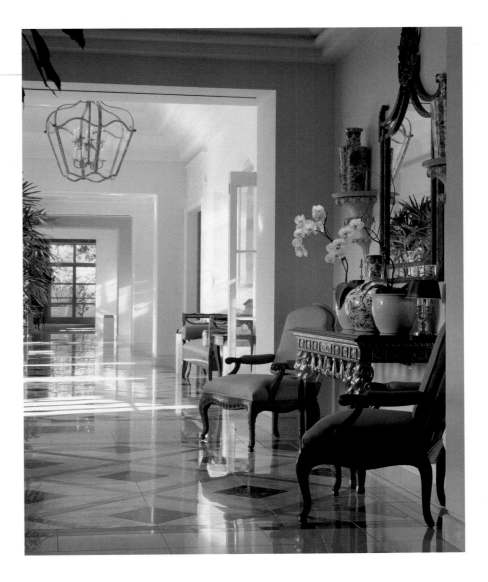

As a guest, I always try to book a villa in the garden courts. (There are just 16 of them, so I arrange well ahead.) In the villas and 200 guestrooms and suites alike, the eclectic palette is evident — seven separate schemes for guestrooms and unique combinations for each villa. Chinoiserie details and traditional furnishings hint at the connections to Peninsula international heritage, but plein air paintings and fresh colors keep the focus all-California.

The success of the design of this magnificent place is a testament to the memory of my dear friend Jim Northcutt.

BOOK TO PACK:
Get Shorty by Elmore Leonard

THE PENINSULA BEVERLY HILLS

9882 South Santa Monica Boulevard
Beverly Hills, California 90212
Tel: 310-551-2888
Fax: 310-788-2319
www.beverlyhills.peninsula.com

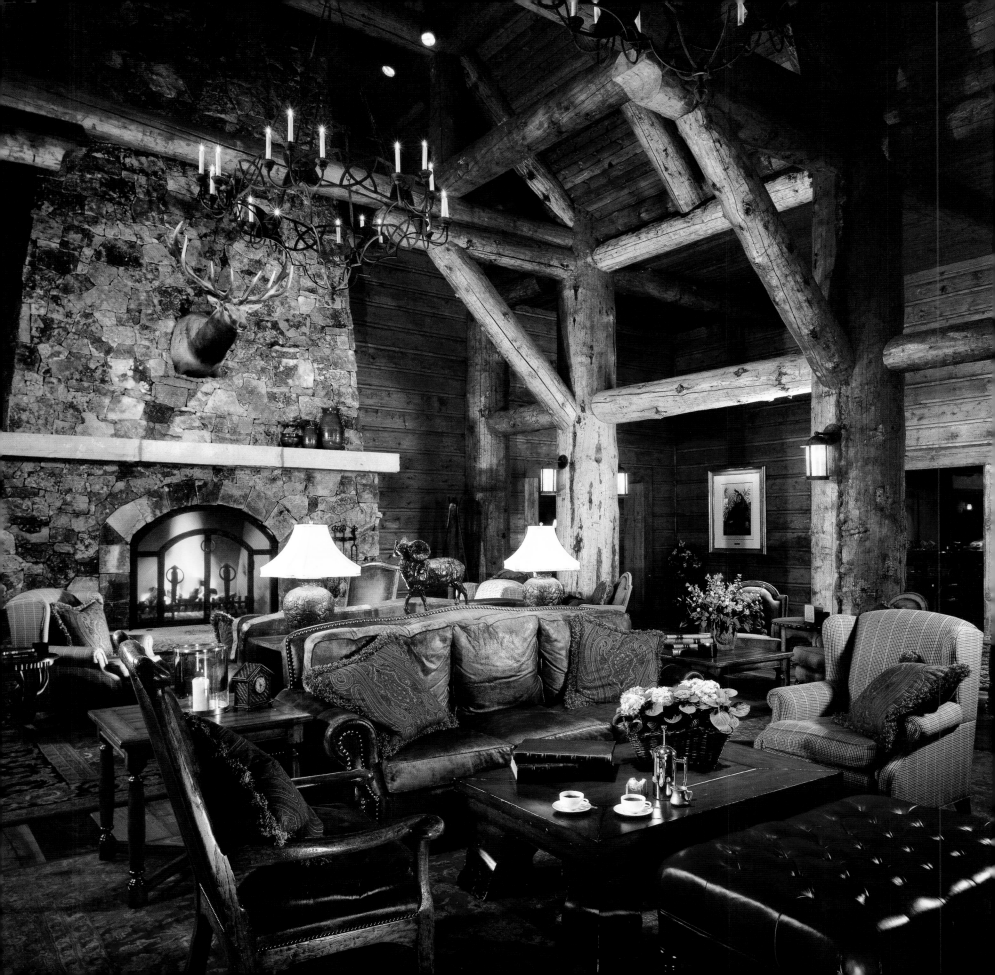

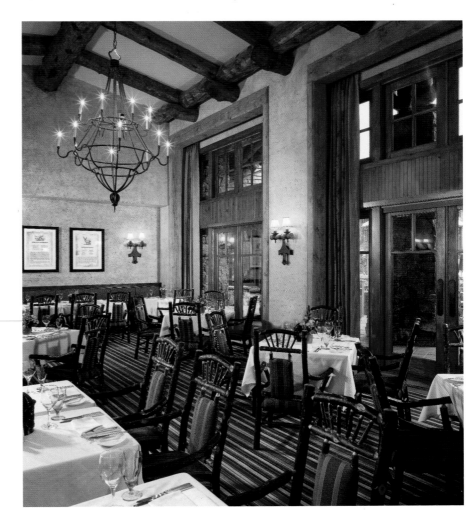

RITZ-CARLTON BACHELOR GULCH

Beaver Creek, Colorado U.S.A.

esigning buildings to make them look like they've been around a while is always a risky proposition. Most of those buildings lack the rich patina of age and can seem contrived, themed, and inauthentic. However, if great care is taken, good imagination used, and a strong relationship between architecture and interior design fostered, the result can be magnificent. The Ritz-Carlton Bachelor Gulch is such a project, offset by the stunning natural surroundings of the Colorado Rockies.

The resort looks like one of America's great national park lodges, such as Ahwahnee at Yosemite or the Lodge at Glacier National Park, and the references are entirely intentional. The project was destined to become what we dubbed "a Great American Resort." Some people call the architectural style "parkitecture."

Left: The warmth and majesty of the Grand Lobby is reminiscent of a national park lodge.

Right: Remington's features gourmet mountain cuisine in a grand, but cozy space.

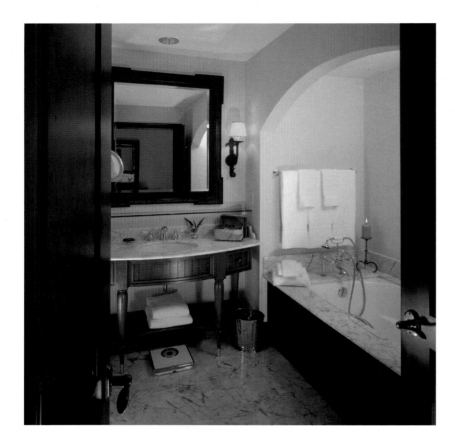

With its construction of enormous beams of hand-hewn timber, the lodge takes on an unmistakable sense of place. It belongs in the Rockies, and it looks as though it's been there for a century. The architecture is grand and iconic; Vail Resorts' development visionaries guided us to create a fitting centerpiece to the Bachelor Gulch community at Beaver Creek.

As interior designers on the project, we collaborated with Hill Glazier Architects, the Palo Alto, California, studio that designed the building. Founding principals John Hill and Robert Glazier were inspired by the national park lodges mentioned. Our initial meetings were enormous fun, brainstorming on how to best recreate the look and, perhaps more importantly, the feel of these architectural wonders. A few road trips and hun-

dreds of photographs later, Hill and Glazier had worked out a magnificent plan and our design team got to work on renderings of interior spaces that would look and feel just right, but not too perfect.

Cheryl Neumann, our interiors guru on the project, wanted ambience beyond design. She wanted the floors to creak, and leather upholstery to appear aged. She wanted original artwork befitting the location. The creation of ambience was kick-started by the presence of more than 100 fireplaces throughout the lodge, and hefty timber truss work that is the signature of the whole building inside and out.

In the Great Room, which is both main gathering space and focal point of the resort, 30-inch, rough-hewn timbers rise three stories, accented by local stone and moss-rock hearth. Outfitting such a space meant completely inventing a design vocabulary. Cheryl's "refined rustic" motif meshed hallmark Ritz-Carlton luxury with oversized furnishings and fixtures that would not be dwarfed by the beefy architectural elements. Scale was the primary consideration for furniture, lighting, and accessories. The design team made paper mock-ups of custom pieces to view in situ to ensure that nothing looked skimpy.

Deftly mixing materials, Jim Rimelspach along with Cheryl, chose elegant wood chinking over plaster chinking for timber-lined walls, and installed reclaimed, wide-plank flooring in richly colored chestnut for the Great Room and adjacent spaces: the Fly Fishing Library and the Buffalo Bar. Under timber beams in the two-story dining room, more elegant plaster walls were selected as counterpoint to rough-hewn woodwork. Overhead, chandeliers are lacy wrought iron, not kitschy wagon wheels or antlers. There is just one trophy in the resort, an elk above the moss-rock hearth. And much of the original art is local, including the work of Rocky Mountain painter Wayne Wolf.

Above: Bathrooms offer every comfort and amenity you expect of a Ritz-Carlton.

Right: The Library Lounge is a rustic retreat of fly fishing and local history memorabilia.

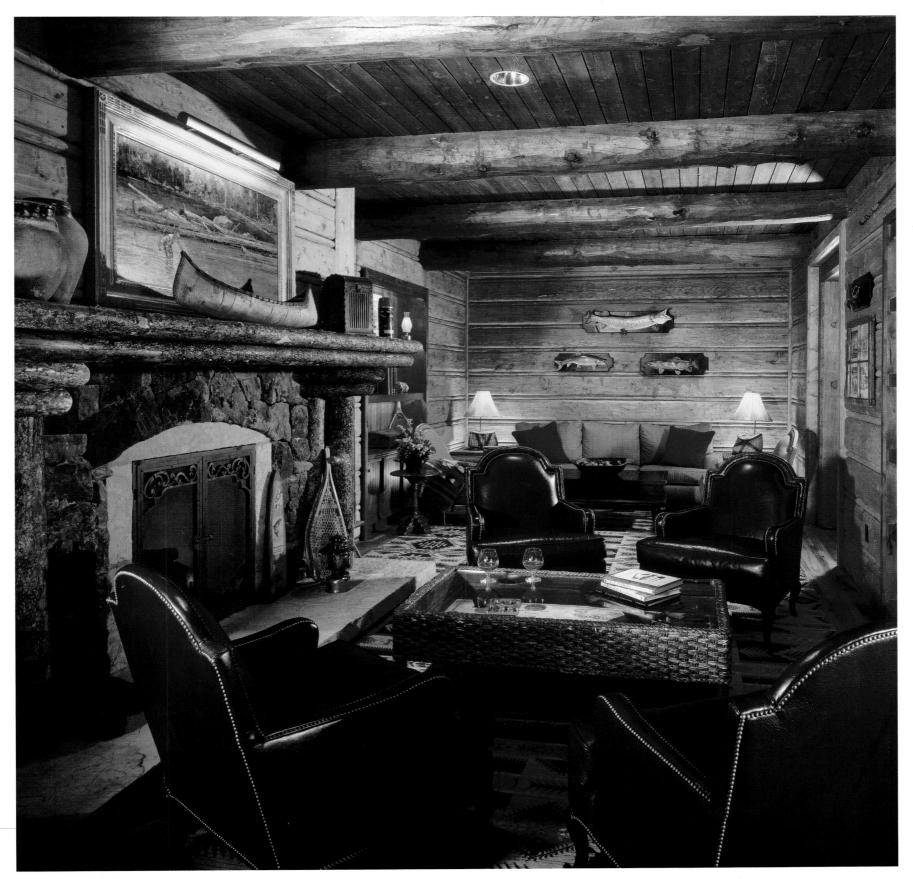

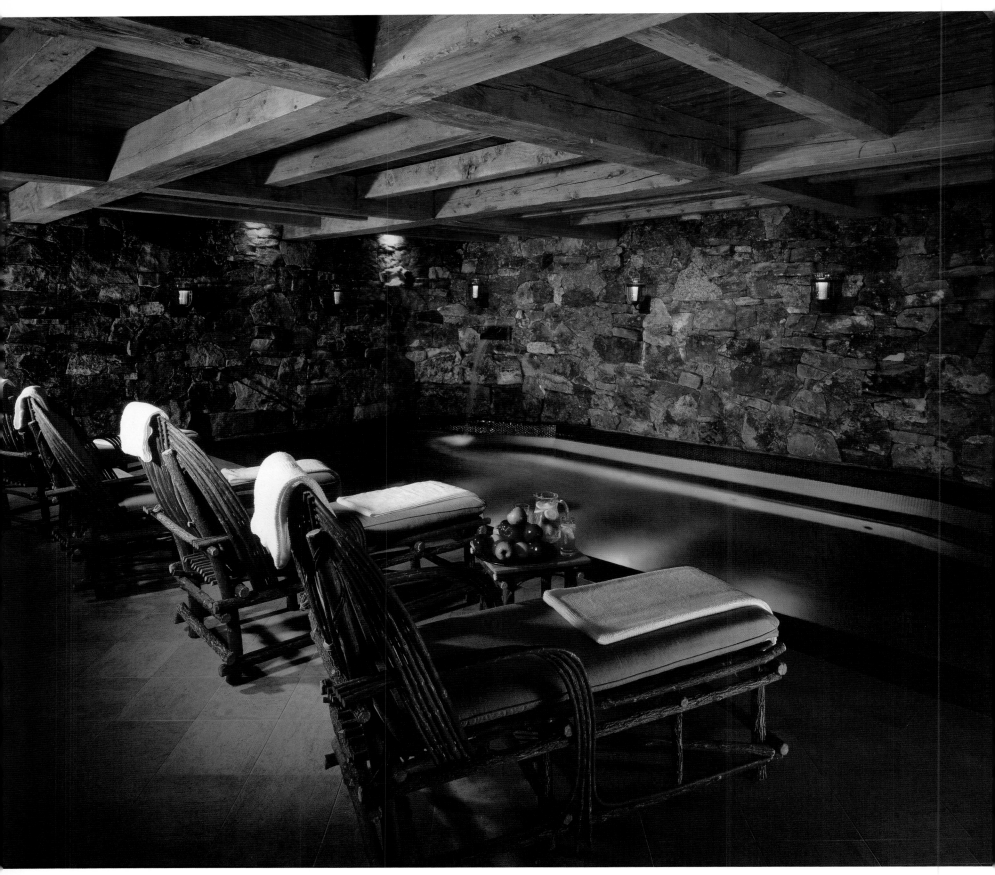

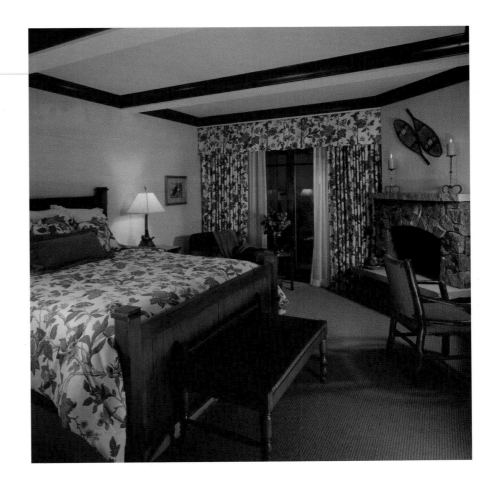

Uniqueness and comfort extend to the guestrooms, which have both rustic verandah balustrades comprised of twigs and luxurious marble bathrooms. That same dichotomy in materials can be found in the spa, an ultra-luxe space that includes a rock-lined grotto (coed, of course) for après ski relaxation.

When I'm skiing Beaver Creek, (which is not as often as I would like!) we head off the slopes directly to the resort's fire ring to warm up, or stow our skis and head for the Buffalo Bar.

Looking out from the wonderful public spaces and rooms of this fine hotel, one can not only admire the breathtaking beauty of the Rockies in summer or winter, but also be enveloped in a cocoon of luxury, while still feeling a little like an old-time explorer.

BOOK TO PACK:
Undaunted Courage by Stephen Ambrose

The Spa has a wonderful grotto feeling and offers an exceptional menu of treatments.

RITZ-CARLTON BACHELOR GULCH

0130 Daybreak Ridge
P.O. Box 9190
Avon, Colorado 81620
Tel: 970-748-6200
Fax: 970-343-1070
www.ritzcarlton.com

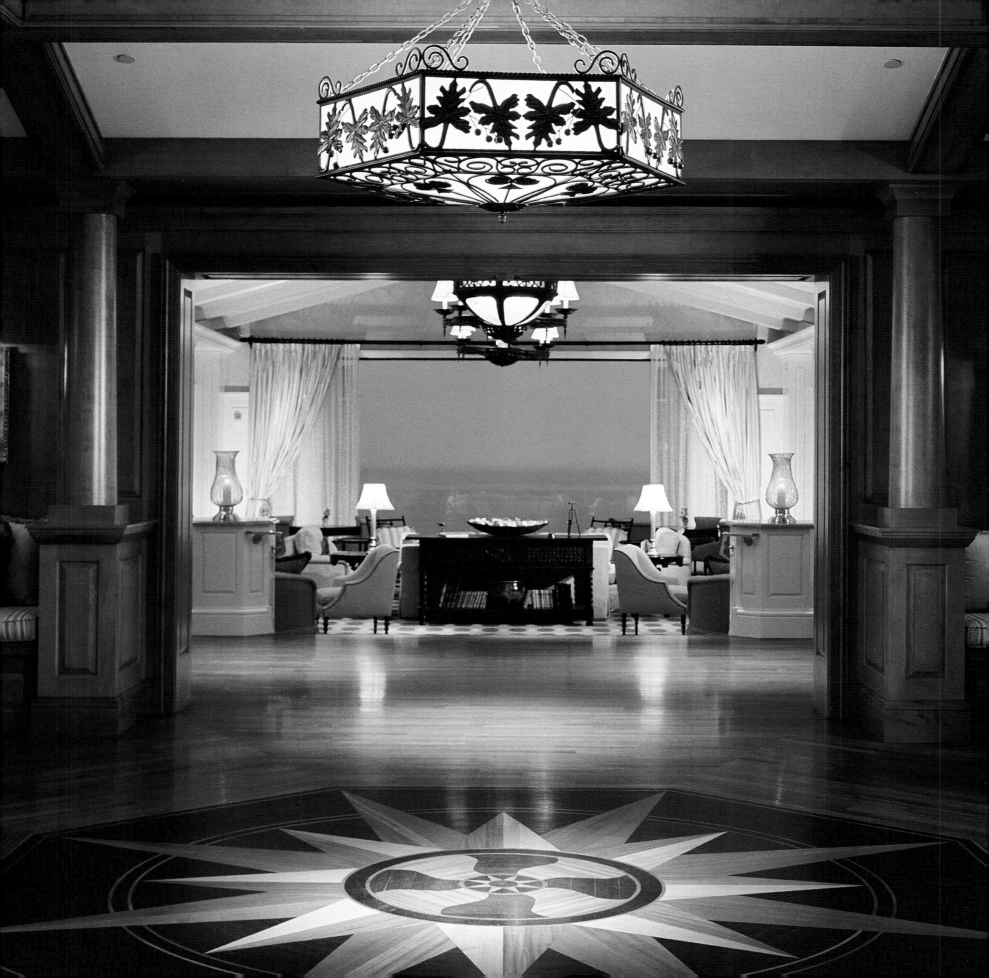

MONTAGE
RESORT & SPA
Laguna Beach, California U.S.A.

*U*ninterrupted California coastline. Views that go on forever. Pristine beaches. Thirty acres. Hearing those descriptions of a hotel site we were about to work on, I imagined a remote stretch of Pacific Coast Highway, yet to be developed. But minutes from the artists' colony known as Laguna Beach? Never.

Yet that is the setting for the Montage Resort & Spa, a luxury resort with architectural roots in the Arts and Crafts tradition. It's situated on a spectacular coastal site with the sort of ocean vistas you might see in the movies. In fact, you probably have seen them on film. The area was once named Treasure Island after the 1934 movie shot there. "Stolen Life," "Tell It to the Judge," and "The Long, Long Trailer" were set there as well.

Left: Entrance lobby with inlaid woods in the craftsman style.

Right: The Porte Cochere sets the tone on arrival.

A trailer park sat on the site, which became the subject of years of dispute involving the land and its ultimate use. After two decades of debate about building on the site, Laguna Beach residents approved a plan that included a hotel and small residential developments. We worked closely with the owner, as well as with Hill Glazier, the Palo Alto-based architects who designed the buildings, to create a resort with a residential scale. Smaller buildings of guest quarters flank the central resort structure. All told, the resort has 262 rooms and suites.

Hill Glazier Architects was challenged to keep the scale from overwhelming the site. At its entrance, the resort appears to be just one story. It then cascades to the Pacific in a series of multi-story buildings. It is charming, elegant, simple, and subtle, and I immediately felt that the architecture allowed us to design with appreciation of materials and texture.

Top: Bathrooms are filled with intricate details and comforts.

Right: A very special space exists in the private dining room next to the kitchen.

Taking from classic Arts and Crafts architecture, the building facades are fashioned of stone and wood, with the deep overhangs that are a specific hallmark of the genre. Exteriors are lightened up a bit, becoming what I call Arts and Crafts reinvented, befitting a beach bungalow.

Overall, the look and feel is residential, touted in hotel brochures as offering "the comforts of home and the luxury of a world-class hotel." I directed our designers to merge our dominant strengths — upscale hospitality and residential expertise — and to give each space the feel of a gracious home. The effect is intended to be as fresh and as classic 20 years from now as it is today. I particularly like the lobby area, which has a luxurious feel, unbelievable views to the ocean, and a sherbet scheme with lots of white and yellow. The decorative wainscoting and picture rail is pure bungalow style. We purposely kept the look light, in contrast to the rich-hued wood box beams overhead, and added historic details such as a fireplace surround in custom ceramic art tile.

My favorite place at Montage is called The Studio, a restaurant unto itself. It's elegant and detailed, freestanding on the bluff between the hotel and the ocean. We took great care to preserve the incredible views and allow diners to enjoy nature as much as they choose.

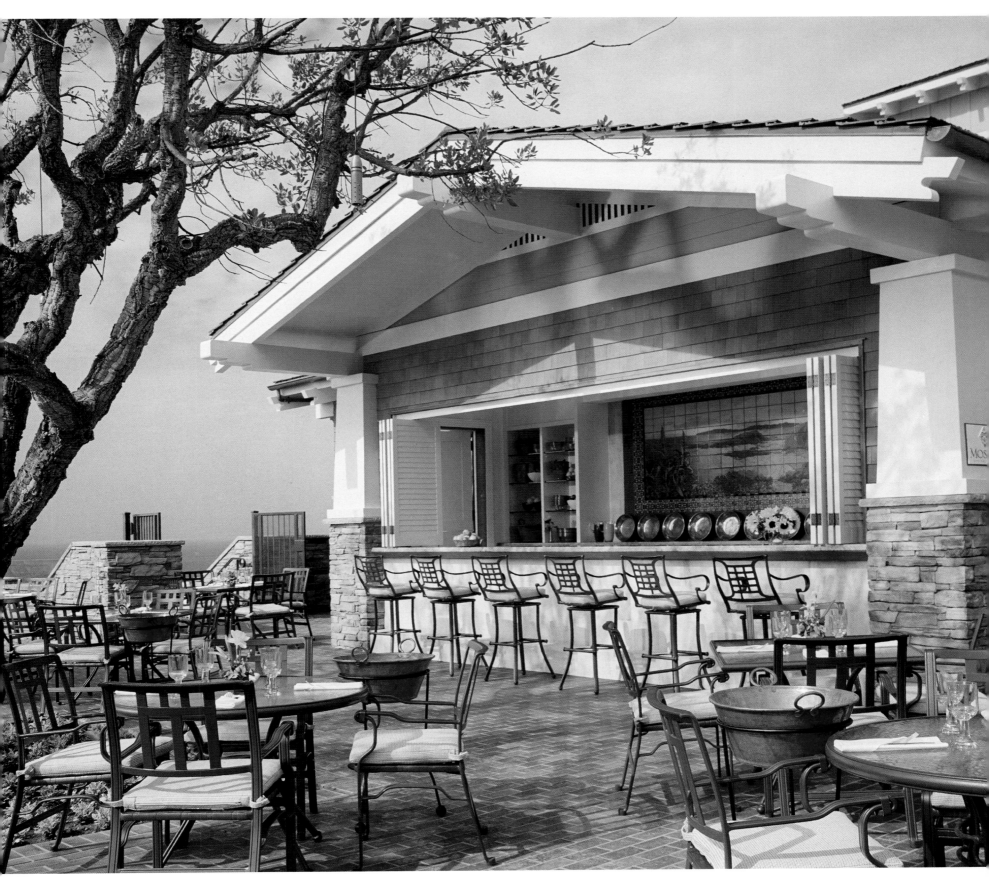

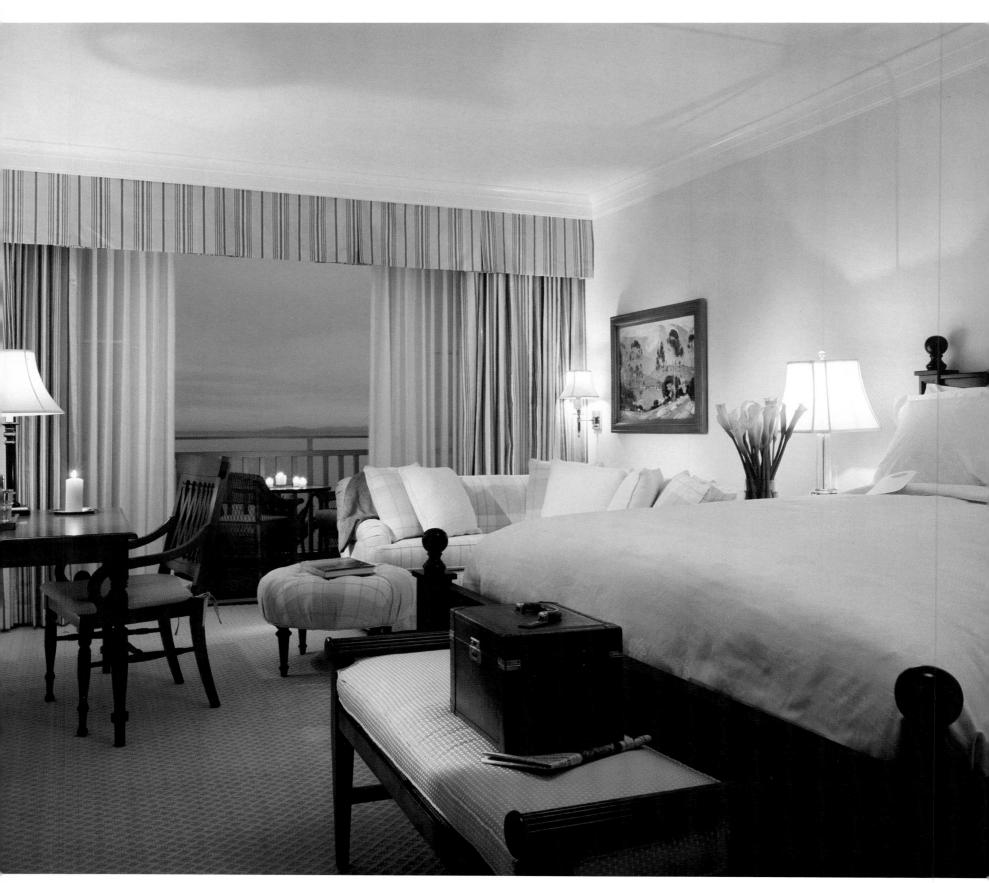

Finally, but not least, in the guestrooms we took great care with the two items travelers tell us they want and need more than any other amenities: a good bathroom and a great bed.

Arts and Crafts architects typically did their work in darker timbers, but principal-in-charge Cheryl Neumann thought this an inappropriate feel in a beach house — so we combined white marble tile, white painted woodwork, striped wall covering, and period-style accent tiles above the tub, lightening up the traditional bungalow vocabulary. For each bath, we specified an under-mount soak tub with wood facing along the tub, adding high-end, nickel-finish, deck-mount fittings. In a separate shower are all the details of a luxury home, such as a shaving ledge for women and a beveled shaving mirror for men. A custom double vanity and private water closet make sharing the guestroom a bit more comfortable, yet the finish details make the space remarkable. Says Neumann, "It's the mixture of wood that makes it so residential."

BOOK TO PACK:
The Lions Game by Nelson de Mille

The guestrooms abound with comfort, grace and magnificent views.

MONTAGE RESORT & SPA

30801 South Coast Highway
Laguna Beach, California 92651
Tel: 866-271-6953
Fax: 949-715-6100
www.montagelagunabeach.com

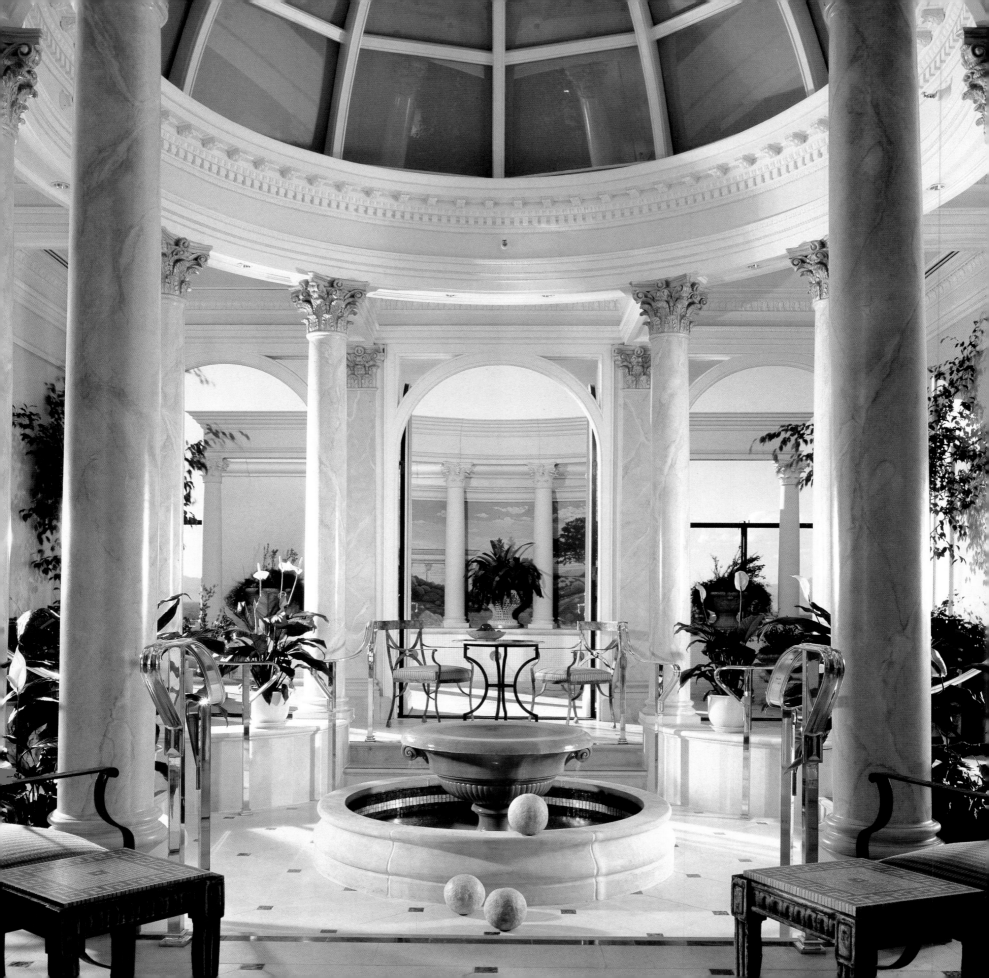

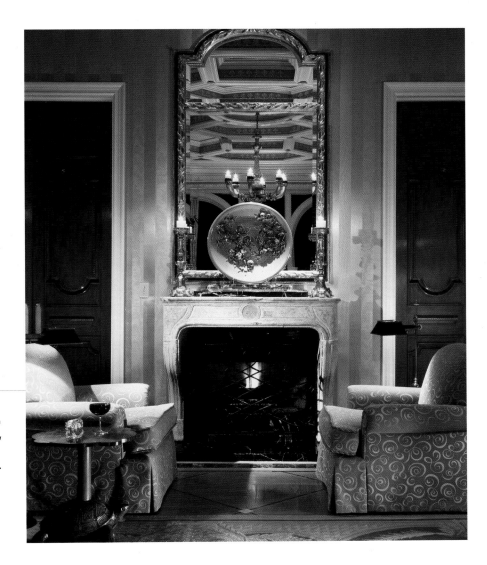

CAESARS PALACE

Las Vegas, Nevada U.S.A.

For a city characterized by camp, Las Vegas has moved beyond the dazzle of sheer glitz to design of style and substance. Caesars Palace, always known for its glamour, has stayed ahead of the trend, continuing to move sophistication and opulence toward the mainstream. So for the Emperor's Tower and tower suites at Caesars Palace our mission was simple — to make every detail all-out luxurious. In fact, I think we went beyond luxurious. These are extraordinary spaces.

Caesars Palace has long stood for quality — in service, in amenities, in design — and the resort showcases finely crafted materials and cutting-edge special effects. It's easy to create stage sets in Las Vegas that look, well, temporary. Caesars commits to substance beyond the glam facades creating distinct looks and unlikely mixes that satisfy the widest range of guests.

Left: Caesars Palace West Forum Penthouse
Living Room overlooking Las Vegas skyline.

Right: This fireplace in a suite living room
envelops guests in a cocoon of luxury.

I love that Caesars Palace Emperor's Tower is a modern classic. There we experimented with form and color in dramatic fashion. The dome over the dining space in the Tower is nothing short of magical. We incorporated a fiber-optic system to set the serene, romantic mood of being under a star-studded sky. In the private suites, we kept the lines clean and contemporary, a backdrop for stunning art, decorative glass elements, and sophisticated furniture. Opulent, yes, but in ways surprisingly different from Caesars' VIP accommodations in another tower.

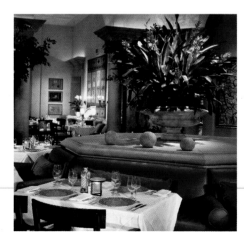
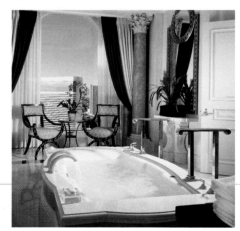
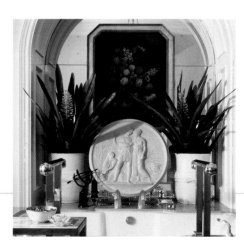

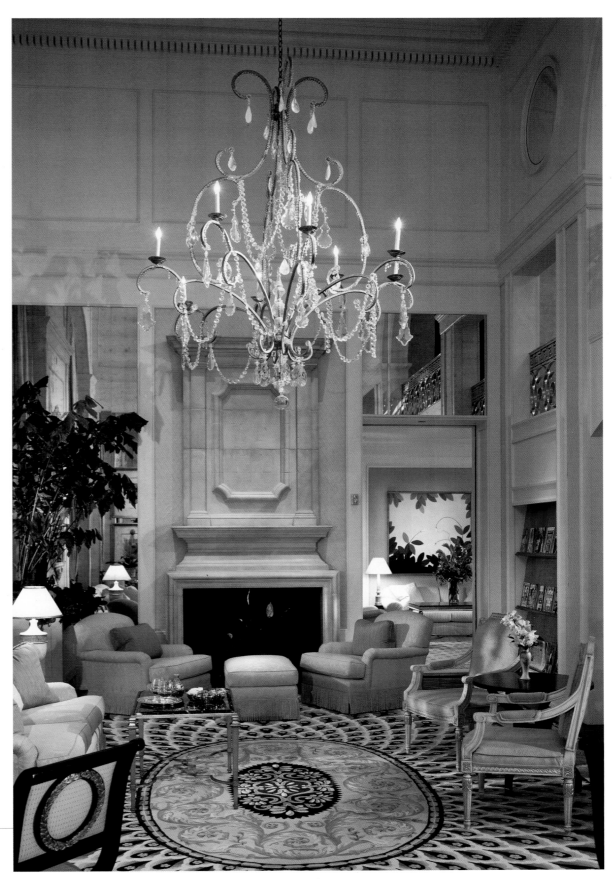

Facing Page
Top: Entry vignette welcomes visitors to
the VIP Lounge.

Lower Left: Caesars Palace Terrazza Italian
restaurant dining room.

Lower Middle and Right: Caesars Palace
bathrooms are truly decadent.

This Page: Comfort and classical detailing
in suite living area.

For two suites comprising 22,000 square feet atop the Forum Tower, clearly no ordinary design would do. The owners wanted the best hotel suites in the world: opulent and sumptuous, yes, but definitely not gaudy. It was with that notion in mind that we set out to differentiate living areas, bedrooms, and baths with the finest detailing and finishes to be had. We also wanted to make a statement: expect the unexpected.

From the beginning, it was quite clear that Forum Tower suites had considerable advantages, not the least of which are 360-degree views from 20 stories up. The panoramic vista lends a glittering, mesmerizing nighttime adornment to the suites thanks to the dramatic blaze of lights lining the area of Las Vegas known simply as The Strip. While we fashioned elegant draperies for the windows, we were careful to preserve the incredible views and keep all the shades operable.

In two of the bathrooms, vanities face the windows, with round mirrors framed by an absolutely incredible mountain view to the west. The natural light creates a perfectly illuminated place for morning grooming rituals. Though motorized blinds may be lowered behind the mirror to block the light, privacy is not an issue. Nobody can see you, except from a helicopter.

We thought of absolutely every luxury for these suites. You will know what I'm talking about, when I say we could play the "what-ifs" of design. What if you could plan this space any way you wanted? When you step out of bed for that inevitable middle-of-the-night trip to the bathroom, your feet touch the electronic sensor-pad that illuminates your path to the loo. That type of amenity is just standard here.

For grand effect, an oversized bathtub "floats" in the middle of one room, surrounded by Carrara marble, dramatic urns, and gold-plated hardware and fixtures. A shower/steam room combination in one bathroom covers 64 square feet, and we outfitted it with a separate sauna as well. Some of the suite bathrooms have five television monitors – each.

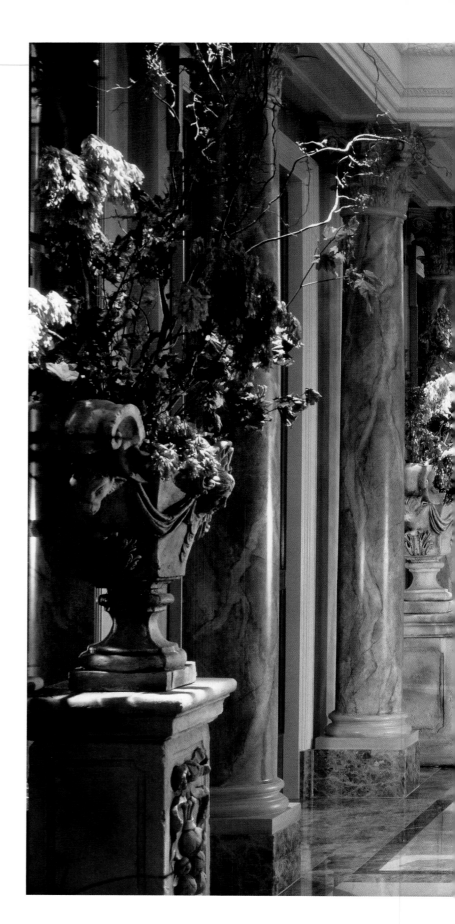

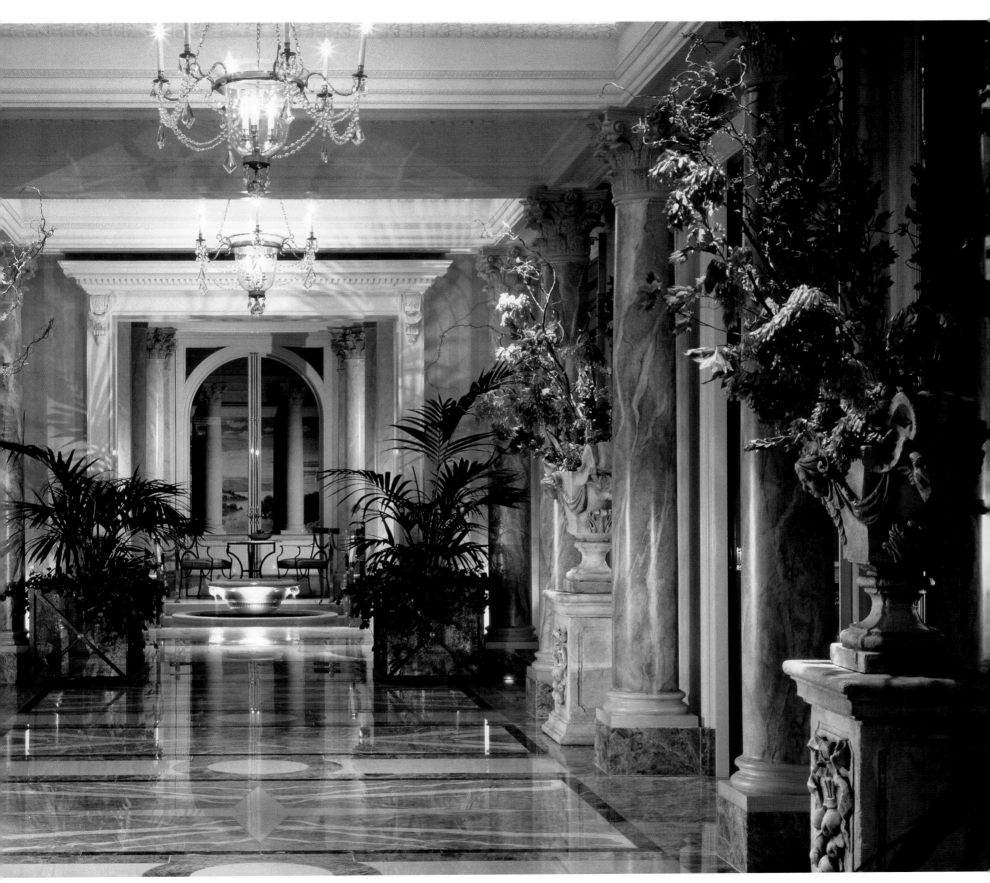

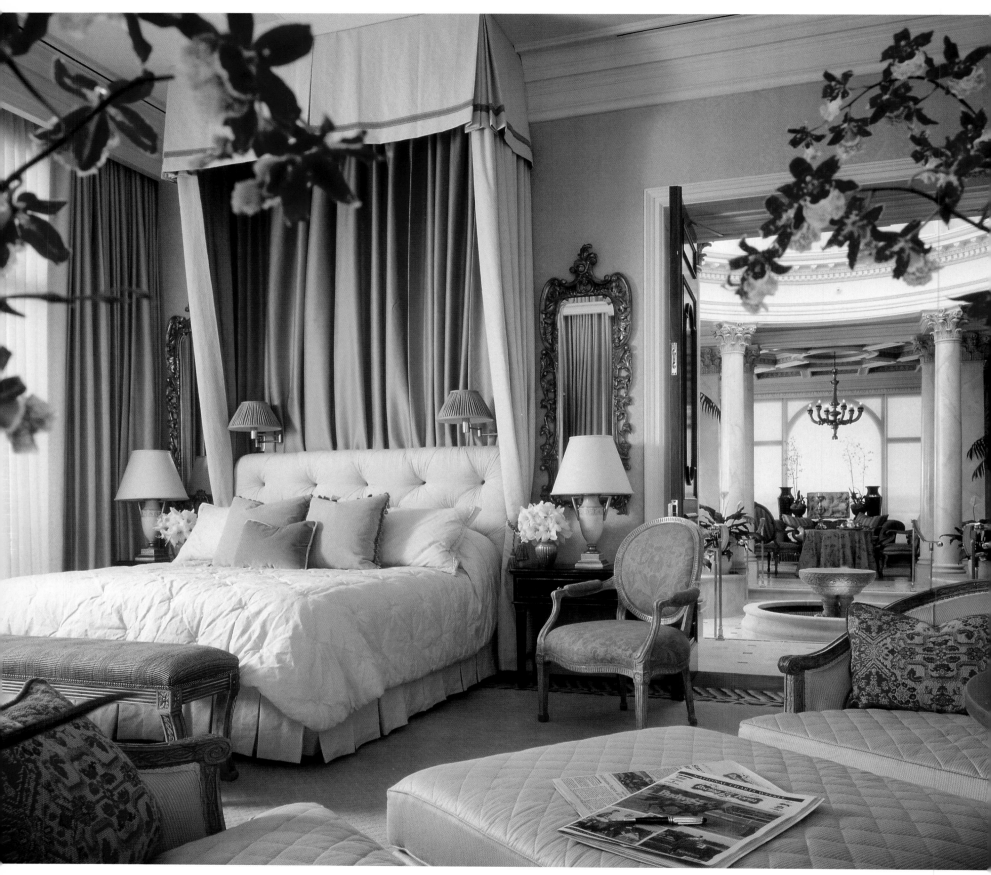

We planned a full fitness and exercise room with weights and cardio equipment. Then there's a hairdressing salon complete with massage chair and salon basin, which simplifies things when you travel with your hairdresser or barber. His-and-hers dressing rooms are specially lighted to showcase warm wood veneers through glass-paneled entry doors. We lined the closet drawers in ultrasuede.

Everywhere, marble and gilded details are layered against elaborate mouldings and decorative architectural features. We worked in the living spaces on this incomparable effect – planning always for something unique to be discovered. We thought and re-thought every piece of furniture, every chandelier, every custom rug to invoke elegance and luxury. The details do, in fact, befit a Palace.

BOOK TO PACK:
Bringing Down the House by Ben Mezrich

CAESARS PALACE

3 5 7 0 L a s V e g a s B o u l e v a r d
L a s V e g a s , N e v a d a 8 9 1 0 9
T e l : 8 7 7 - 4 2 7 - 7 2 4 3
w w w . c a e s a r s . c o m

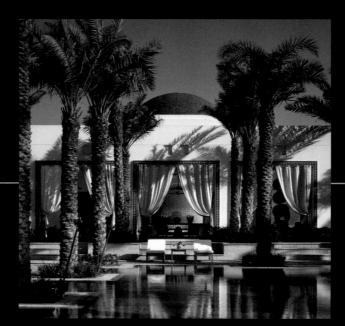

Park Hyatt Dubai, Page 140

Asia / Middle East

YOKOHAMA
ROYAL PARK HOTEL

Yokohama, Japan

I've seen so many sights it's hard to imagine one that simply consistently takes my breath away. But the sight of snowcapped Mount Fuji seems almost dreamlike, with its jagged white peak providing an absolutely stunning backdrop for the 70-story Landmark Tower and the Yokohama Royal Park Hotel within, which occupies the top 15 floors.

Commanding views are no surprise, given that Landmark Tower stands at 972 feet (296 meters), the tallest building in Japan. Overlooking Mount Fuji, Boso Peninsula, Oshima Island, and Tokyo Bay, the hotel needed luxury interiors that would complement such grand vistas, not compete for attention. While the aesthetic is primarily western in effect, Japanese elegance and loveliness gave us a central theme. The outcome is a mix of the finest in materials, craftsmanship, and detail, woven into a serene, classic palette.

Left: The entrance lobby welcomes guests to an elegant and graceful atmosphere with warm hospitality.

Above: The Yokohama Royal Park Hotel in Yokohama City, Japan.

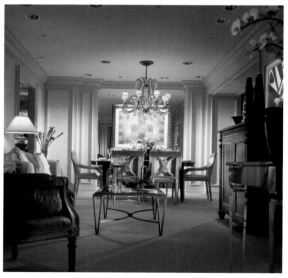

Design wise, we covered a lot of ground. We started on the Landmark Tower's lobby floors, creating a luxurious entrance to the hotel, seemingly worlds apart from the futuristic high-rise. Quiet and refined, the marbled hotel lobby signals the warmth and elegance evident in the entire hotel project. Architects Stubbins Associates with Taisei Construction Company gave us a brilliant building within which our work began. Though the hotel guestrooms and some of its public spaces are situated on the uppermost portion of the building, Landmark Tower offers guests a remarkable segue from ground to sky: the world's fastest elevator, traveling at 750 meters per minute.

High atop the Landmark Tower sits the Yokohama Royal Park Hotel's Sky Lounge, Sirius. Definitely among my favorite spots in the hotel, it offers a sparkling, twinkling evening panorama of the surrounding city. If I miss having a nightcap there, I can take in views of the famous Bay Bridge and Yamashita Park over breakfast – a perfect start to the day. We took a simple, urbane, yet cozy approach to design, keeping the focus entirely on the views.

On the 49th floor, the Landmark Fitness Club beckons hotel guests to swim, or work out, with a panoramic backdrop and fantastic view. Twelve banquet rooms offer a skyline experience as well, and each is outfitted distinctively. We planned Hoh-shoh, a 2,000-seat space, as the largest banquet hall in the city.

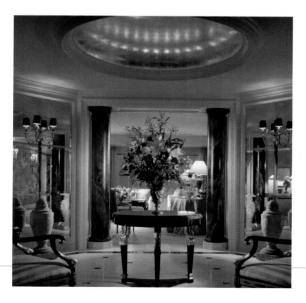

Luxuriously decorated French restaurant Le Ciel, the Presidential suite and the Royal suite are filled with the ultimate in comfort.

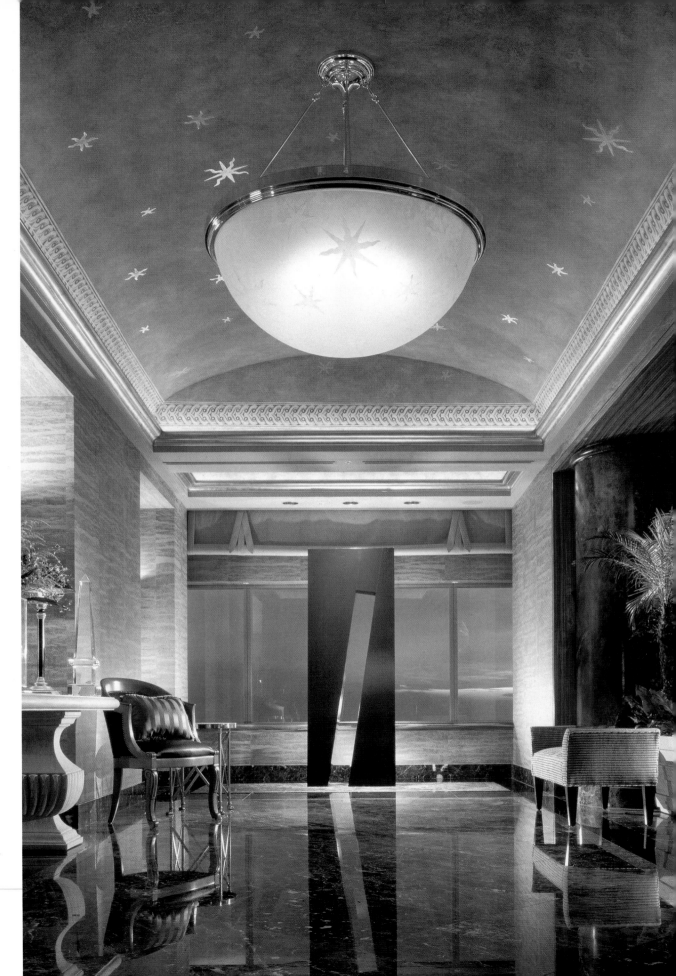

The Sirius Sky Lounge on the 70th floor of the Landmark Tower offers spectacular views of Yokohama harbour.

The main lobby furnished with classical pieces and modern art creates the atmosphere of the European Grand Residence. The book-matched marble detailing is exquisite.

With real estate at a tremendous premium in Japan's urban areas, the sense of spaciousness at Yokohama Royal Park Hotel is a luxury in and of itself. From the 52nd floor to the 67th floor, guestrooms take on grand proportions and are outfitted in sophisticated, neutral color schemes with black accent pieces for effect. Among the hotel's 19 suites, the Japanese-style suite offers the charm of traditional local guest accommodations and features a soaking tub made of Japanese cypress. I have asked for that suite on occasion, knowing that it will relax and rejuvenate me — and give me a fresh eye on the elegance of simplicity, on the fact that less really can be more.

As in most great hotels, executive floors take on a tradition and clubby style all their own. What's unusual here is that they span a two-story central gallery space for meetings or cocktails. It has the aura of a club rich in history and legend, though its "membership" is but visiting for the duration of their stays. Designwise, we employed a similar aesthetic in the Royal Ascot, the hotel's main bar, intended to evoke the image of a prestigious British club.

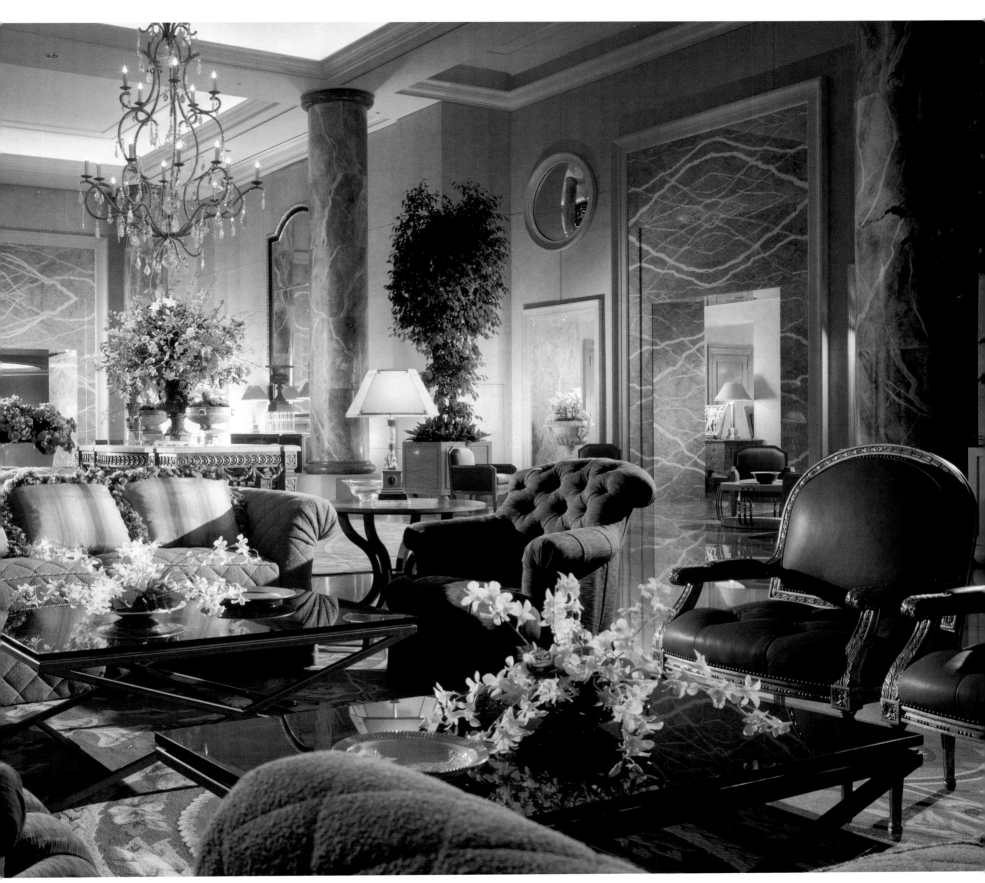

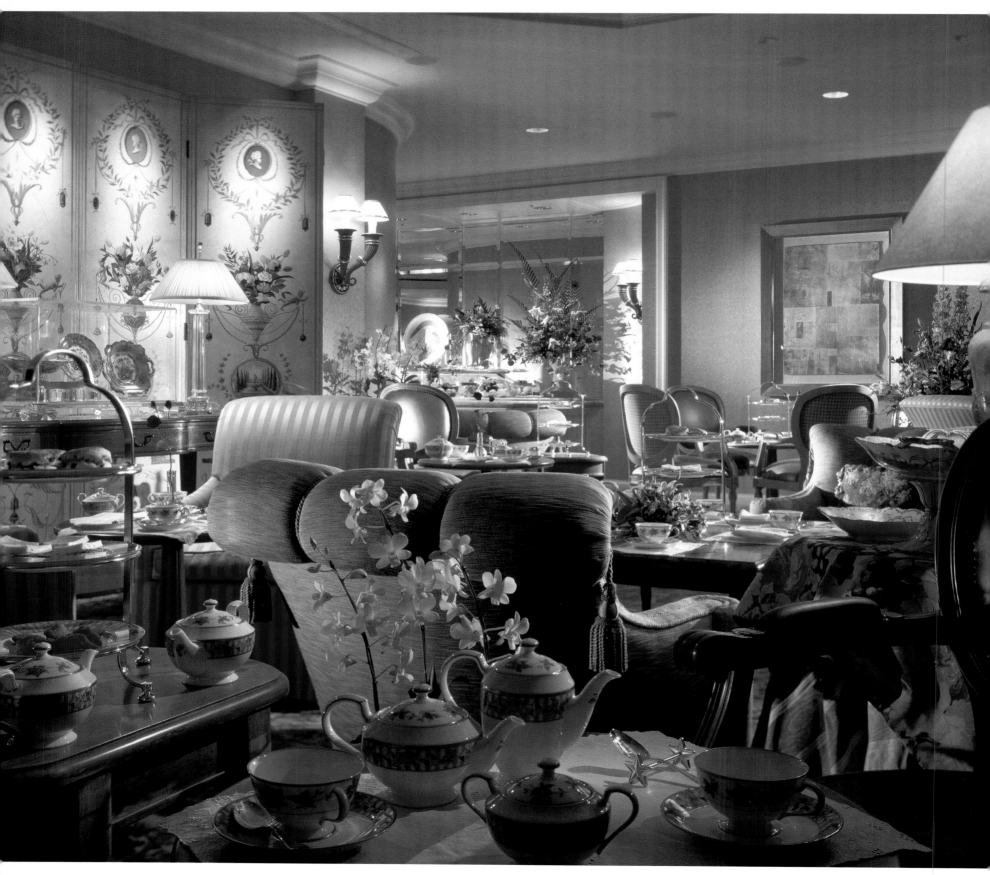

Across nine dining spaces, interior schemes range from stately and castlelike to *sukiya* – the authentic Japanese style. Bluebell, a tea salon filled with soft, warm colors, offers overstuffed furniture and eclectic charm, a look I love for its comfort as well as its stylishness.

Invoking all the serenity of centuries-old Japanese design, we created the hotel's tea ceremony room, Kaikoh-an, on the 65th floor. As a Westerner, I am in awe of the ceremony and history that merges in this truly cultural experience. In fact, the whole experience of being involved in this magnificent project in Yokohama, combined with visits to historic Osaka, allowed me to grow both as a person and a designer. The Japanese people were always gracious and charming, while challenging my team to produce their best. If one is open, there is much to learn from other people's culture and sense of style.

BOOK TO PACK:
Memoirs of a Geisha by Arthur Golden

A traditional English-style tea can be enjoyed with a teacup specially designed to match the interior of the Tea Salon Bluebell.

YOKOHAMA ROYAL PARK HOTEL

2-2-1-3 Minato Mirai, Nishi-ku
Yokohama 220-8173
Tel: 045-221-1111
Fax: 045-224-5153
www.yrph.com/index-e.html

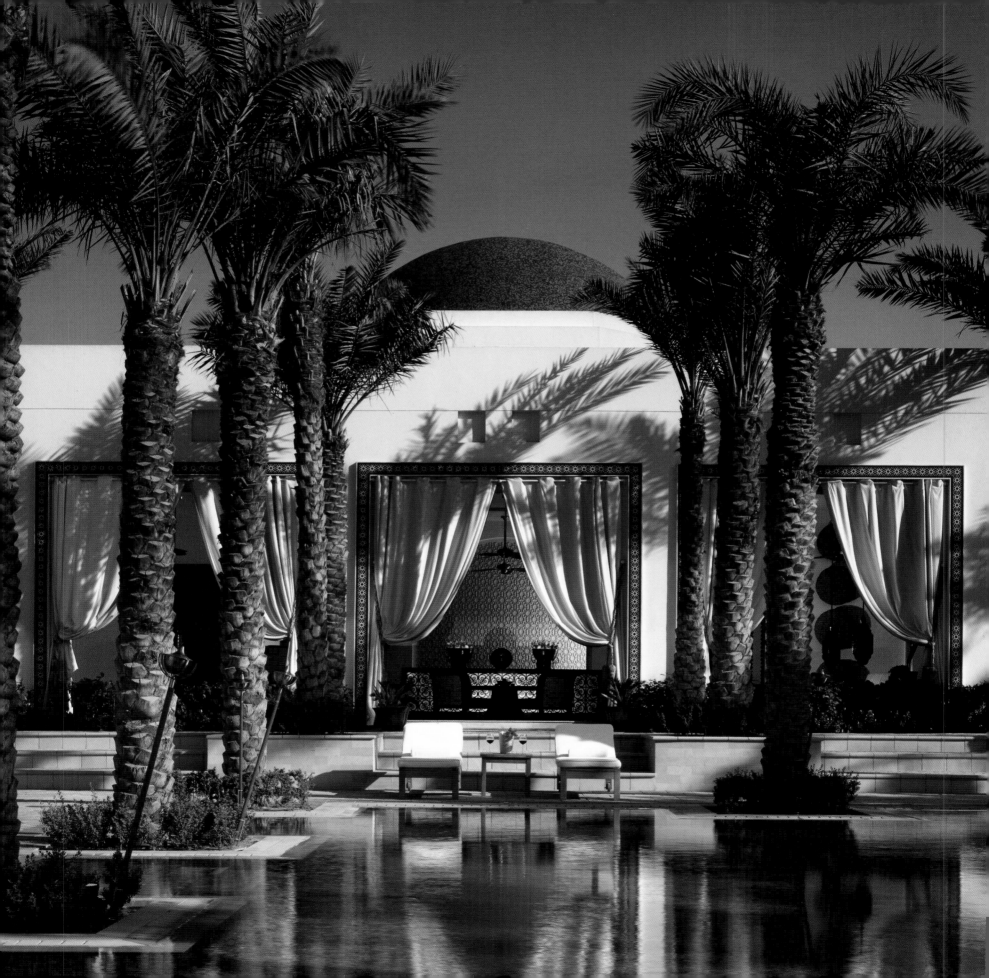

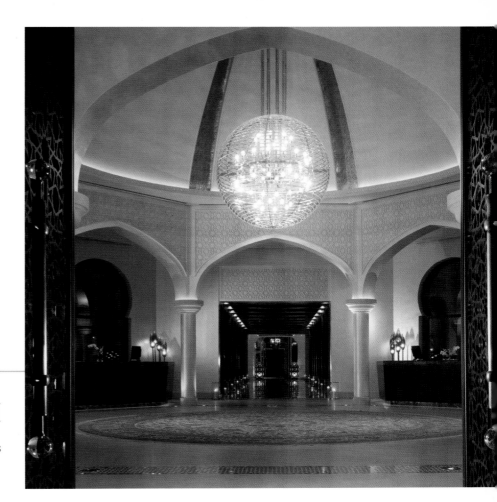

PARK HYATT DUBAI

Dubai, United Arab Emirates

The vibrant, multicultural city of Dubai is unlike any other place in the world to me. Amidst this capital of living large lies The Park Hyatt Dubai, a luxury waterfront retreat in an idyllic setting on the banks of the Dubai Creek and adjacent to the world famous Dubai Creek Golf & Yacht Club. This suits my idea of a tranquil haven where I can relax and take a moment away from the rush of this booming city.

Facing Page: The exterior drapes add a unique ambience to the pool lounge.

Right: Park Hyatt Dubai's lobby captures the essence of an urban resort.

Neutral tones were a natural choice for design resembling the surrounding landscape. Detail in the architecture is highlighted through shadow and texture, which creates an oasis of calm and serenity. Entering the lobby, I am in awe of the serenity of the dramatic creek views at every angle.

I enjoy every minute of my spacious, technology-savvy guestroom suite on the top floor of the hotel. A quick e-mail to the office, no problem. My every need is handled with the utmost attention during my stay thanks to the personal butler service (I for one LOVE butler service)!

Dinner at Traiteur is an experience in itself. The striking architectural setting creates the stage for the delicious offering of modern European cuisine. The theme here is a "theatrical super yacht." The interior showcases a backdrop of sail shapes with the attention to detail as in a Captain's cabin.

I would suggest private dining in Cave Privee, a 1200-bottle wine cellar. An after dinner drink is quite enjoyable at the upper level bar, connected by a timber staircase suspended to the ceiling by stainless steel ropes.

The ultimate stay would not be complete without a day of rejuvenating rituals and spa treatments. Amara Spa is a retreat within a retreat. Each room features a private garden with a rain-shower. It is very unusual for a resort spa experience to be fully attained in the center of a city and The Amara captures that relationship.

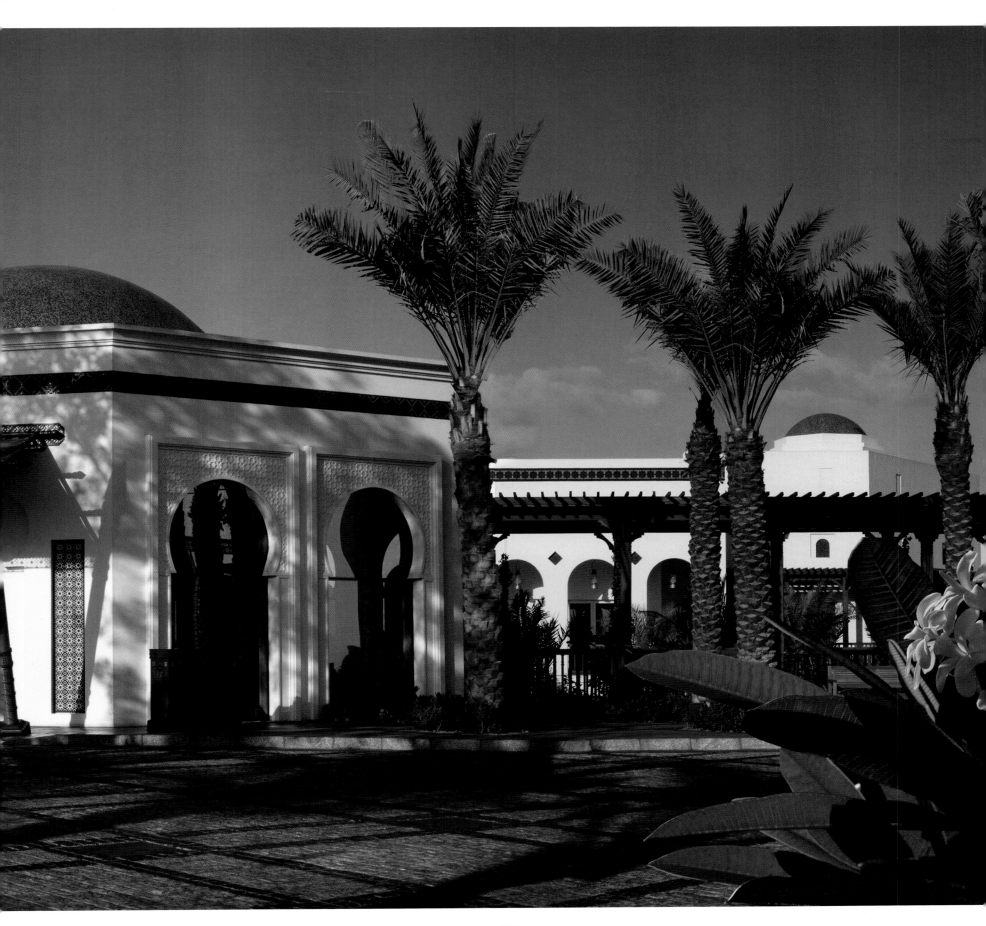

Top Right: Textiles and accessories add splashes of color to the treatment rooms at Amara Spa.

Bottom Right: The guest room suites are waterfront retreats featuring luxurious amenities.

Facing Page: Sit and relax on the terrace overlooking the Dubai Creek Yacht Club.

One of my favorite elements of the sophisticated Mediterranean design is the Pool Lounge, an open-air pavilion located off the pool deck, with oversized furniture and exterior drapes. It is an essential stop to my visit to catch a cool breeze or go for a refreshing swim.

I am never one to pass up an opportunity to explore the creek while yachting. Private yachts define elegance as they cruise away from the dock. Complete with a crew and service staff, what more could you ask for?

BOOK TO PACK:
Arabian Nights & Days
by Naguib Mahfouz

PARK HYATT DUBAI

Dubai
United Arab Emirates
Tel: 971 4 602 1234
Fax: 971 4 602 1235
www.park.hyatt.com

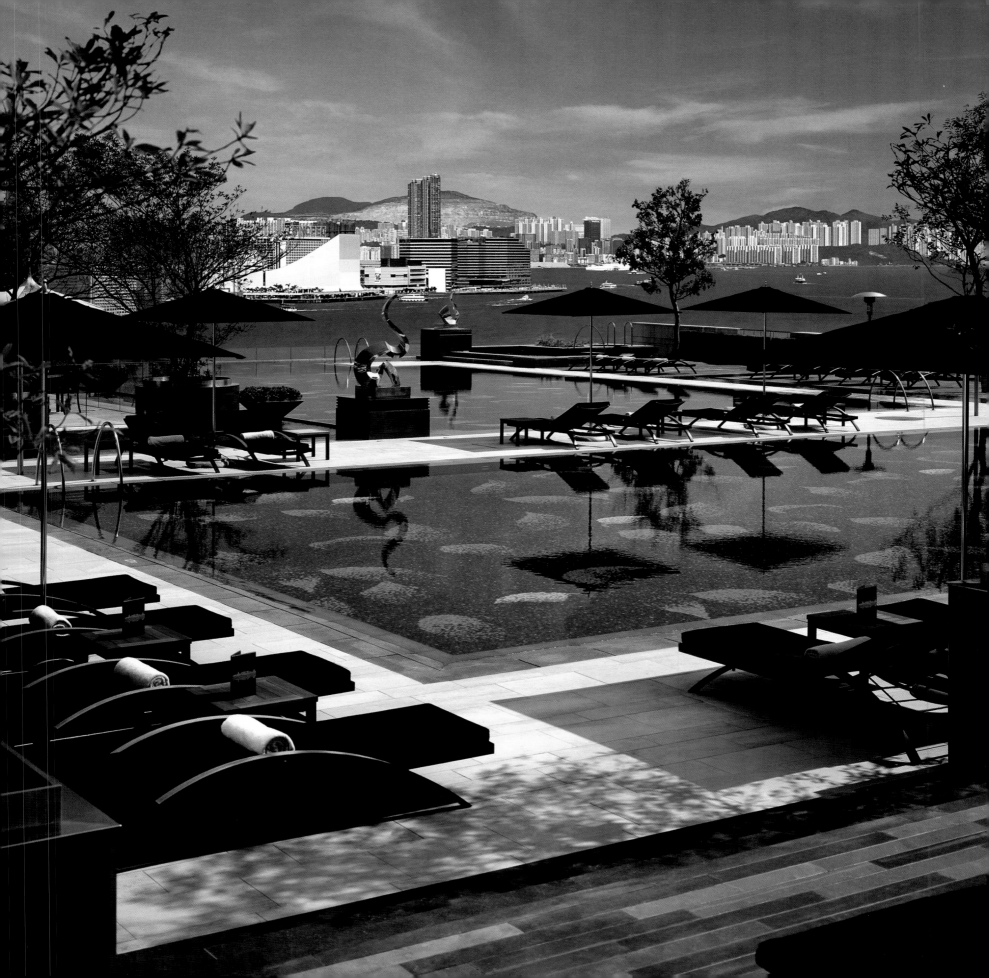

FOUR SEASONS HOTEL

Hong Kong, China

have always loved Hong Kong. It is a city rich in culture and tradition, yet it is wonderfully diverse, with its blend of Eastern and Western traditions. Hong Kong really has it all—an incredible skyline, glittering harbor, vibrant business community, an array of shopping and entertainment options, and a scenic countryside. Whether I am traveling to Hong Kong for business or pleasure, I know that each trip there will be an experience more interesting and enjoyable than the one before!

One of the reasons is the new Four Seasons Hotel Hong Kong. In a city known for luxurious hotels, the Four Seasons Hong Kong shimmers as the city's newest crown jewel. Consistent with the Four Seasons' reputation for sophistication and style, the Hong Kong hotel carries a distinctly international tone with an ambience of high culture and luxury.

Facing Page: The Four Seasons Hong Kong infinity-edge pool and lap pool are equipped with speakers so swimmers can enjoy music underwater.

Right: Experience the exciting diversity of the Pearl of the Orient.

Top and Bottom Left: Enjoy enhanced services in the executive club lounge.

Facing Page: Curving planes and luminescent metallic rays of the lobby lounge create an intimate space for any social occasion.

Our design goal for the Four Seasons Hong Kong was to fuse art and architecture to create an experience that was both awe-inspiring and welcoming. Each space was designed to emphasize the hotel's impressive harbor views, beginning with the main lobby and atrium, which features a spiraling grand staircase that pulls the eye upward toward the seven-story high windows. Walking down that magnificent staircase, you can't help making a grand entrance!

The lobby lounge next to the atrium is a welcoming spot for taking my morning tea or having a light luncheon. Rising above the quiet conversation is the "Allium," a 1.5 meter diameter sculpture by English artist, Ruth Moillet, one of the many unique art pieces in the collection of the Four Seasons Hong Kong.

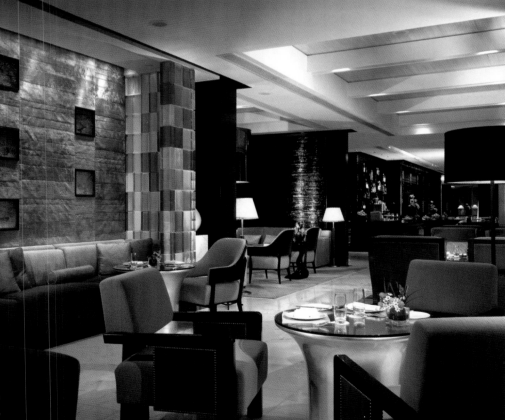

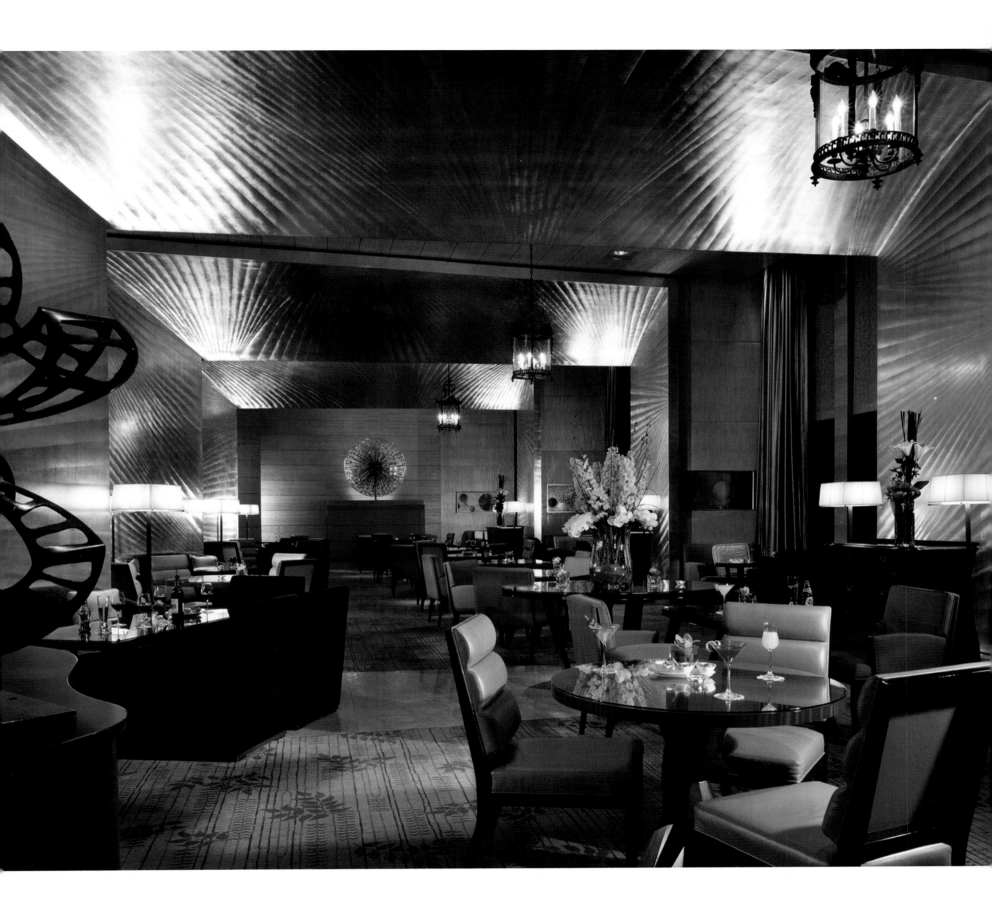

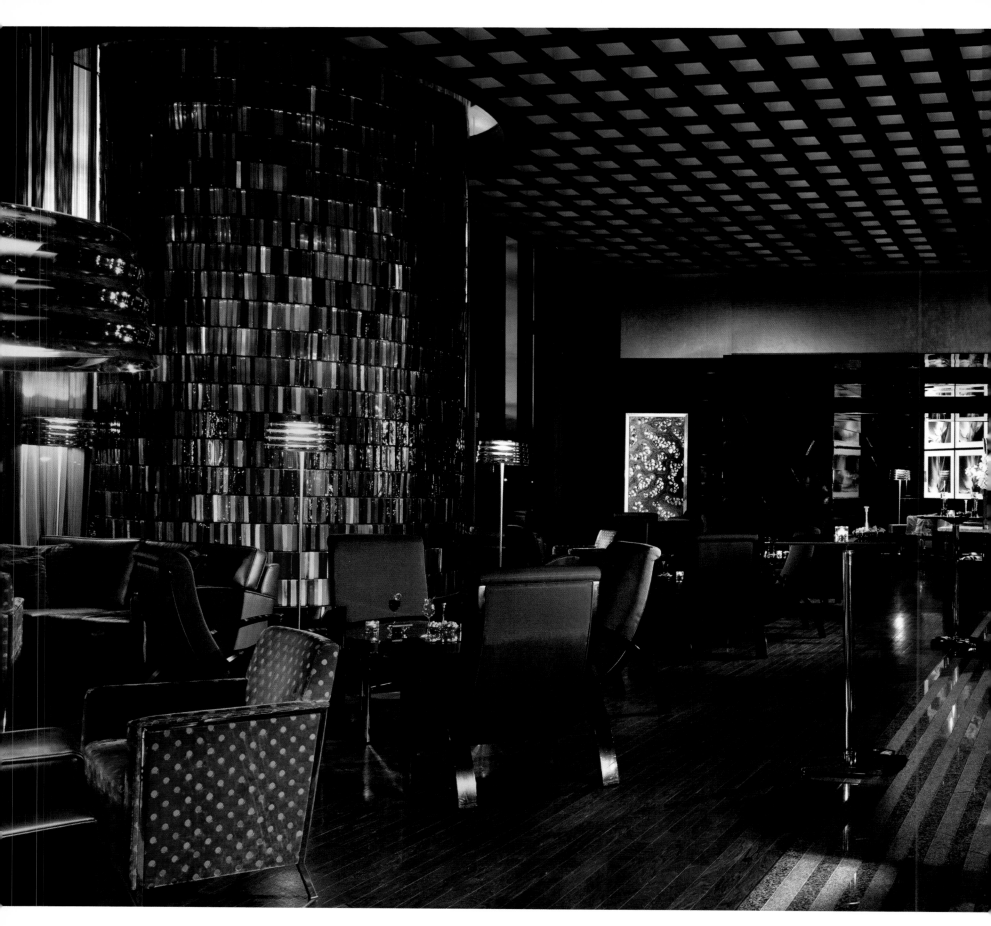

Left: Enjoy Harbor views from the metropolitan-chic lobby "Blue" Bar.

Of the many incredible design features at the Four Seasons Hong Kong, one I think definitely has the 'WOW' factor is the Lobby Bar. This area boasts a silvery ceiling of small, square recesses and hanging chain mail set against glossy timber walls with glass inserts. The focal point, though, is an internally lit cast glass column of watercolor shades that reflect the harbor waters. It never fails to draw compliments and "How did they do that?" comments from visitors.

After a day of business meetings or, if I'm lucky, some serious shopping, I always look forward to winding down at the Four Seasons Spa. I begin to relax the moment I walk through the door. The three-story facility features the full range of spa services, along with a well-equipped gym and vitality pools. A series of private treatment rooms float like islands on rippling infinity pools of water that seem to cascade into the harbor itself. I prefer the lavish Aqua Spa suite!

As a seasoned traveler, I consider myself a discerning judge when it comes to the comfort and luxury of the guest rooms and the Four Seasons' 399 guest rooms do not disappoint. The controlled architectural lines offer art deco-inspired detailing accented by soothing palettes of wild plum and ivory. There is an atmosphere of luxury and comfort accented by the breathtaking views outside the full-height windows.

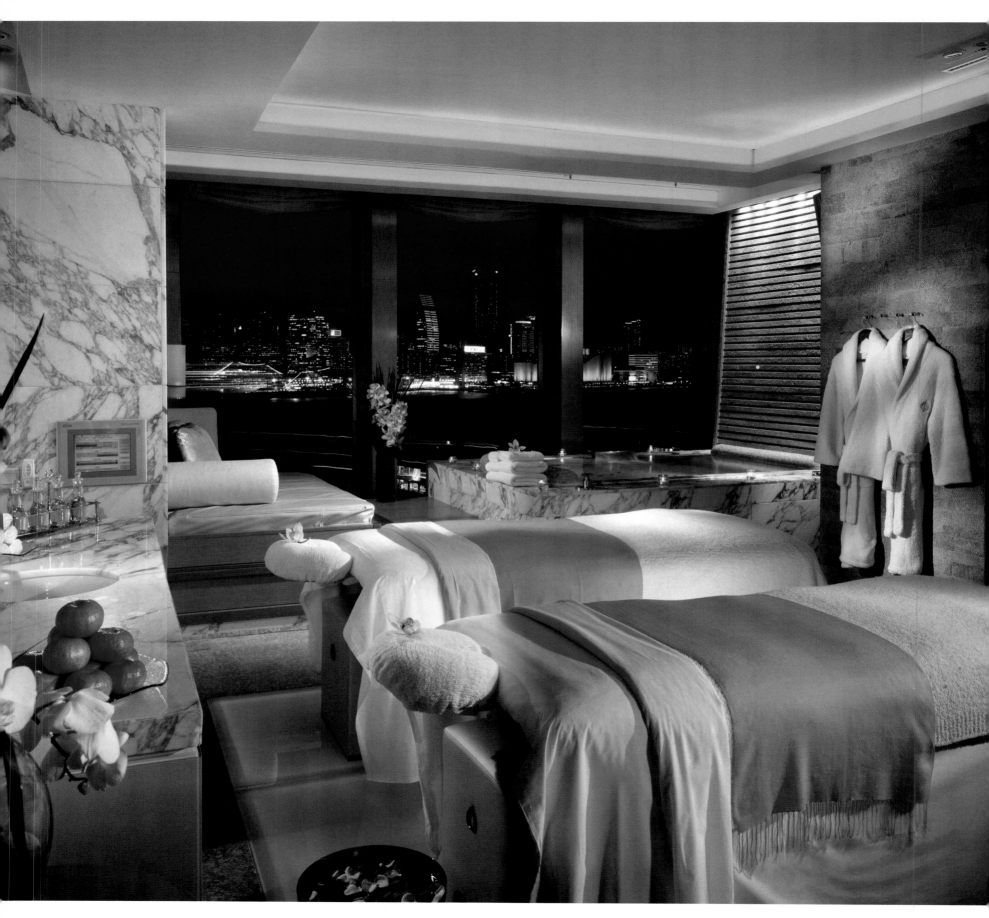

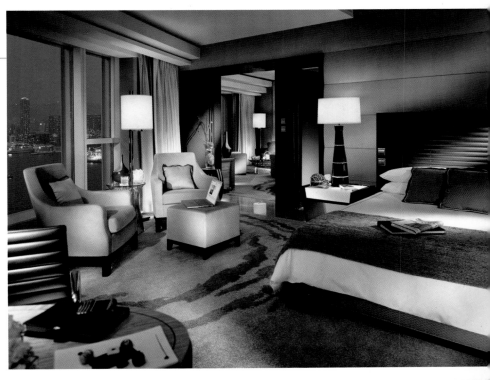

Top Right: The Four Seasons executive guest rooms are corner suites offering breathtaking views of Victoria Harbor and Kowloon.

Bottom Right: The spacious marble-clad bathrooms are fit with Four Seasons touches.

Facing Page: The Aqua Spa suite will leave you well-rested and rejuvenated in mind, body and spirit.

Business travelers will appreciate the attention to detail of the meeting rooms, which feature every possible amenity, discreetly concealed behind timber panels and offset by artwork that is displayed in recesses between the panels. Amid all that luxury, it may be easy to forget you're traveling on business!

In short, whether you travel to Hong Kong for business or pleasure, the Four Seasons will awe and inspire, making you wish you never had to go home!

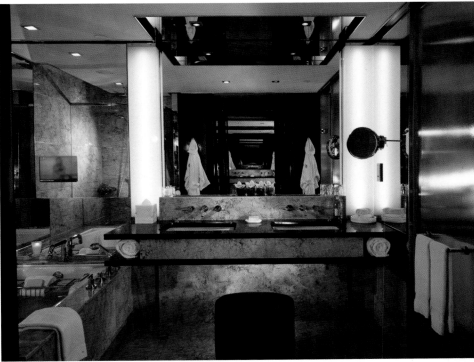

⁂

BOOK TO PACK:
Tai Pan by James Clavell

FOUR SEASONS HOTEL

Hong Kong
China
Tel: 852 3196 8888
Fax: 852 3196 8899
www.fourseasons.com

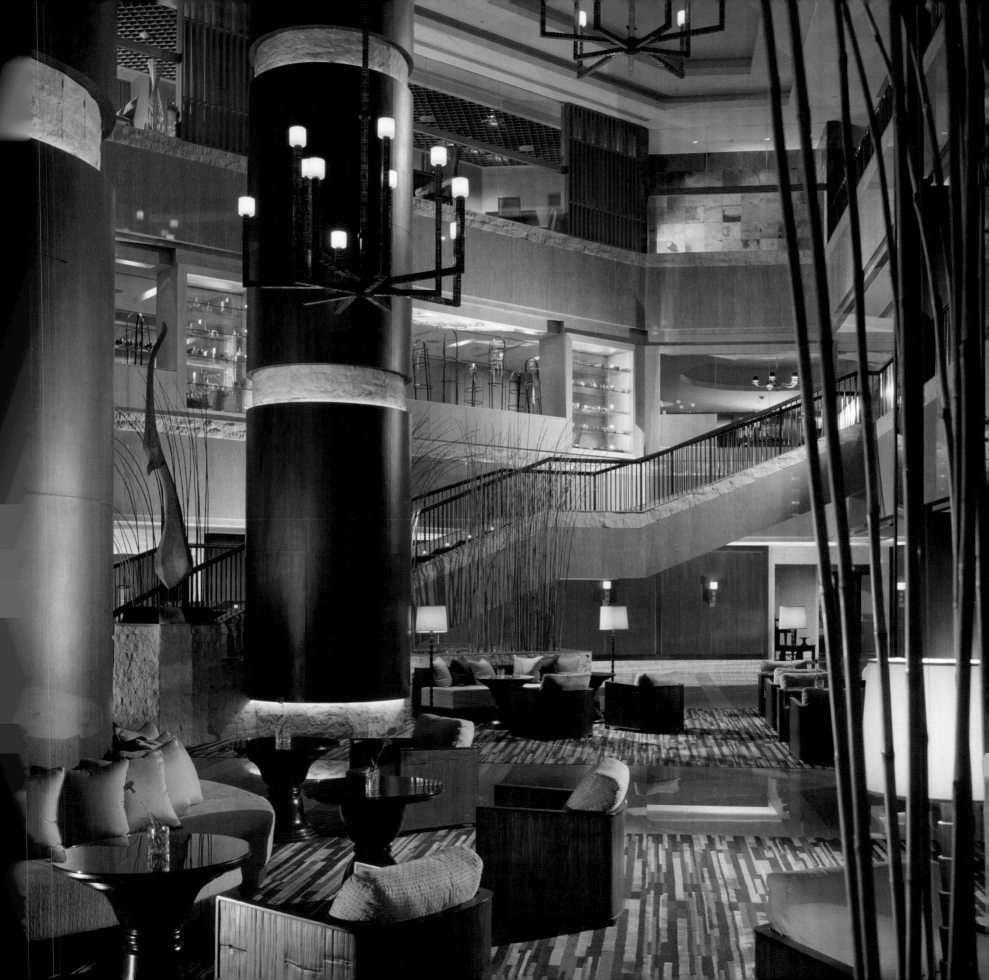

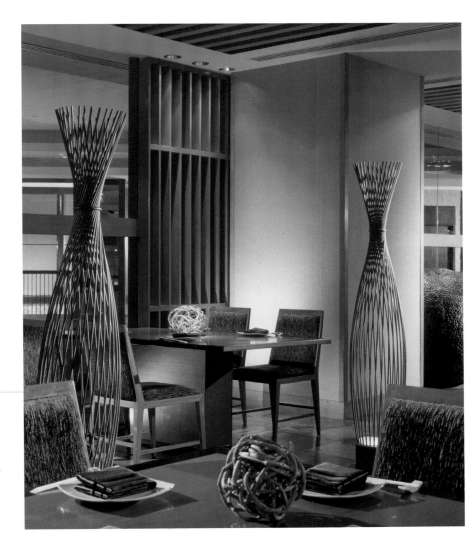

CONRAD BANGKOK

Bangkok, Thailand

*A*s often as I can, I make design pilgrimages to places and spaces especially recommended to me. Few trips stay as persistently fresh in my memory as my visit to the Thai house of legendary silk dealer Jim Thompson in Bangkok. His former residence is comprised of six small, traditional teak dwellings that convey the warmth and character of Thailand. After seeing the charming architecture with its naga (serpent) roofline, I wished for a project where we could use traditional Thai design elements.

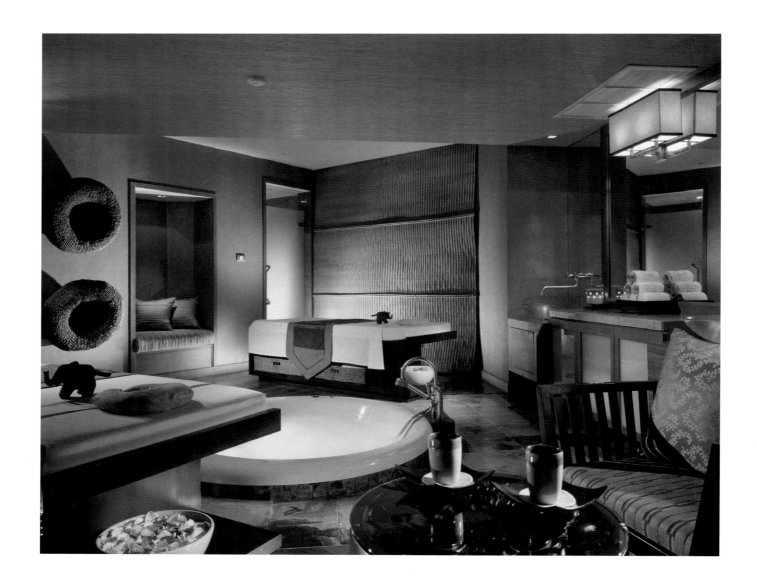

I got my wish with the commission for the Conrad Bangkok Hotel in Thailand's largest city, designing the interiors for 375 rooms and suites. The hotel is located at the All Seasons Place in the main business district, near Ploechit and Sukhumvit, within walking distance of major embassies, commercial centers, and the Skytrain. The hotel's generously large guestrooms offer breathtaking views of Lumpini Park.

Above: Dramatic accessories accentuate the luxury of a spa treatment room.

Right: Carved wooden panels and dramatic light fixtures make each public space a work of art.

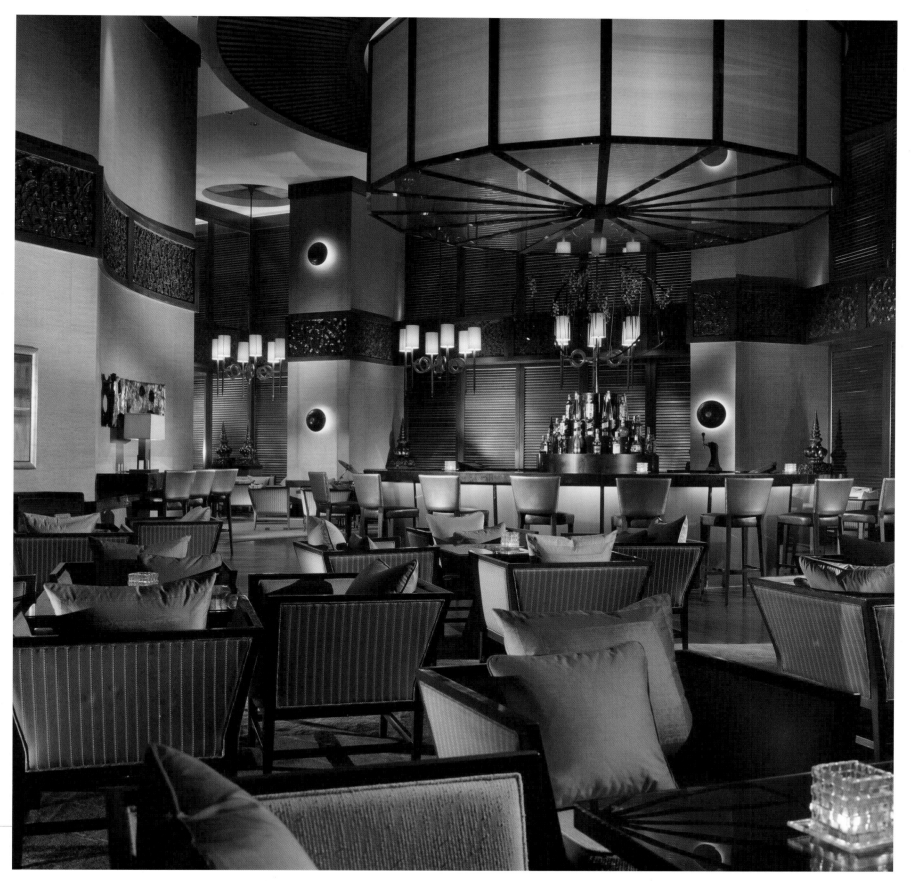

Display cooking in the hotel's Japanese restaurant, Drinking Tea Eating Rice.

After preserving views, Mike Fiebrich, from our Singapore office, intended to borrow on a strong Thai influence but express it in a more contemporary way. For inspiration, Mike took many interesting excursions to Thai markets, in search of just the right furnishings and art. To set an overall tone in the hotel, we decided on teak paneling in the rooms very early in the design process. Teak panels are used extensively in traditional Thai architecture. Here they added luxury and warmth — and sense of place. There's no mistaking you're in Thailand, where a sort of sensible elegance and use of local materials prevail.

What makes this hotel spectacular is the unexpected. Because it was important to have a few unanticipated delights even in this first-class business setting, we created very tailored, but unique, guestrooms. We focused on the mesmerizing views afforded by huge windows, and added carved teak platform beds dressed in sumptuous, tailored linens. We wrapped the headboard in silk and added a luxurious, silk runner for drama. And we were careful to preserve the views from the guest bathrooms by making them merely draped zones. Simply open the draperies to the bedroom and it's a bath without walls, unconfined. Just pull them closed for privacy. Even more unexpected: the drapes are remote-controlled.

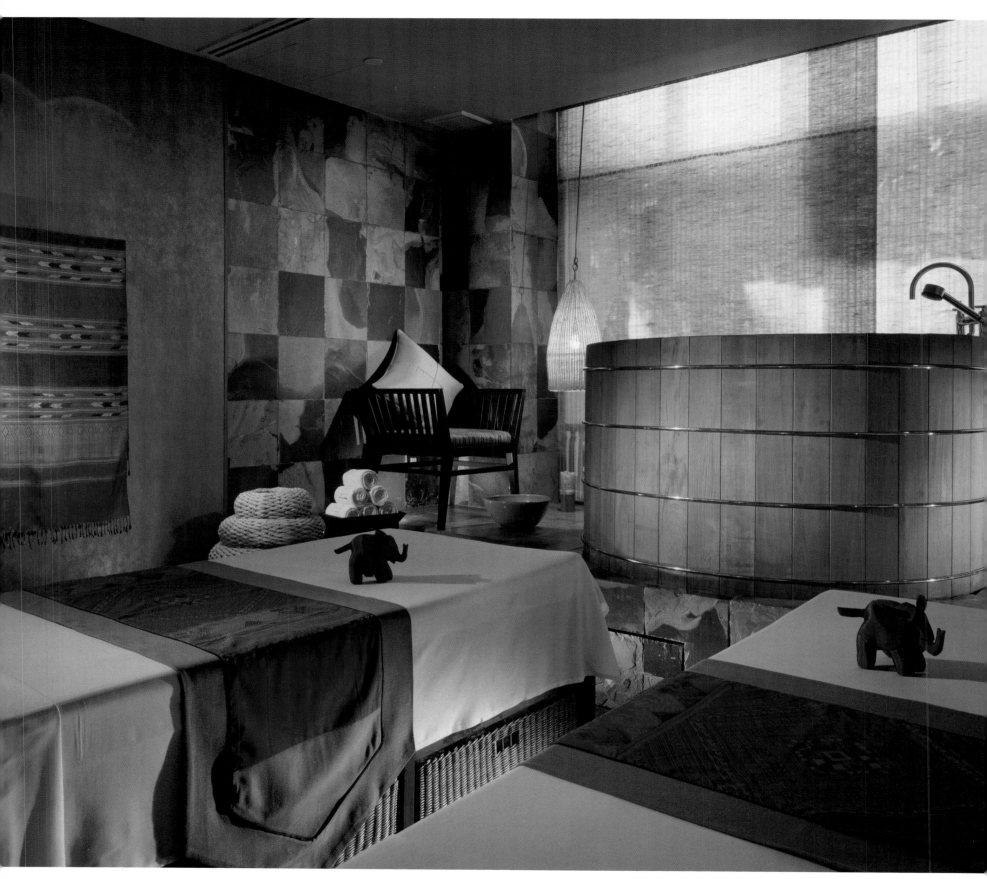

Attention to detail creates harmony and balance throughout the hotel.

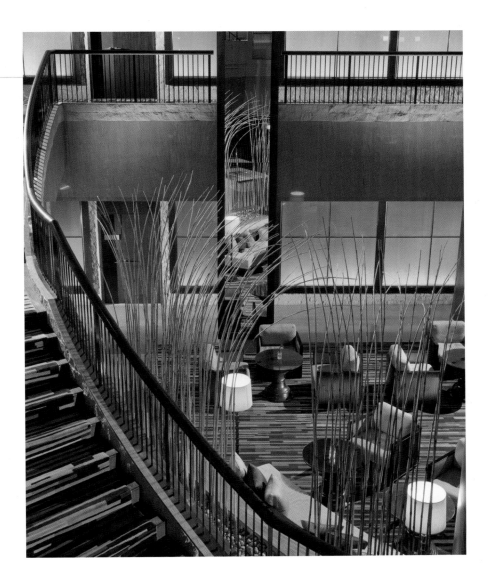

Throughout the hotel, the mixture of teak and metal strikes a harmonious balance. I like the glow of the lobby bar particularly, and the sheen of the ballroom as well. As with most of the world's large and busy cities, one always needs a bolt hole and a refuge for some quiet time, and the Conrad Bangkok is a serene and wonderful haven for just that purpose.

BOOK TO PACK:
Bangkok-a-go-go by John Hail

Asian spa treatments are exotic and relaxing.

CONRAD BANGKOK

All Seasons Place
87 Wireless Road
Bangkok, Thailand
Tel: 66 2 690 9999
Fax: 66 2 690 9000
www.conradbangkok.com

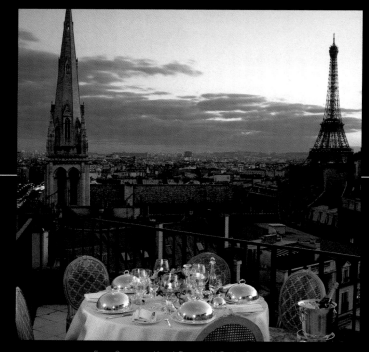

Four Seasons Hotel George V Paris, Page 200

CHAPTER FOUR
Europe

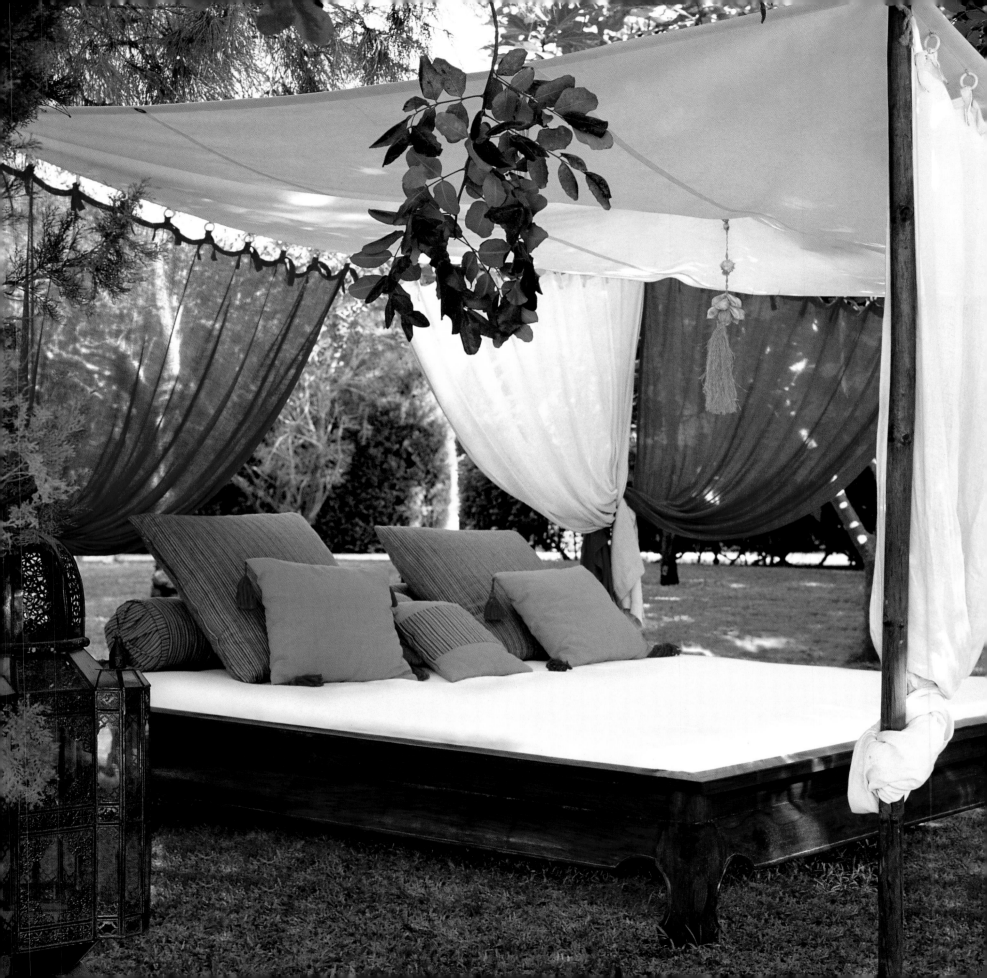

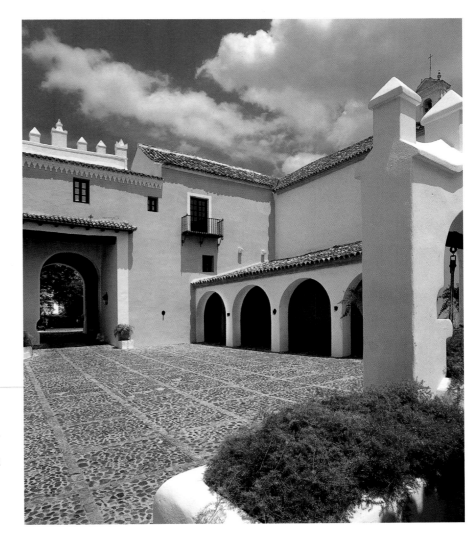

Hacienda Benazuza

Sanlúcar la Mayor, Spain

Of all the beautiful, romantic and diverse regions of Spain, it is Andalucia that evokes the most passion in travelers. This is a land of contrasts, of beautiful landscapes, friendly and proud people, and fascinating history. For the designer and architect, the fusion of Moorish, Jewish and Christian influences is irresistible.

Sitting on a hill in the little town of Sanlúcar la Mayor, overlooking the Guadiamar River Valley, only 10 minutes outside of Seville, is the Hacienda Benazuza, my favorite hotel in Spain.

Left: Daybeds are dotted among the orange trees near the swimming pool.

Right: The entrance courtyard to the Hacienda transports you to another time.

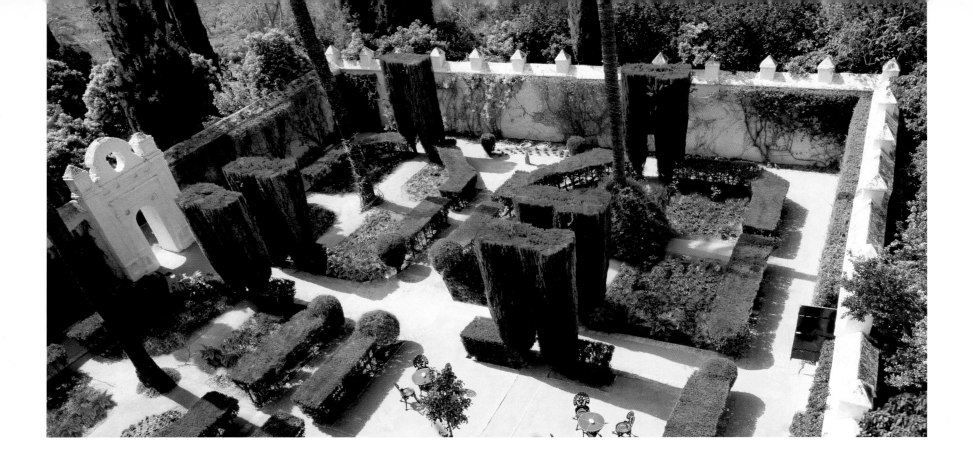

Arriving at the Hacienda Benazuza is a delightful assault on the senses. Surrounded by groves of centuries-old olive trees, it is a haven of perfumed courtyards, gardens, and fountains, offering beauty at every turn.

The region has a rich heritage, full of mystery and romance. In A.D. 711 the Moors swept in across the Straits of Gibraltar and dominated this part of the Iberian Peninsula. It was reconquered by the powerhouse combination of King Ferdinand and Queen Isabella in 1248, and this area literally became the center of the civilized world. The Guadalquivir River was the key to this. Navigable all the way inland to the great ports of Cadiz and Cordoba, it was a refuge from the pirates that prowled the Spanish Main. From here Columbus set forth to discover the new world and open up the richest trade routes the world had known.

The Hacienda Benazuza is like a microcosm of the mixture of Muslim, Jewish and Christian cultures that is Andalucia. It was originally an ancient Moorish farmhouse and its previous owners included the Counts of Benazuza, for whom it is named, the Order of St. James, and, more recently, the Pablo-Romero cattle-raising family. In 1991, Rafael de Elejabeitia acquired the Hacienda, with a view to converting it to a hotel for the 1992 Sevilla Expo. In 2000, the El Bulli Hotels and Resorts group became involved with the hotel and brought their signature cutting-edge management, service and cuisine style to this gem of a property.

Above: A walled Arabic garden attached to the bar is typical of Seville's Moorish roots.

Right: An inner courtyard and vignettes of different aspects of the hotel convey the beauty and magic of the Hacienda.

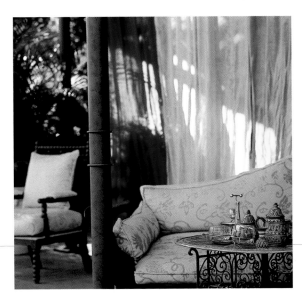

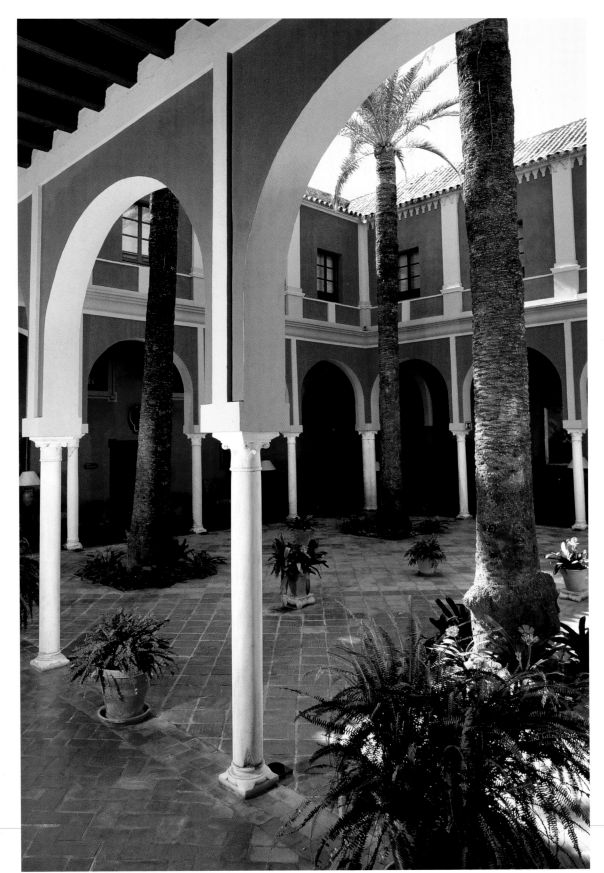

Everything at the Hacienda fits perfectly with its character — when you pass through the front walls into a cobbled courtyard, you are instantly transferred to another place and time. The rooms all have different aspects and views — the grounds are a treat to explore with interconnected gardens and lawns that one just stumbles across. The swimming pool is set beside a beautiful pavilion, and daybeds dot the lawns with wispy, colored fabric curtains blowing in the breeze.

Inside, Manuel Gavira San Juan created the interiors, and every space breathes history and romance. My favorite room is the Bar Guadarnes, a long room with two lounges, a bar at the end and soaring ceilings. Stuffed with antiques, opening out onto an interior courtyard on one side, and an Arabic garden of palm trees hedges and jasmine on the other, it is achingly romantic. We ordered room service one night and asked for it to be served in the bar, where we shared tapas with a couple of friends and laughed the night away.

And the food…. The region is home to the wonderful Spanish tradition of tapas, tasty small bites of traditional delicacies of melt-in-the-mouth smoked hams, croquettes and cheeses, all washed down with excellent Spanish wines in startling variety. This is also the home of my favorite soup — gazpacho.

The El Bulli philosophy however, has elevated the cuisine at the Hacienda to an art form. Even breakfast is a delight. There are medleys of fresh fruits blended in delicate tasting glasses, small spoons with bites of egg and ham that you pick up and pop in your mouth. But there is more — sweet butters blended in the kitchen, fresh pastries, jams and marmalades from house recipes, and then mousses, creams and chocolates that make this normally straightforward meal an adventure.

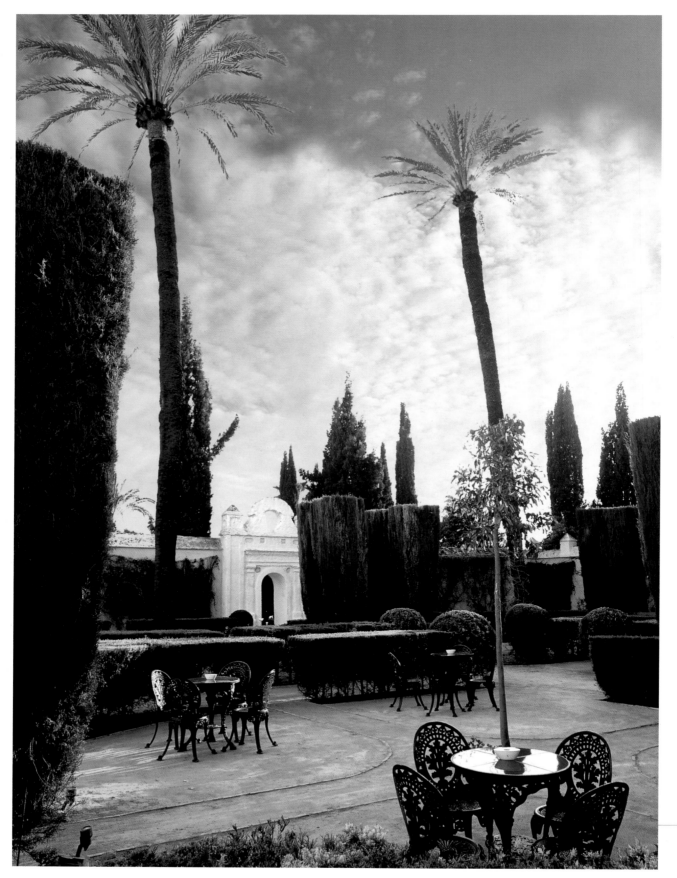

It is enough to just spend time within the thick cool walls of the Hacienda, absorbing the architecture, ambience and food, or lying by the pool washed by the sun and fragrances of orange blossoms. But again – there is more.

In the immediate area, one can take a walking tour of Seville itself. Further afield are the bodegas and wineries of Jerez and the famous Andalucian school of Equestrian arts where the horses literally dance. You can hike or horseback ride on the rolling hills where lonely fighting bulls stand under trees in their own fields, or get picked up in a hot air balloon from the grounds of the hotel.

For me though, the magic of the Hacienda, and Andalucia, were encapsulated in one magic night with a performance of the soul of this area – flamenco. A group of friends and I requested a private performance which the hotel set up for us in a beautiful private dining room. They sourced the greatest flamenco guitarist in Seville today, and a male and female dancer. The performance lasted just over an hour and a half – and no one moved in their seats. It was so powerful, poignant, sensual and moving, that when the last heel stamp finally echoed off the walls, and the last guitar chord hung in the air, the room exploded as we all jumped to our feet – most of us in tears.

BOOK TO PACK:
Don Quixote by Miguel de Cervantes

Soaring palm trees dominate one of the gracious outside dining spaces.

HACIENDA BENAZUZA
41800 Sanlúcar la Mayor
Spain
Tel: 34-955-703-344
Fax: 34-955-703-410
www.hbenazuza.com

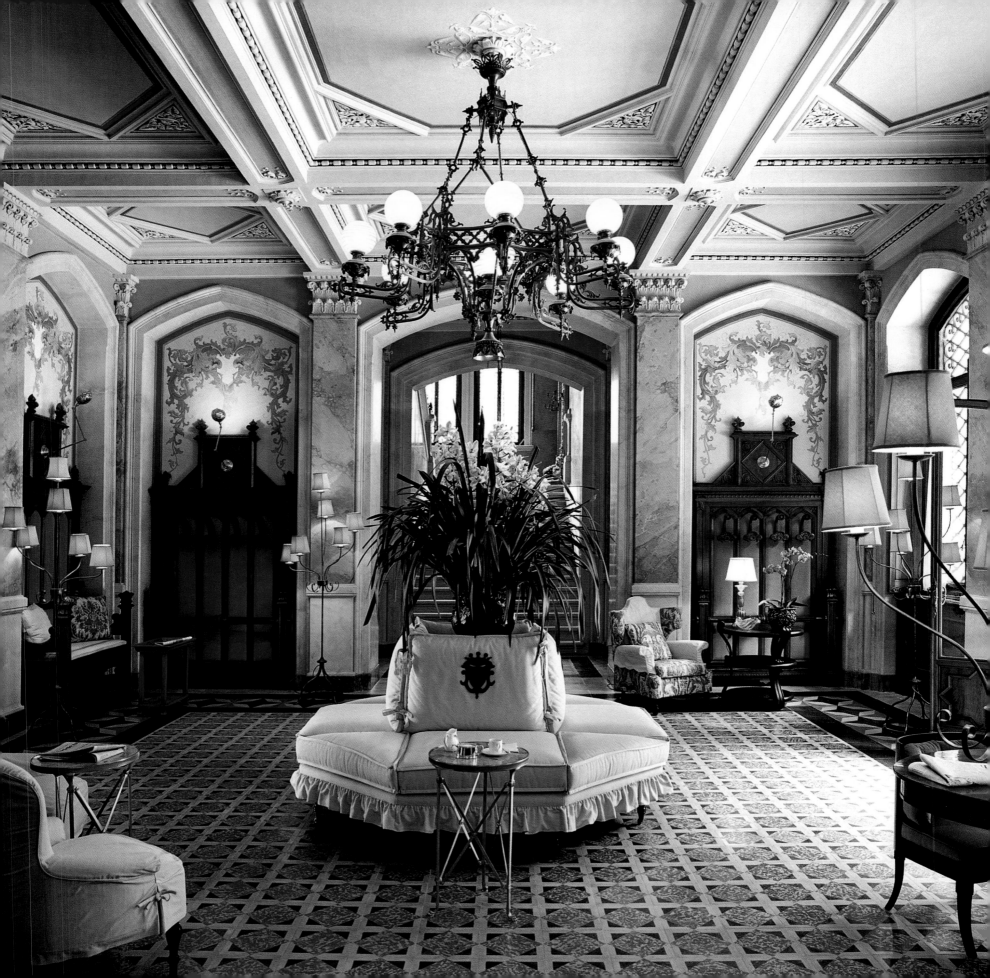

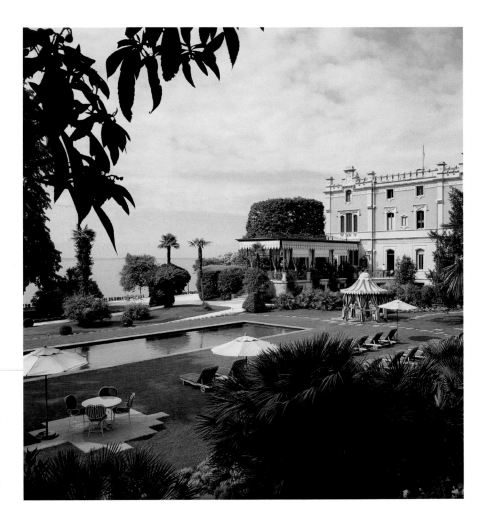

THE GRAND HOTEL A VILLA FELTRINELLI

Gargnano, Italy

The first time I was privileged enough to set my eyes on the beauty of Northern Italy's Lago di Garda (Lake Garda), I knew I was looking at one of earth's loveliest scenes. Nothing, however, could prepare me for my first sight of the Villa Feltrinelli.

Left: Parlor at entrance to Villa Feltrinelli.

Right: The incomparable Villa gardens offer history, beauty and serenity.

Above: The gracefulness of the past blends with the needs of the modern traveler.

Right: Period features bespeak antique elegance in a drawing room.

The Grand Hotel a Villa Feltrinelli sits like a fairy-tale castle at the foot of a hill nestled among ancient trees, surrounded by beautifully manicured lawns that roll down to the shore of the lake. It is truly one of the most breathtaking settings of any building on earth. And then there is the building itself. My criteria in writing about the hotels in this book are exemplified by this masterpiece of a hotel. It combines history, luxury, style, serenity, and sheer beauty in measures of each that leave one completely at peace with the world.

To get a sense of how special this hotel is, one must delve into its history. It was designed by Milanese architect Alberico Barbiano di Belgioioso in the neogothic style and built around 1892 for the Feltrinellis, a prominent Italian family that had made a fortune in lumber, banking, and publishing. It gained notoriety as the last residence of Italian dictator Benito Mussolini, who was a virtual prisoner there from 1943 to 1945 during the German occupation. Famous visitors through the years have been moved to record the beauty of the place; D.H.Lawrence wrote about it, and Winston Churchill captured it on canvas.

In my view there is only one man in the world who could have pulled off transforming this treasure into a beautiful, tasteful yet functional hotel and that man is Bob Burns. Bob, one of the world's great hoteliers, began his career at age 14 performing civic duty during World War II with a job extracting sheets in a hotel laundry. He went on to develop Regent International, a collection of ultra-luxurious hotels in the Pacific Rim such as the Regent Hong Kong (opened in 1980), which raised the bar on design, service, and such marvelous touches as doormen greeting first-time guests by name upon arrival.

When Burns first saw the Villa Feltrinelli he was smitten. It would be his first venture as both developer and financier, but first, he had to get the project approved. Mussolini's granddaughter had proposed it become a state-run memorial to her grandfather. In Rome, Parliament debated; in the little nearby village of Gargnano, citizens voted (1,700 pro-hotel, 1,200 pro-museum). Landmark preservationists had a massive say, and Burns spent about $30 million on the painstaking restoration, 10 times the price he paid for the property.

The interior restoration had to take place within the strict parameters of the Italian Historic Preservation statutes, which involved documenting furnishings and keeping the work in character with the original style. The idea was to achieve the feeling of a private home, strictly respecting the history of the space while allowing for comfort, luxury and functionality.

The villa has 20 guest accommodations — 13 in the main villa and seven in the guesthouses, as well as numerous beautiful public spaces. Interior elements include magnificent frescos (restored over two years), a marble staircase flanked by 18th century mirrors, and incredible stained glass windows. With such good "bones," it became an eclectic retreat filled with original pieces and the unexpected whimsical motif. It is elegance without excess. Each space has signature dramatic elements — from the intricately carved benches and coffered ceilings in the Entry Hall, to the incredible frescos in The Salon to the octagonal shape of Bob's Bar.

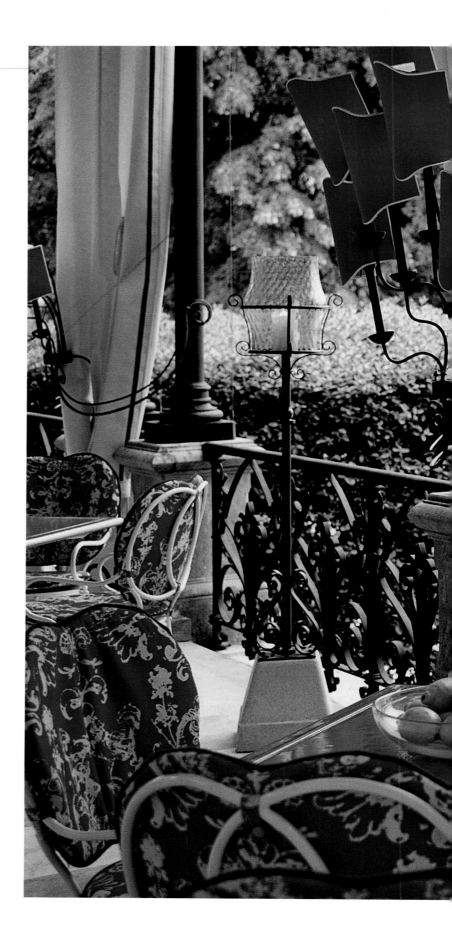

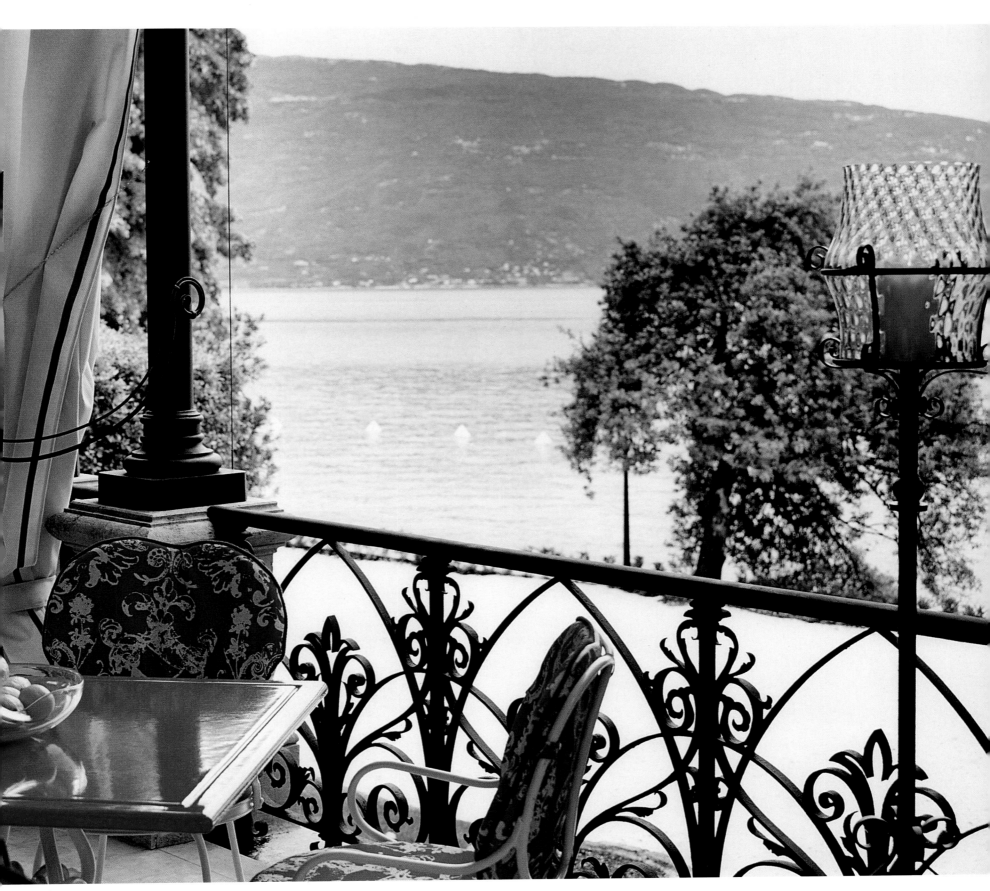

Rustic elegance combined with a sense of history — such pleasure.

Villa Feltrinelli is one of those places almost impossible to leave. When I have had a few days of just absorbing the beauty, there is so much more that beckons. The Villa's eight-acre park of restored gardens includes a croquet lawn and a tiered lemon garden or lemonaia (the work of landscape artist Andreas Kipar). One can board the 16-meter pleasure craft the La Contessa — designed after a circa 1920 American classic — and cruise across the lake to dinner at a nearby restaurant. The surrounding countryside and the peaceful village of Gargnano constantly beckon exploration.

Of course, one could always just mix a cocktail at Bob's Bar and enjoy the peace of the Villa, which Burns believes has "escaped the march of the modern world."

BOOK TO PACK:
As Max Saw It by Louis Begley

THE GRAND HOTEL A
VILLA FELTRINELLI

Via Rimembranza 38-40
25084 Gargnano
Italy
Tel: 39 0365 798000
Fax: 39 0365 798001
www.villafeltrinelli.com

Architectural details and seamless guest services pamper even the most seasoned traveler.

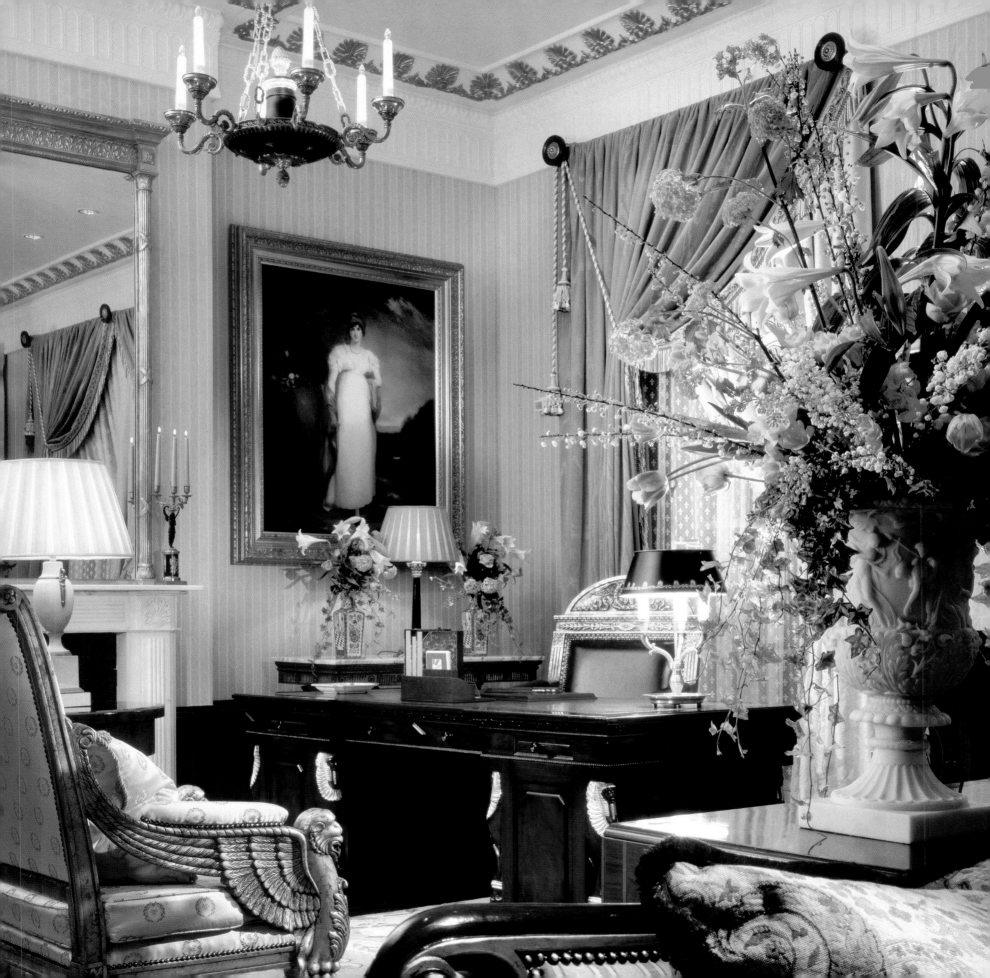

THE LANESBOROUGH

London, England

The Lanesborough is prestigiously located across from Hyde Park and Constitution Arch and adjacent to the grounds of Buckingham Palace.

*T*his is the essence of London. Butler service. Tea offered upon arrival. A change of clothing pressed immediately. The impeccable service seems almost regal at The Lanesborough, just steps from Buckingham Palace and all the pomp and pageantry that is England.

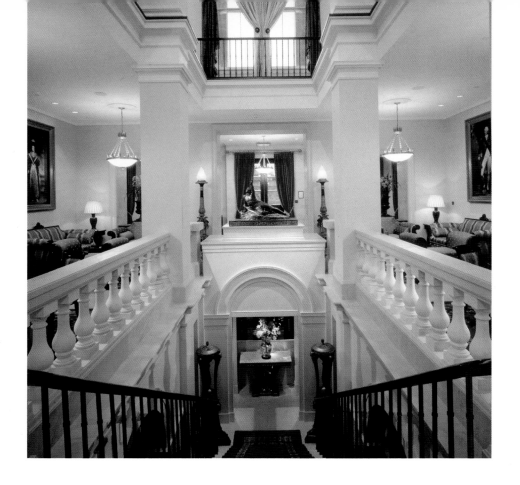

The residential notion of The Lanesborough is thanks to such unrivaled service and a thoroughly singular setting. On Hyde Park Corner, across from Hyde Park and Constitution Arch, Viscount Lanesborough established his country retreat in 1719. His home became St. George's Hospital in 1733 and was demolished nearly a century later to make way for its distinguished architectural replacement, now The Lanesborough. William Wilkins, architect of the National Gallery, blended classical and Greek Revival elements that render this magnificent building to be considered among London's finest structures. In Regency style, Wilkins fashioned the Great Hall, an impeccably ordered space offering the grandest sense of having arrived.

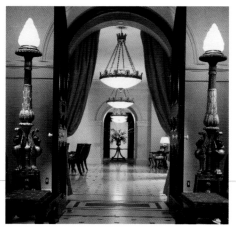

Left: The historic character of the hotel is integrated with Regency furnishings.

Right: A Chinoiserie inspired tea room.

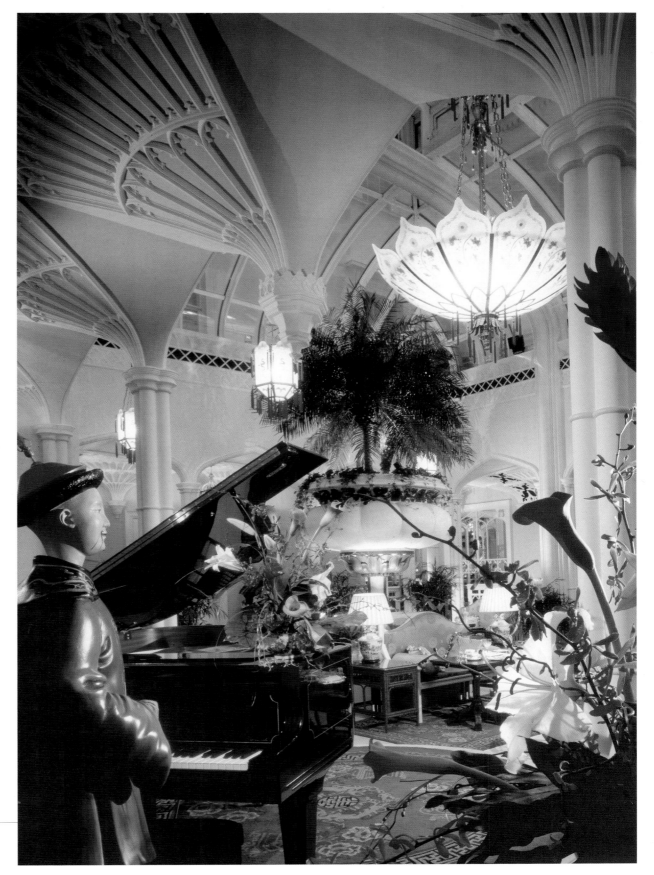

The classically elegant dining room, replete with sumptuous furniture and dramatic fresh floral arrangements.

The elaborate restoration that was to transform Wilkins' masterpiece into The Lanesborough was overseen by England's most prestigious organizations: the Royal Fine Arts Commission, the Georgian Society, the Victorian Society and English Heritage. The charge included recreating an elegant 19th-century residence in Regency fashion. It becomes magical to rework a structure with such good bones. The inlaid wood floors are incredible, especially those in guestrooms. Grand arches, mouldings and details stand out, with elaborately draped bedsteads, window treatments and period furniture defining interior residential style.

The Lanesborough is the place in London for high tea, quite traditional. It's also the place for the quintessential after-theatre supper. The Conservatory provides the perfect see-and-be-seen setting for both. Architecturally, its classic glass roof reminds me of the Brighton Pavilion. A bit more cozy and clubby, the hotel's Library Bar includes cognacs dating to 1770, a nod to Britain's "liquid history."

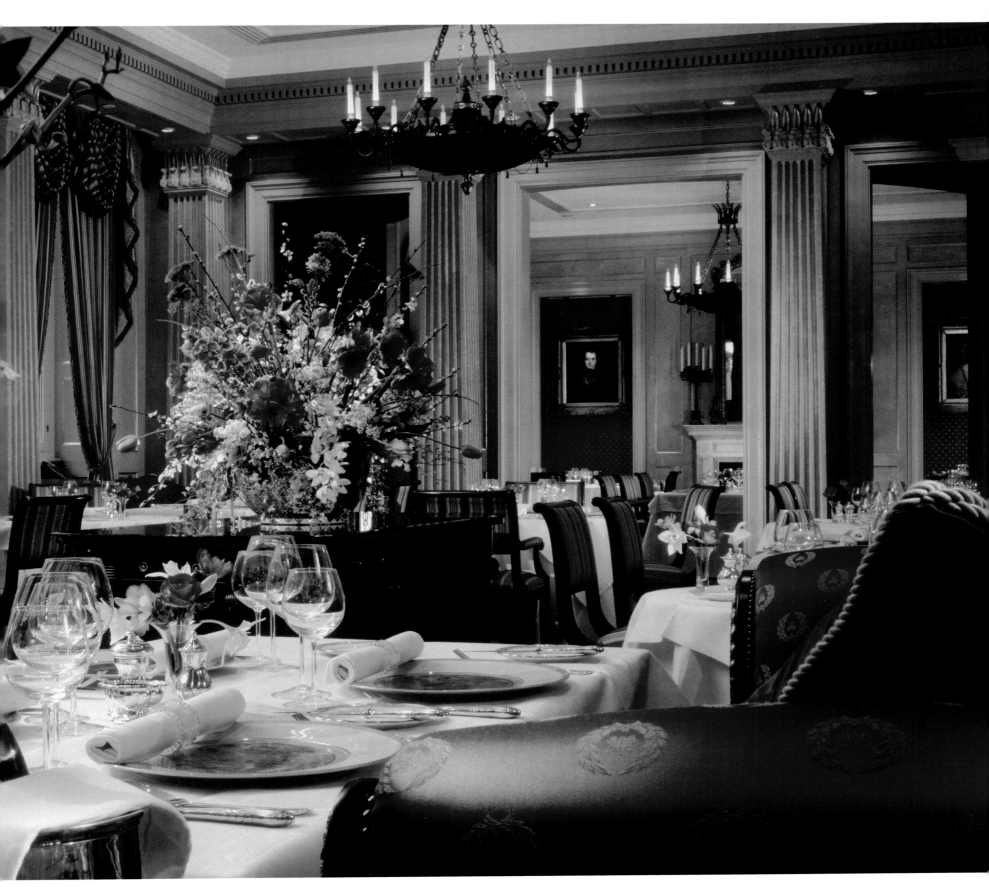

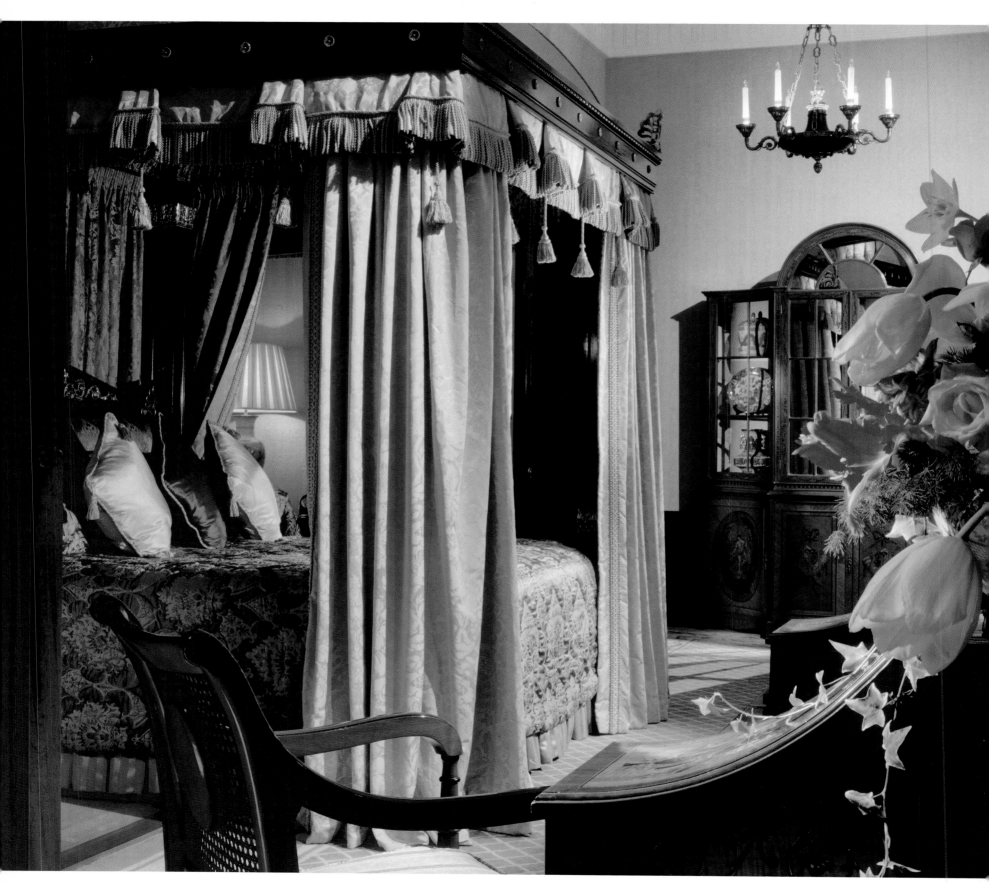

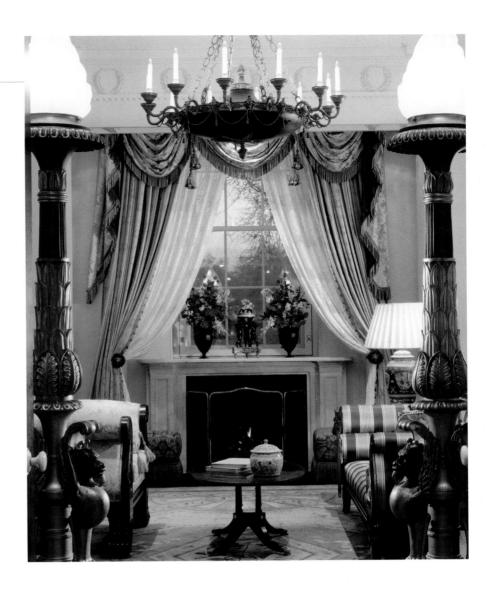

With a view over Hyde Park, this suite is one of London's finest rooms.

Architecture and furnishings may create an unparalleled package, but The Lanesborough's service bowls me over. Summon a butler round the clock, or reserve The Royal Suite, which includes a personal butler and a chauffeur-driven Bentley at your service. This life recalls that of a very proper London townhome, quite unequalled, and perhaps the closest I'll ever come to being treated like royalty.

BOOK TO PACK:
Portrait of A Killer, Jack the Ripper Case Closed
by Patricia Cornwell

Each bedroom makes one feel like a guest in a stately English home.

THE LANESBOROUGH

Hyde Park Corner
London, England
SWIX7TA
Tel: 44-207-259-5599
Fax: 44-207-259-5606
www.lanesborough.com

OLD COURSE HOTEL

St. Andrews, Scotland

*U*ntil this project, I had never worked on a hotel that had its own signature tartan. It is, no less, a tartan designed by Kinloch Anderson, tailors and knitmakers to the royal family. Like everything at St. Andrews, the tartan itself has historical ties, drawing from two tartans (the Melville and Earl of St. Andrew) strongly connected to the town.

Design at the Old Course Hotel relies on celebrating St. Andrews' heritage, creating ambience worthy of its dramatic setting while respecting the history of this hallowed place. Since the 15th century, golf has been played here, and it is this great game for which St. Andrews is famed. However, I found the early history of the town itself fascinating: its name comes from the apostle whose relics were brought here by St. Regulus, a shipwrecked monk, drawing Christian pilgrims to pay homage to St. Andrew. The Middle Ages saw the town as a thriving marketplace and educational and religious center. Scotland's oldest university, St. Andrews University, was established here in 1411, about the time golf was first played.

One of several recognizable holes on the hallowed St. Andrew's Old Course.

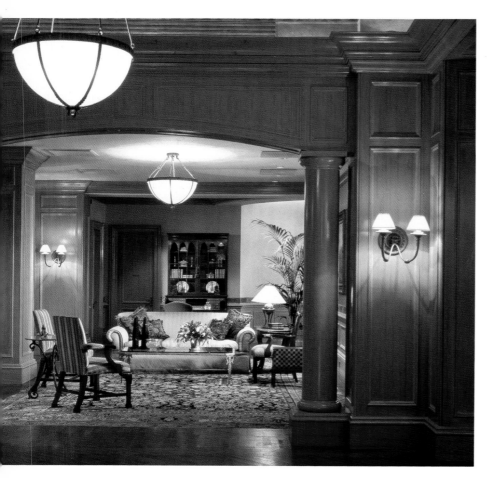

The Living Room offers comfort and traditional details.

For well over half a millennium, the game of golf has been played between town center and Eden Estuary in St. Andrews. (Though King James II banned golf in 1457 – believing it distracted men from archery practice). Official records from 1552 confirm the rights of citizens to play golf and football in addition to allowing them to dry their fishing nets and bleach their linen on the links. In 1754, 22 noblemen and gentlemen organized The Society of St. Andrews Golfers. The Royal and Ancient, the sport's official regulating body and its most prestigious golf club, came about in 1834.

On the site of a former railway station, the Old Course Hotel sits atop underground floats to counterbalance the sand on which it's built and alongside the famous 17th fairway of the Old Course, the Road Hole, acknowledged as the toughest par four in golf. So acclaimed is the Old Course that, during hotel construction in the 1960s, town planners were alarmed at the removal of railway station sheds to make way for the project, fearing the effect on Road Hole conditions. The fitting solution involved building new sheds to exact specifications of the old, thereby preserving the hole's challenging dogleg. The stationmaster's house became an inviting pub, the Jigger Inn.

The hotel has evolved in ways complementary to golf at St. Andrews. Its new identity emerged as the Old Course Hotel Golf Resort & Spa in conjunction with the opening of the par-72 Duke's Course in 1995. Recent design investments have increased the number of course-facing suites and enhanced conference space. Our work on the interiors has kept the focus on world-famous views of the championship golf courses and the North Sea or St. Andrews town.

It was, of course, a strange and happy occurrence that a non-golfing, female Texan would have the design of one of the most revered – almost sacred – places in all of sport, placed in her hands. However, it did not take me long to come to understand, and respect, the hallowed golf ground we were treading.

Facing Page
Top: Private dining room.

Left: The Library is a unique retreat.

Right: A quiet corner of a special suite.

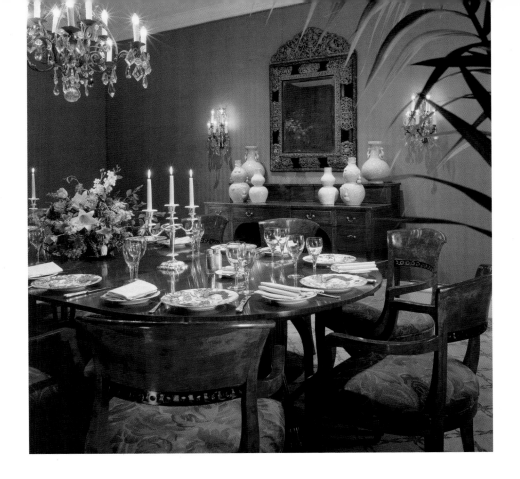

We also focused on perfecting the details that helped earn the resort its five-star status. We purposefully kept guestroom interiors airy and restful. I love the fact that we have summer and winter quilts to reflect the changing seasons. In public spaces, the tartans of the hotel staff signal a sense of place. And throughout the hotel we wove the elegant luxury anticipated of a vaunted resort with the casual charm of a Scottish village. It's what I refer to as relaxed casual – simultaneously perfect and comfortable.

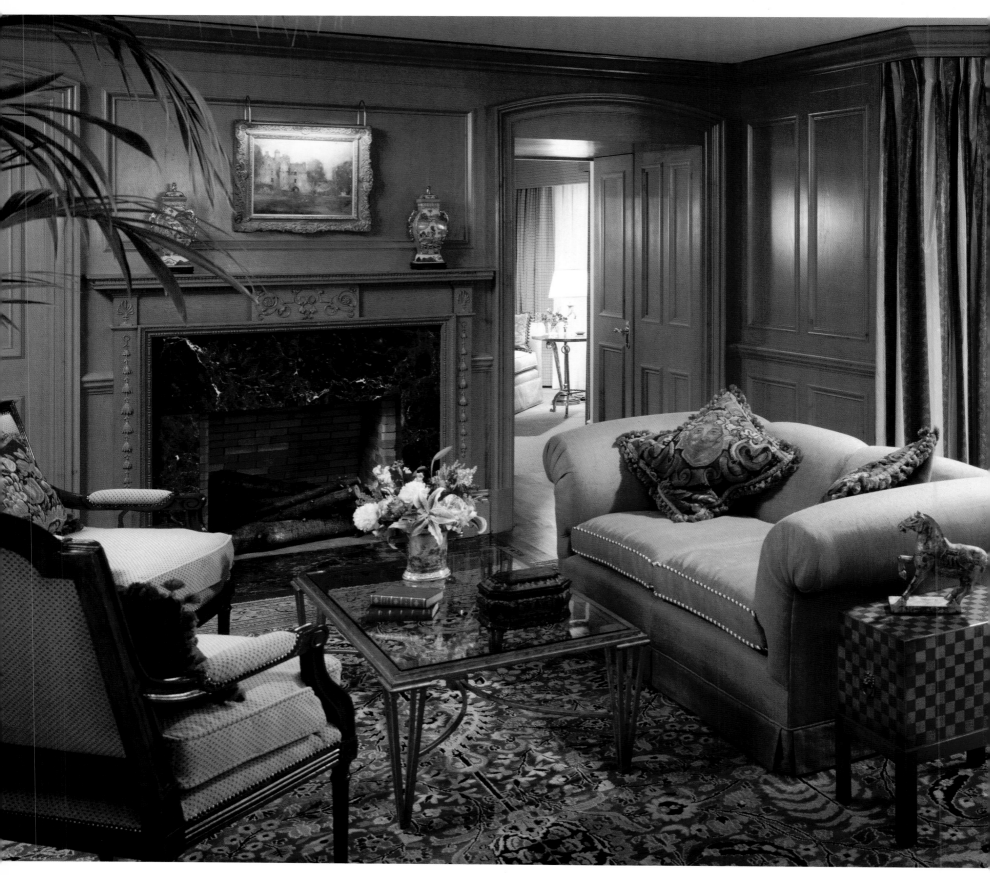

Traditional finishes and furnishings combine with chintz fabrics in the guestrooms.

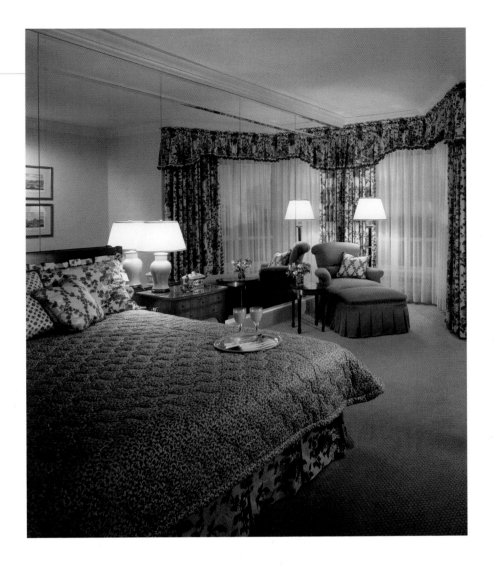

The conservatory, which juts out from the hotel on the 17th fairway, is as close as I get to the links without actually playing golf. The view is astounding and the occasional wayward ball just clinks off the reinforced glass roof. After a day of business or shopping, I retreat to the Road Hole Bar for a sampling of Scotland's finest: whiskies from 120 distilleries. (You can even arrange a pre-dinner whisky tasting for friends.)

I try always to choose a suite overlooking the 17th "Road Hole" of the Old Course. I like the aesthetics of both the traditional suites and the urbane, contemporary ones — and have stayed in both. In the Millennium Wing we went with classic materials interpreted in modern style. As a result, the look is sleek, but not out of place. Each is relaxing and refined in its own way. Everything about the resort provides a memorable — and singular — escape.

BOOK TO PACK:
Golf in the Kingdom by Michael Murphy

A cozy living room in one of the hotel's special suites.

OLD COURSE HOTEL

St. Andrews • Kingdom of Fife
Scotland KY16 9SP
Tel: +44 1334 474371
Fax: +44 1334 477668
www.oldcoursehotel.co.uk

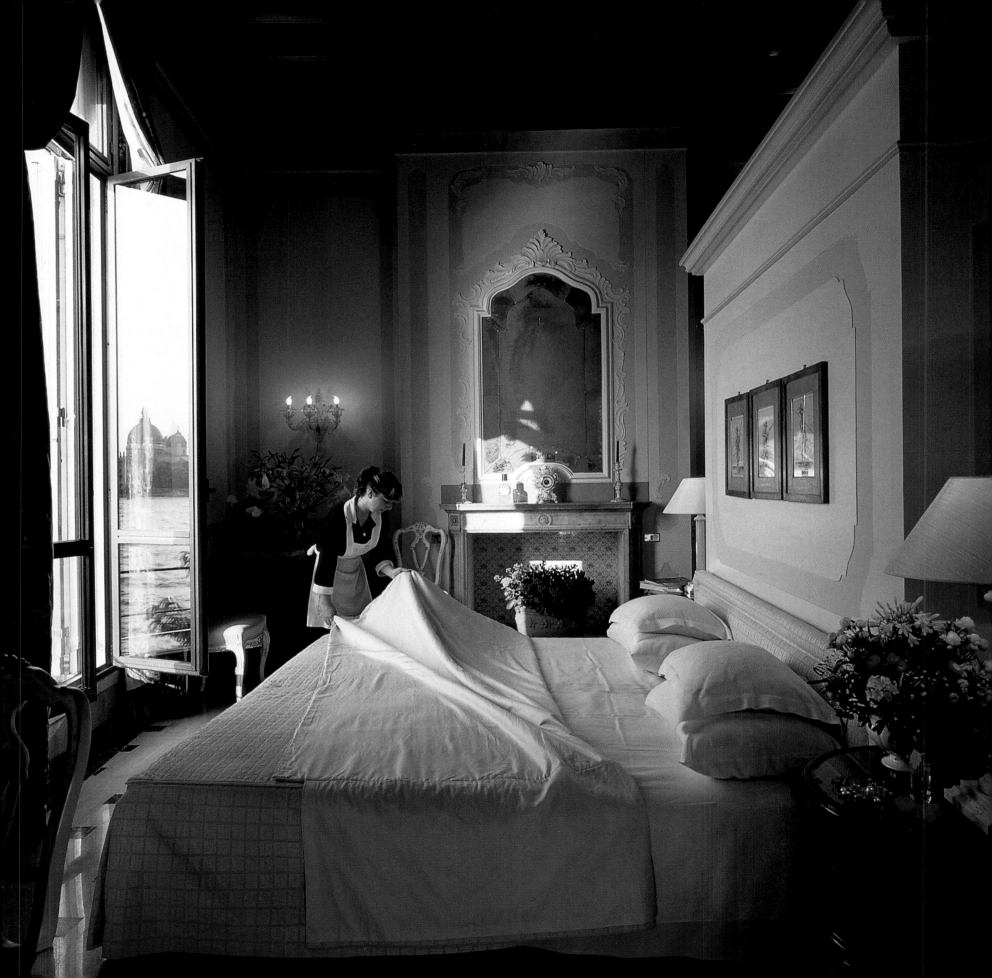

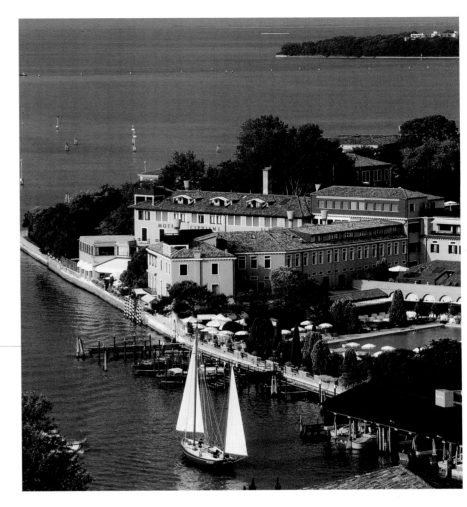

HOTEL CIPRIANI &
PALAZZO VENDRAMIN

Venice, Italy

Left: A junior suite in the Palazzo Vendramin.

Above: The Hotel Cipriani offers splendid views of both the lagoon and St. Mark's Basin.

Venice is unparalleled. I've turned to Venetian grandeur and style time and again in my work for ideas and inspiration. I'm charmed by the romance of the city; I'm struck by the smallest details, like the ways colors fade and change with canal water lapping against them. I'm in awe of the city's vibrancy in architecture and art; I'm particularly partial to Venetian glass, which is among the finest in the world.

I love to travel with my sketchpad. Everywhere. My enthusiasm for local sights can be captured in a hastily sketched architectural detail, open market scene, and in Venice, a gondola. Venice is a captivating city built, I was astounded to discover, on more than 100 small islands. One particular inspiration is the Palazzo Vendramin, the opulent and beautiful Venetian residence that has become part of the Hotel Cipriani.

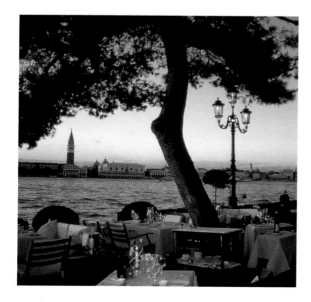

It is in the grandest style that Hotel Cipriani welcomes its guests. I've long regarded the legendary Cipriani as the place to stay when in Venice. It offers the best service, the best views of the lagoon and St. Mark's Basin, and the only Olympic-size swimming pool in the city. It's close to everything but remarkably secluded and removed from the madding tourist bustle. From Cipriani, you can be anywhere in the city by private launch or water taxi in minutes.

By incorporating the stunning Palazzo Vendramin and Palazzetto Nani Barbaro into the hotel, Cipriani preserves the rich art and architecture of the High Renaissance, when stylish residences were fashioned for the wealthiest maritime trade merchants and nobles. When Rome was sacked in 1527, many of its architects and artists settled in Venice, enchanted with the city as their new home. They also brought with them talent and ideas; their penchant for color, deep arches, lacy balustrades, and sculpture imbued the city with High Renaissance opulence. I experience life at the Hotel Cipriani as a celebration of Venetian culture, which flourished with examples of monumental, yet exuberant and sensual, style half a millennium ago.

At Hotel Cipriani, the deep mouldings and elegant arches set its luxurious design tone. I like the simplicity of creamy off-white and eggshell covering the interior of its signature fine dining restaurant which sparkles with lavish chandeliers. One should also reserve two outdoor lunches at Cipriani, one at the Terrace Restaurant, surrounded by fountains and flowers, and the other at the newer Cip's Club, a restaurant with a floating terrace that allows for incredible views of St. Mark's across the Giudecca Canal.

Top: Dinner on the terrace embodies the romance that is Venice.

Middle: A Venetian style bedroom of a suite in the main hotel.

Bottom: The terrace of Cip's Club on the Guidecca Canal, facing St. Mark's Square.

Terrace of a junior suite in the main building,
overlooking the Olympic-size swimming pool.

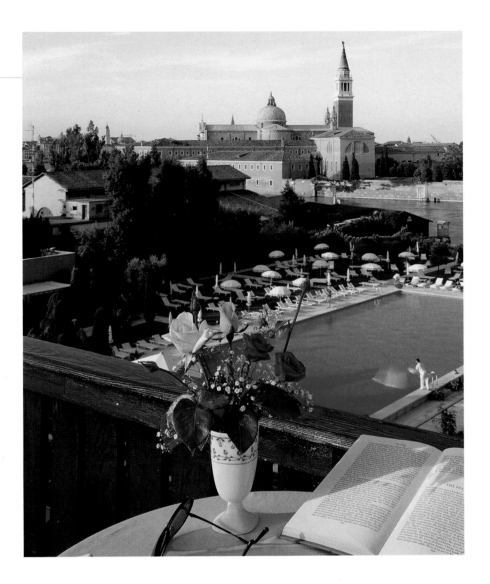

Cipriani's Venetian garden is absolutely lovely – a confection of
flowers, trees, and grapevine arbors, perfectly planned and mani-
cured – with lavish growth thanks to the hotel's fertile island site.
If I'm lucky enough to reserve the hotel's romantic La Meridiana
suite, I get my own elegant, private garden and Italian courtyard,
complete with plunge pool.

Hotel Cipriani planners have beautifully incorporated and carefully
renovated a range of buildings – the palazzo, the palazzetto, and the
Granaries of the Republic – ingeniously connecting some of them
via loggias, and utilizing them to expand Cipriani's guest space and
services across the tip of Giudecca Island. The hotel's design updates
over the years have introduced clean, contemporary lines in furni-
ture and subtle tones in luxe fabrics that do not compete with the
graceful architecture of the Palazzo Vendramin. In the main guest
quarters, the furnishings represent classic, period pieces.

Everything about the Hotel Cipriani feels just right. Once I get to
Venice, I never want to leave. It is a spellbinding place of deep his-
tory, endless romance and beauty, everywhere beauty. The same can
be said for this hotel – truly one of the world's most remarkable and
unforgettable places.

❧

BOOK TO PACK:
A Venetian Affair by Andrea di Robilant

HOTEL CIPRIANI & PALAZZO VENDRAMIN

Giudecca 10
30133 Venice, Italy
Tel: +39 041 520 7744
Fax: +39 041 520 3930
www.cipriani.orient-express.com

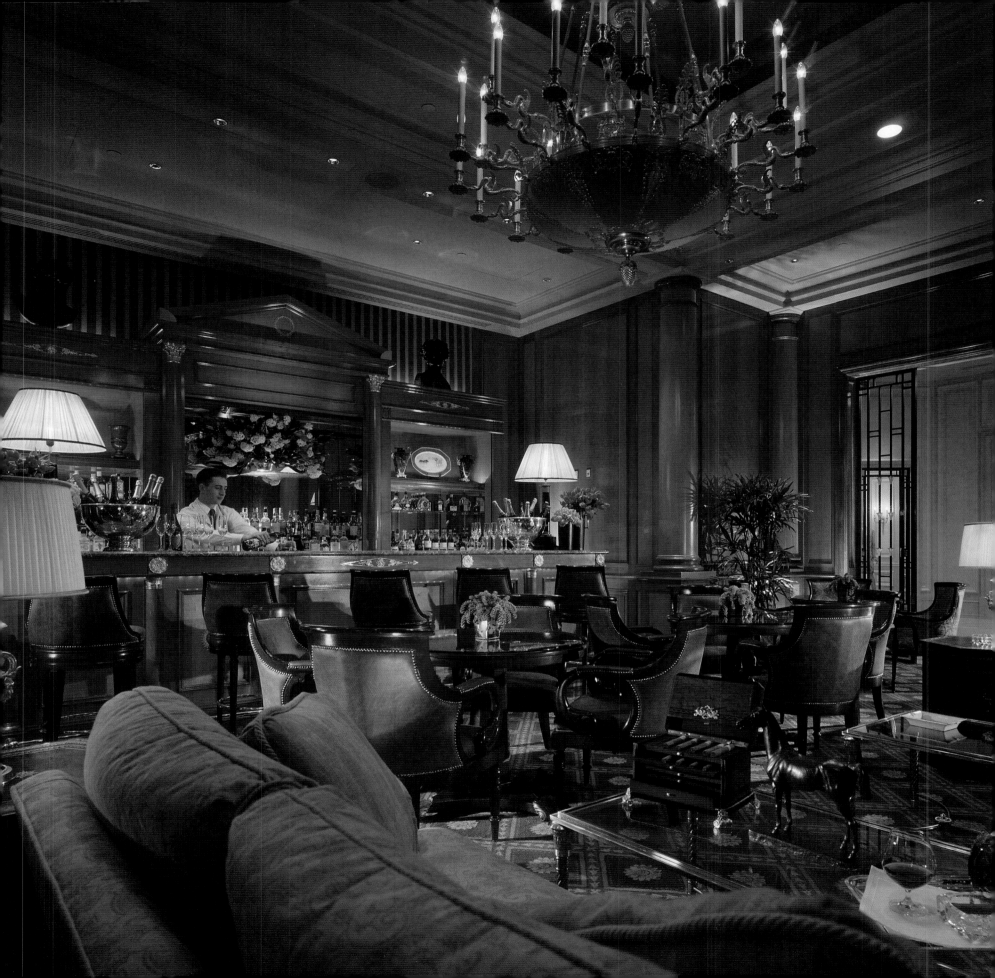

FOUR SEASONS HOTEL
GEORGE V PARIS

Paris, France

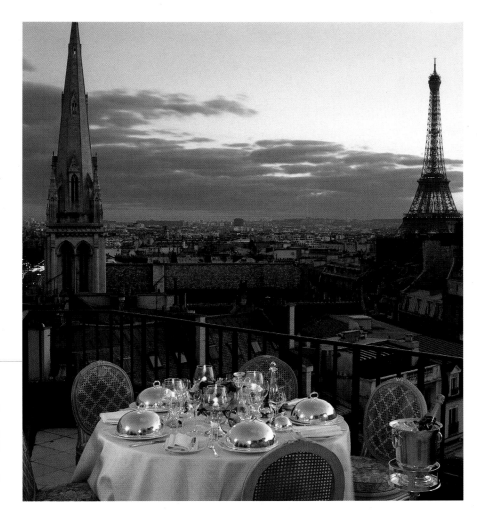

I marveled at the recent account of a journalist whose assignment was to spend a long weekend in Paris. Imagine the opportunity for travel coverage of the Louvre, L'Opera, and remarkable restaurants. Instead, his sole charge was never to leave his hotel room, and report back on the experience. Despite seeing nothing of the grand city, his excursion, he reported, was not disappointing in the least. Of course, he had stayed at the George V.

Many people are passionate about Paris, and it is a city that I love, but I often think it is as much the George V that draws me back there as it is the City of Lights itself. This is a hotel with a glamorous history, but it is the pedigree of the building too that fascinates me.

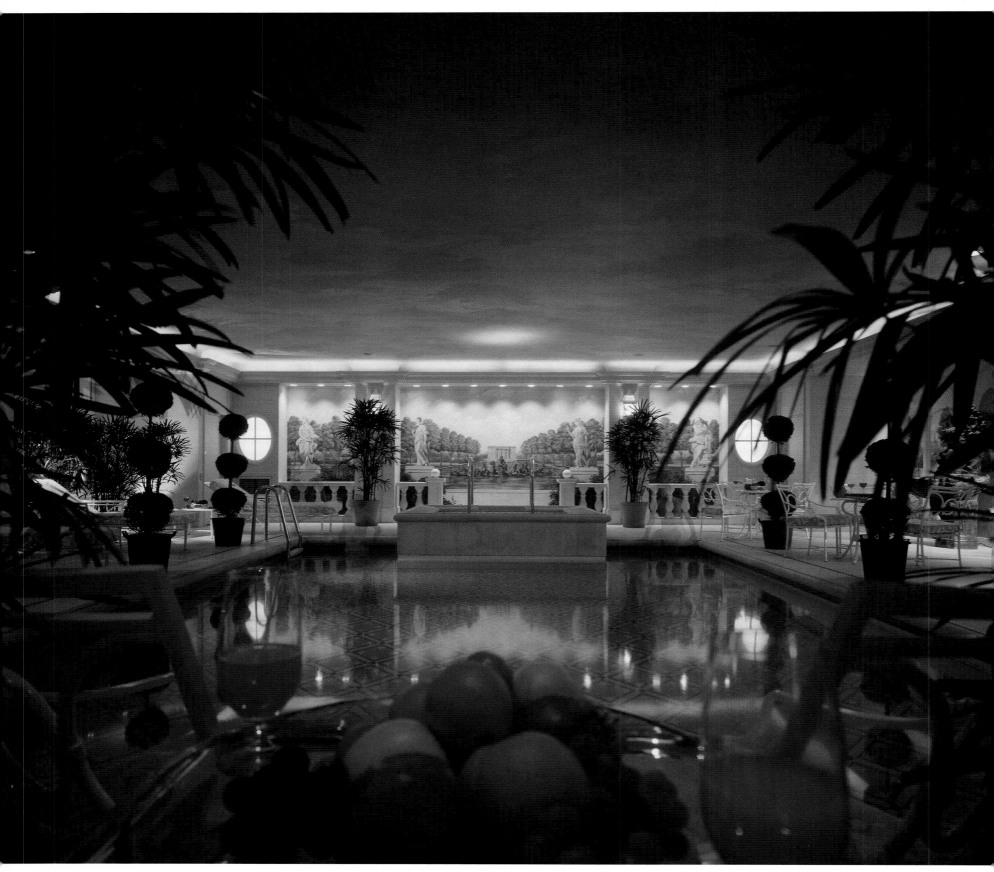

Built in 1928 at a cost of $31 million, its innovations included fire alarms, fitted closets, telephones with direct outside lines and inside service lines, two-bath suites that allowed two guests to bathe and dress for dinner at the same time, and extra-wide corridors to alleviate luggage gridlock. Its innovative floor plan included a first-floor kitchen and courtyard. Heralded at the time for modern and elegant luxury, the hotel was the product of an American owner and French architects Lefranc and Wybo. Architecturally speaking, I consider it an icon of the modern hotel – it was certainly revolutionary in its time, and set the standard for the way we design for functionality in the hospitality business.

Through out the century the George V saw historic moments and people come and go. During the war it served as General Eisenhower's headquarters during the liberation of Paris in August 1944, among other historic milestones.

In 1997 the hotel was closed for complete renovation. With the combined vision of new owner, Prince Alwaleed Bin Talal Bin Abdulaziz Al Saud, and Four Seasons, it was majestically transformed. When it reopened following a $128 million redesign, the skills of architect Richard Martinet and the work of over 1,100 artisans and workers were on dazzling display for all to see.

While some call the design results over the top, I see them as befitting a jewel of a building. In renovation, architect Martinet set out to preserve and restore original details of this Art Deco gem, including its magnificent facade and interior proportions. The interior has a sophisticated and sumptuous palette and an eclectic yet tasteful selection of antiques.

It is the attention to detail and the touches of elegance and style that make a good hotel truly great, and the Four Seasons George V does it better than anyone.

Beautiful flowers burst out of every corner of the lobby, rose petals strewn among votive candles, and crystal vases with tulips, roses, hydrangeas and peonies bring color and scent to the magnificent grand lobby.

The service is sublime – from the welcoming elegant doormen to the gracious staff at reception, through the entire housekeeping and catering department, every person in the hotel makes you feel not only welcome, but special.

The suites are breathtaking – plush sofas, deep comfortable chairs, huge marble bathrooms with deep tubs, separate showers, soft towels, more flowers and candles, and stunning views. There are also work stations for the business traveler, and all the modern electronic equipment needed to entertain kids from nine to 93.

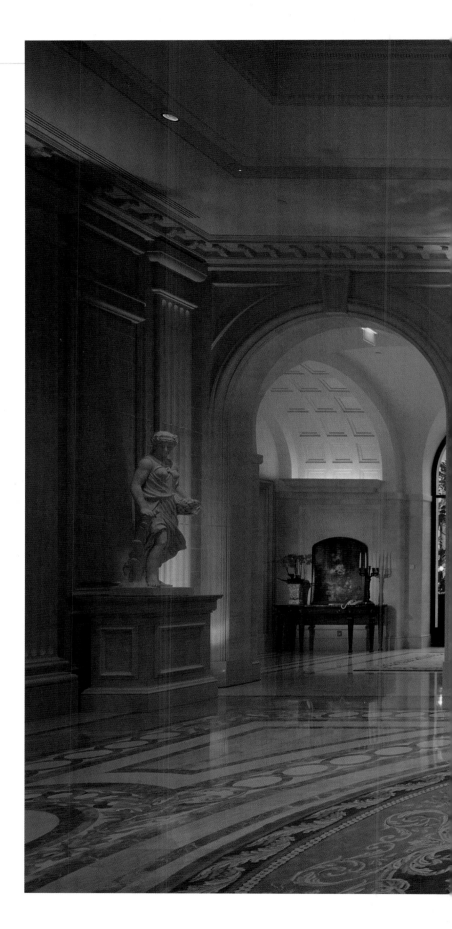

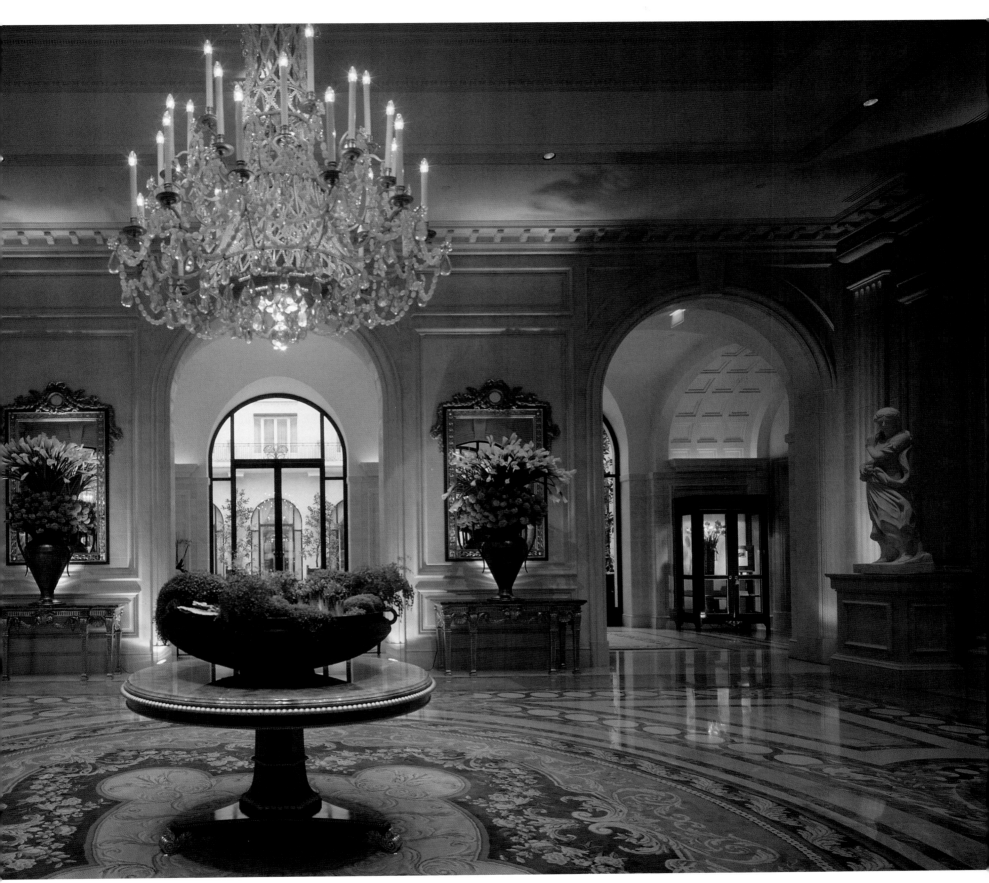

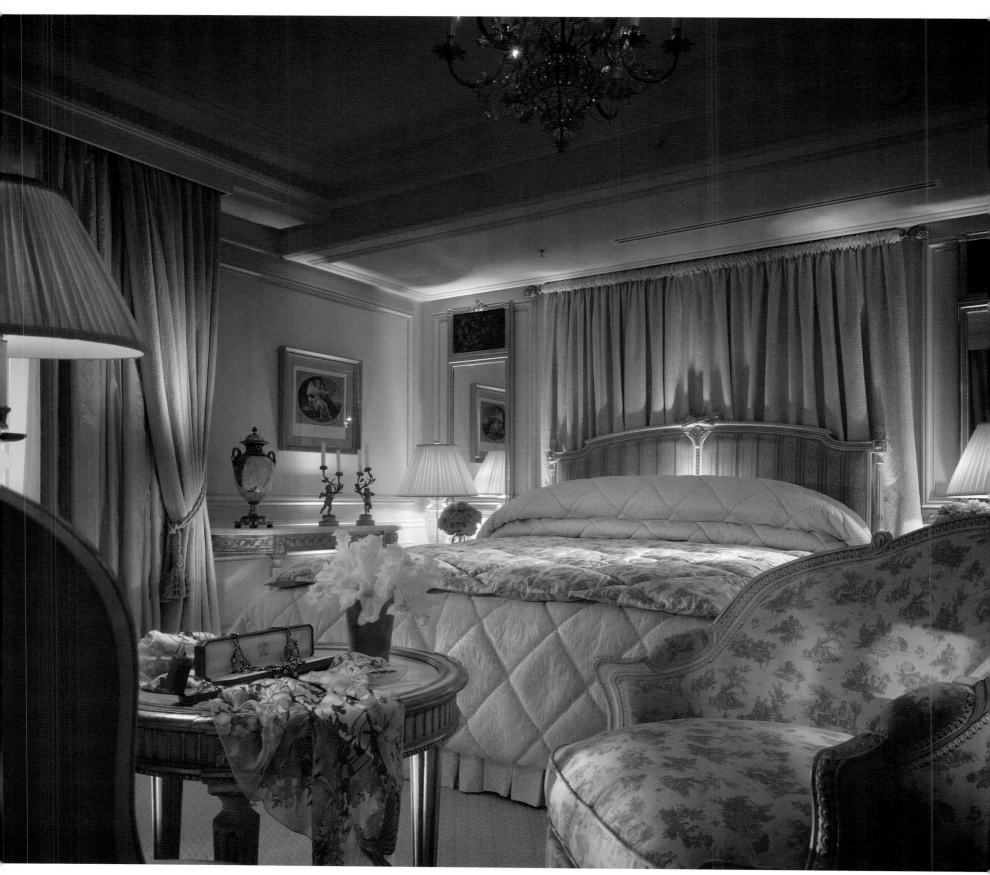

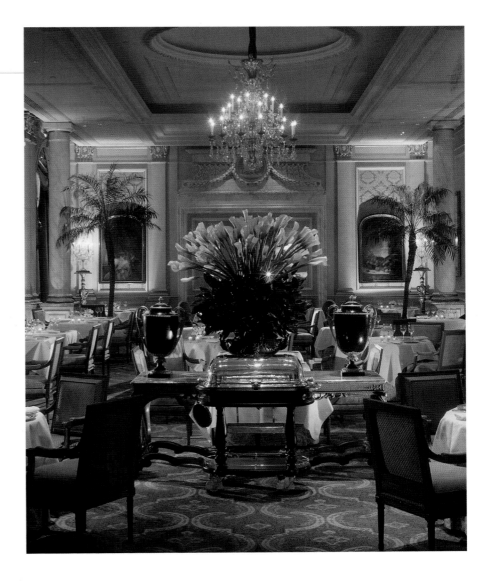

Of course, the service is impeccable. The concierges are the best in Paris, immediately able to detect a guest's preferences and likes almost telepathically. They can guide you to the hippest restaurants, get you the best tickets, fill any request, and make you feel like it was all your idea!

The commitment to special touches extends into the Spa, where an excellent gym is available to those so inclined, and bottles of mineral water of all kinds are kept chilled along with hand towels strewn with orchids – nice touch. The Spa staff are outstanding, and the treatments among the best in the world.

All the while, one is surrounded by wafts of delicate perfume – flowers and candles – marble and soft furniture, and just outside the city beckons. This is one of the few hotels in the world where I could quite easily live for a very long time.

BOOKS TO PACK:
Les Miserables by Victor Hugo and
Perfume by Patrick Suskind

Simple luxury in a special suite.

FOUR SEASONS HOTEL GEORGE V PARIS

31, Avenue George V
Paris, France 75008
Tel: 33 (1) 49 52 7000
Fax: 33 (1) 49 52 7010
www.fourseasons.com

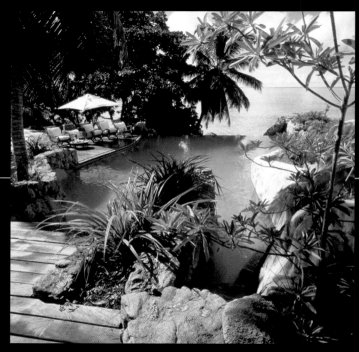

Frégate Island, Page 226

Islands

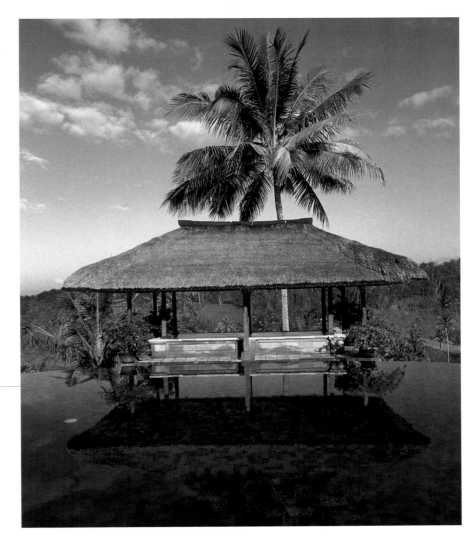

AMANDARI

Bali, Indonesia

This hotel helps keep Bali on the A-list of insider travel destinations worldwide. Amandari, like all of its Aman siblings, has an alluring sense of place. For the elite of the travel world, it represents privacy and – above all – a complete departure from the ordinary.

The incredible appeal of Aman resorts can be traced to one man, Adrian Zecha, the inventive hotelier behind the Aman brand. Zecha has a penchant for reinventing luxury and exclusivity, and for understanding the lifestyles of those who can best afford them. He also has a penchant for choosing sites and linking indigenous architecture to them. I think this location (one of three distinctly different Aman sites in Bali) is nothing short of amazing.

Architecturally, Amandari follows Zecha's strong sense of what's luxurious and appropriate (again, it's all about creating a sense of place). What I like best about Aman style is its subtlety. It's authentic. Culturally, it fits. This time, Zecha's incarnation in central Bali echoes the design of a Balinese village with stone pathways to each resort element and to neighboring villages, including the creative, cultural center of Ubud and others known for crafts in silver and cloth.

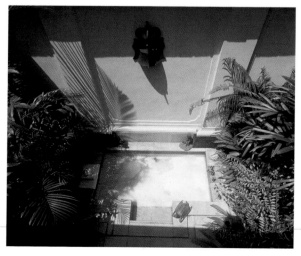

Top: In the library, a wealth of information on Bali and the art of Ubud can be found.

Bottom: All suites enjoy a large sunken marble bathtub in an outdoor garden setting.

Right: Protected from the elements by the alang-alang thatched roof, the hillside restaurant gazes out over the lush greenery of Ubud.

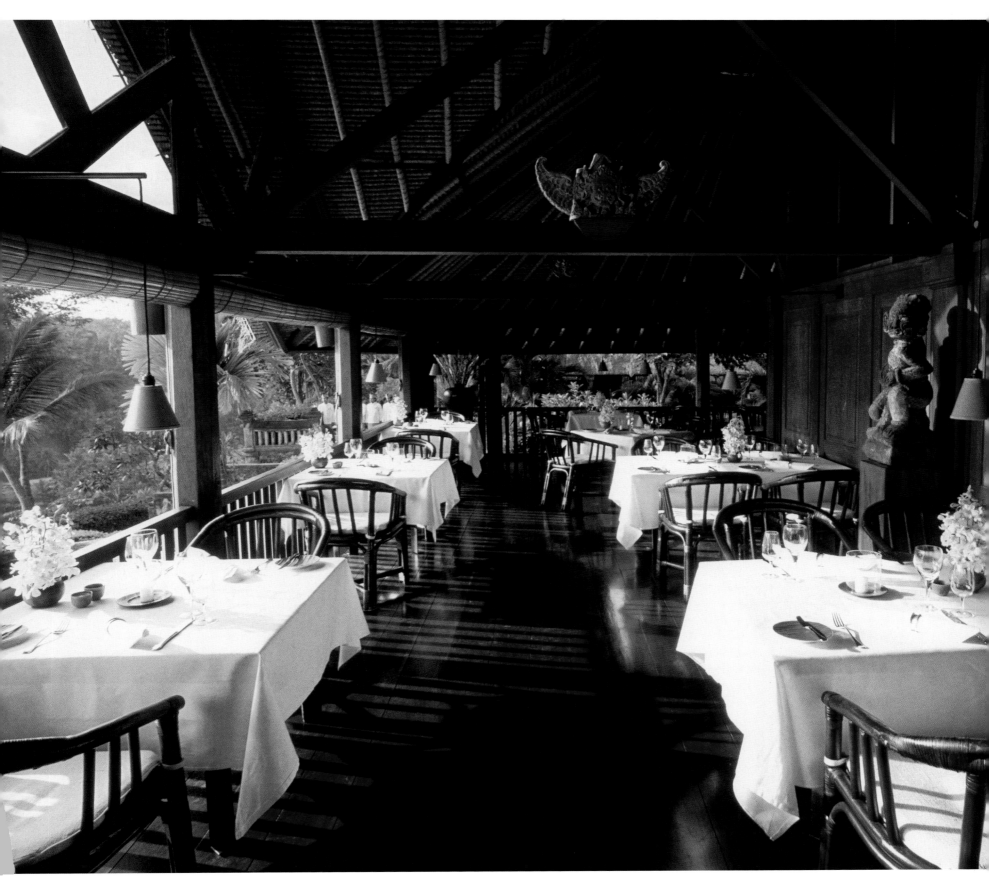

Amandari owes its luxuriousness in part to its simplicity and its privacy. Local materials add character and design authenticity. I like the stone gateways to each suite, influenced by traditional Balinese style. Inside the airy suites, tropical coconut wood and teak elements provide the perfect counterpoint to cool flooring of stone and polished Japanese marble. Eleven of the resort's 30 thatched-roof suites have private swimming pools; every suite has an outdoor, sunken tub of Japanese marble, flanked by stone planters filled with ferns and baby bamboo, a Balinese mainstay. Spectacular tubs – often outdoors – remain an Amandari design hallmark. Here they are perfectly secluded.

While Amandari's most spacious suites have detached bedrooms and separate living pavilions, its ultimate guest accommodation is a three-bedroom villa adjacent to the resort, situated to capture views of the Ayung River Gorge and three distant mountainous peaks. Five pavilions comprise the villa, including three detached, terraced bedrooms, a complete kitchen with staff quarters (two staff come with the villa and there's a chef on call), and a living pavilion surrounded by sliding glass panels. I think the villa's reflecting pond provides a great focal point for the outdoor dining space. A garden and a landscaped deck area encase the private swimming pool, a two-tiered escape that you'll never want to leave.

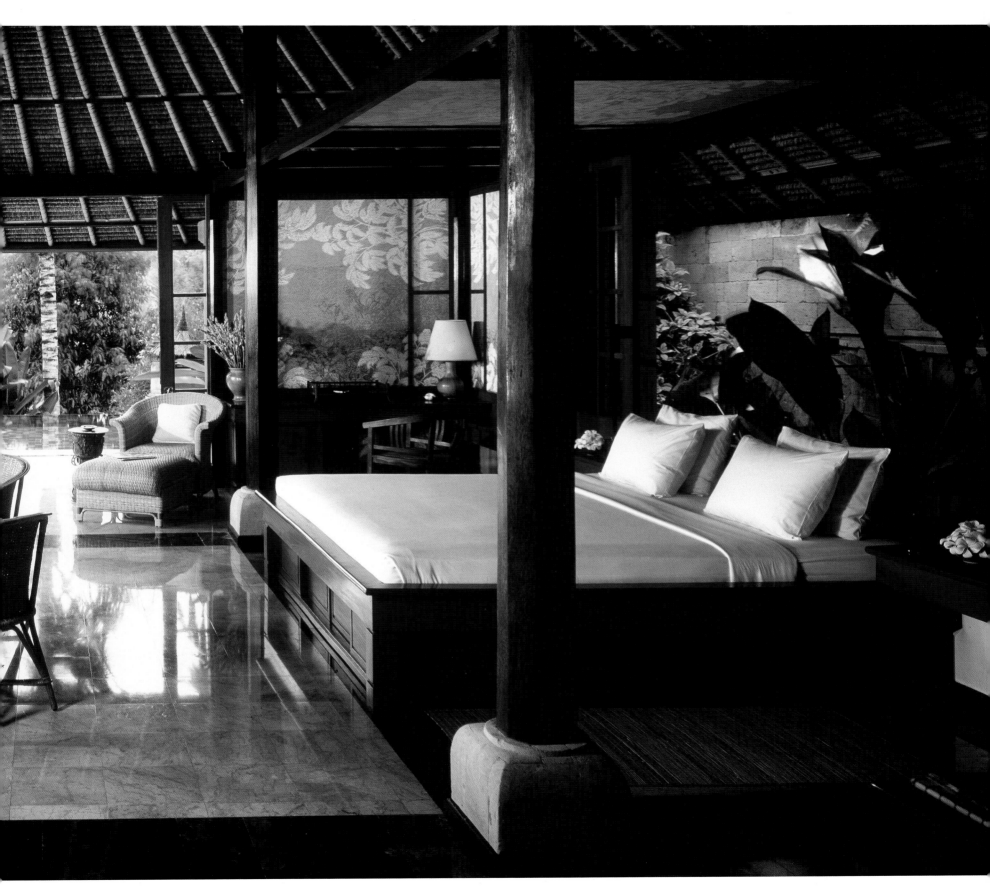

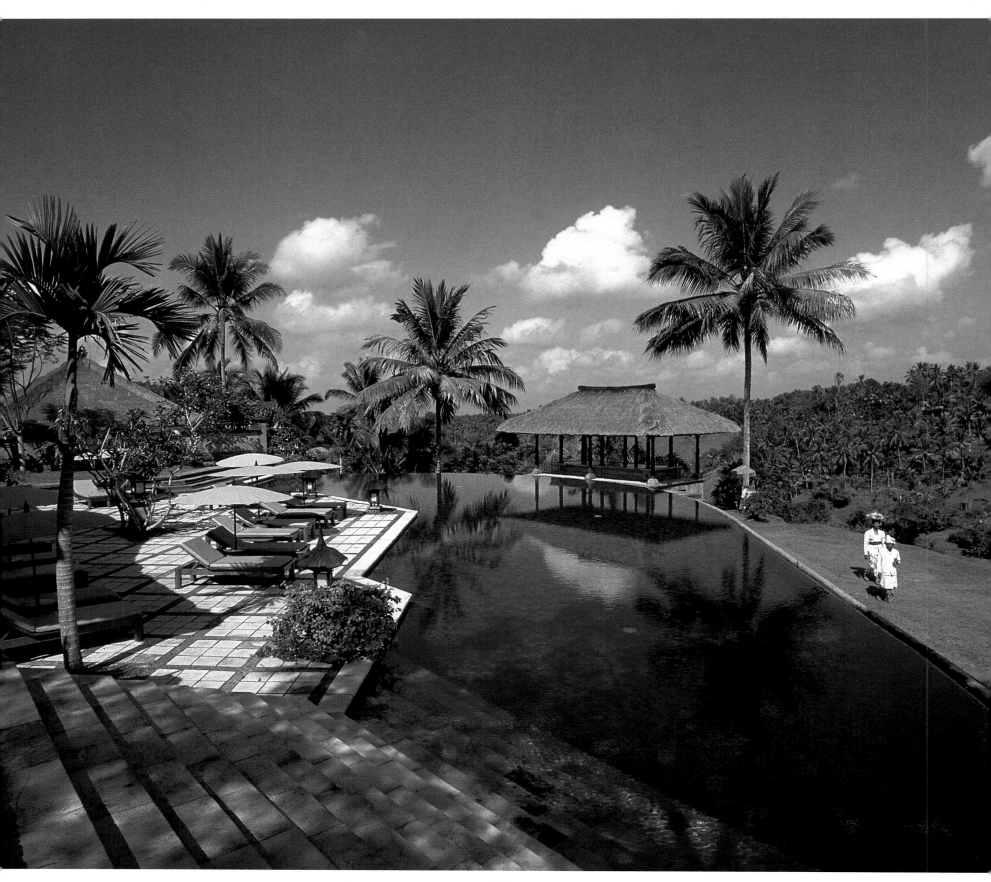

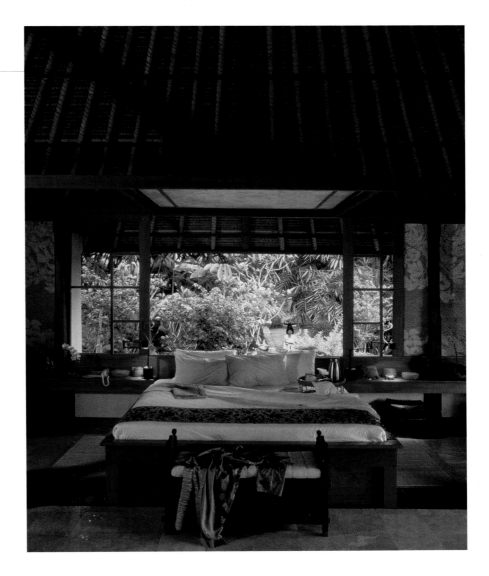

Each spacious suite features marble flooring, wall-sized glass door panels, exposed timber and in the terrace suite, a king-sized bed.

I come to Amandari especially for the spa. It was here that I experienced my first outdoor massage (before the concept went mainstream). Only one word describes it: tranquil. The breeze was blowing; there were the multi-layered sounds of nature. It was a true escape. Amandari's fitness compound itself is an escape, as the entire health and fitness center surrounds a lotus pond. And the resort's main swimming pool is simple, yet stunning. Set along the edge of the Ayung River Gorge, the pool is tiled in green and curved to mimic the patterns of the rice terraces below. A great resort set near rice paddies? It's the sort of locally rooted, non-hospitality approach to hospitality that guests crave – as long as it's luxurious.

BOOK TO PACK:
Indonesia: People and Histories
by Jean Gelman Taylor

Reminiscent of Bali's numerous rice paddies, Amandari's pool overlooks the Ayung River Gorge.

A MANDARI

Kedewatan, Ubud
Bali, Indonesia
Tel: (62-361) 975-333
Fax: (62-361) 975-335
www.amanresorts.com

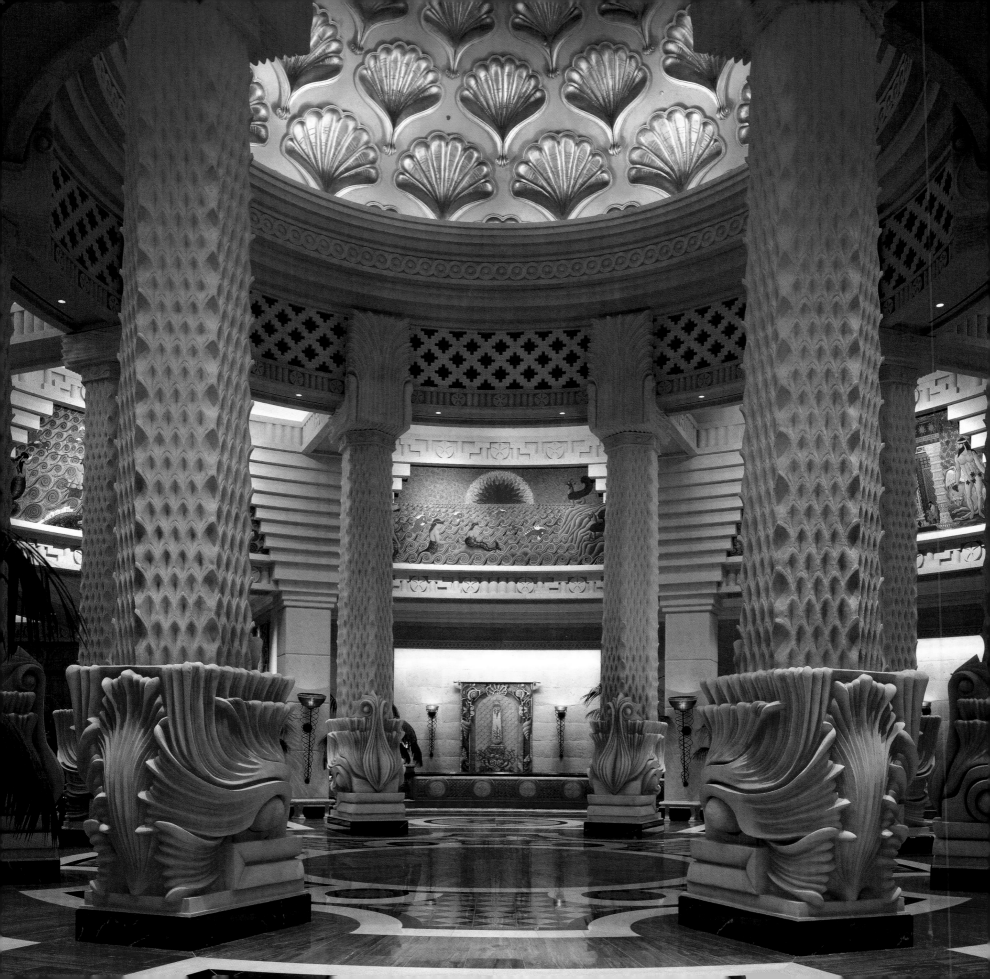

ATLANTIS

Paradise Island, Bahamas

From myth to reality. Everything that entered the collective psyche of the team creating Atlantis revolved around this mantra, and the result is a place where ancient fantasy meets modern luxury. An unlikely blending of diverse styles, with roots in many cultures and all things pertaining to the sea.

Left: The Great Hall of Waters' golden dome ceiling soars 70 feet high, encircled by original murals depicting ancient Atlantean mythology painted by artist Albino Gonzalez.

Right: Atlantis enthralls the Bahaman skyline.

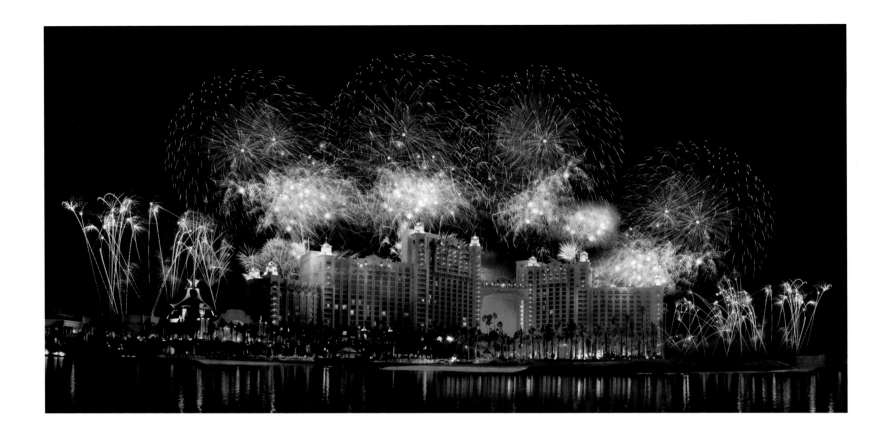

Before the first architectural drawing was ever on paper, hotel legend Sol Kerzner shared with us his notion to render a Bahamian paradise unlike anything on the islands, with fabled worlds, natural treasures, and unparalleled artistic expression. It is the legend of Atlantis, the oceanic tale of the 10 sons of Poseidon, King of the Seas. Fair and gentle, these five sets of twins ruled a kingdom where music, art, and learning flourished; where adventure and knowledge merged in technological discovery; where the highest of civilizations advanced the potential of all humankind. When an earthquake sunk this utopia, all but the legend was lost. Kerzner decided to recreate it.

Above: The dazzling pyrotechnic extravaganza by the world-renowned Grucci family heralds the grand opening of the Royal Towers in December 1998.

Far Left: The elegant Five Twins Restaurant, named after Poseidon's five sets of twin offspring, features exotic Asian-influenced cuisine, a sushi and sake bar and a signature rum and cigar bar.

Left: Atlantis' 34-acre waterscape encompasses the world's largest marine habitat, second only to Mother Nature, that is home to over 50,000 sea animals representing 200 species.

Right: The center of the golden shell dome ceiling in the Royal Towers lobby changes in phases to mirror the Bahamian day and night sky.

I cannot really call Atlantis, Paradise Island, a hotel: it is a vision. Design wise, Atlantis is a fantasy, richly constructed of ruin and luxury. We loved helping forge what might have been, making what is so mysterious come to life. Masterfully managed by James Carry, our design team's details include the relics of the lost civilization, alongside the sea life that was its constant companion. Gilded seashells, flying fish, ancient seagoing vessels, and extinct maps come together in an amazing palette of vibrant color and architectural form.

Kerzner believes a resort should transport guests into a dazzling, imaginative world unto itself. The huge team of experts — architects to marine biologists — that helped create Atlantis conjured a contemporary playground for exploring ancient habitats. From The Dig, a mythic archeological journey filled with underground chambers and passageways, to the 34-acre marine complex, which features 50,000 animals in 200 species of sea life, Atlantis creates an incomparable experience.

The incredible scope of Atlantis includes more than 2,300 guestrooms and suites, including my favorite, The Bridge Suite, a 5,000 square foot aerie in an archway connecting the Royal Towers. From here one can overlook the whole of Atlantis: the Atlantic Ocean, nearby Nassau, the yacht-filled marina, and the resort's spectacular pools (11 in all).

With all of its sea creatures and extraordinary opportunities for entertainment, sport, and leisure activities, Atlantis becomes one of the greatest spots on earth for family fun. I watch children — big and small — admiring and observing fish, sharks, and rays. Atlantis is part aquarium, part playground, part amusement park.

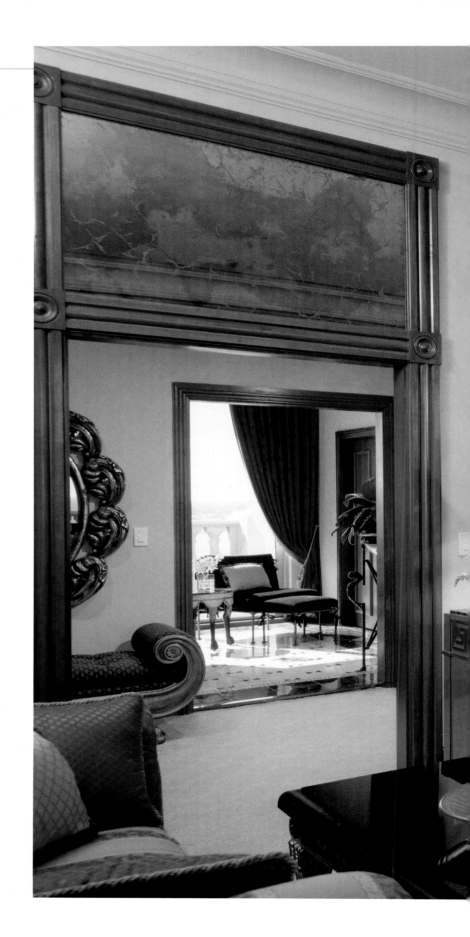

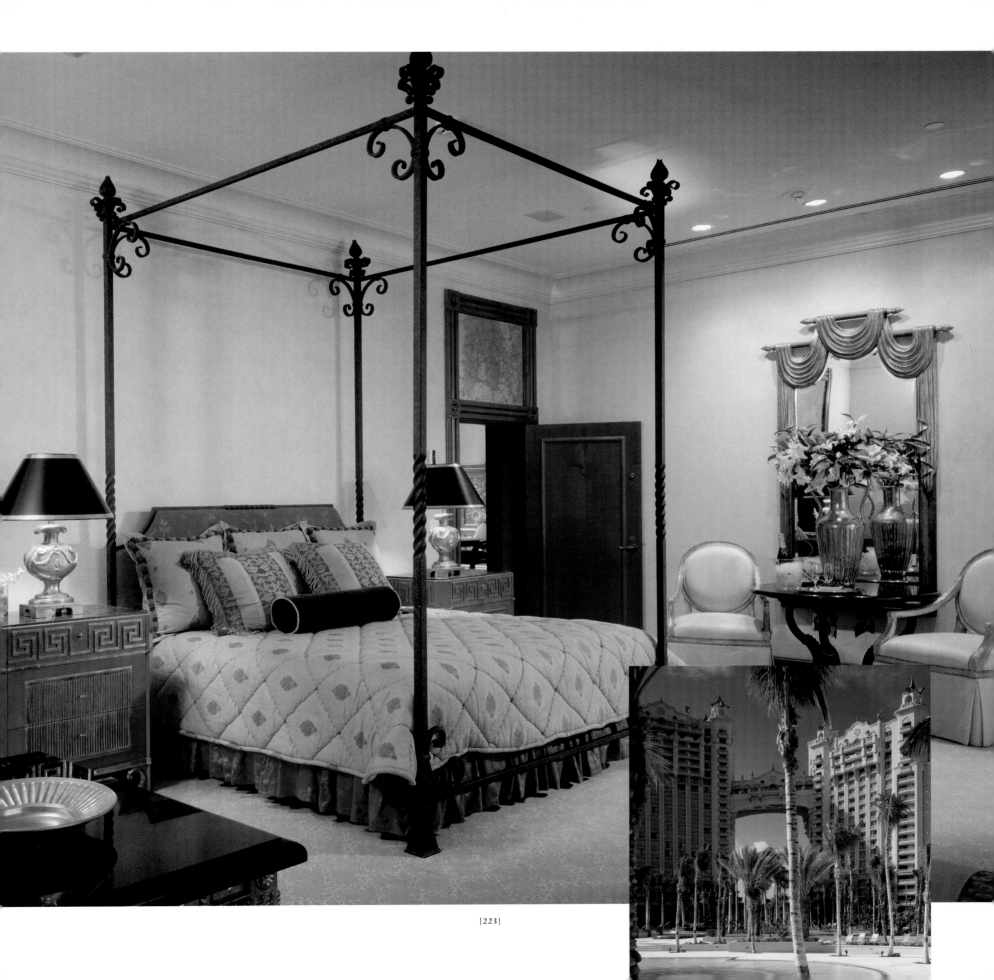

Among the top family attractions is The Dig, a labyrinth of undersea chambers set for exploration. At the pools, a Mayan Temple offers the perfect waterchute, the Leap of Faith, a slide that careens the daredevils among us down its steep facade, a 60-foot vertical drop. Another rush is the Jungle Slide, which thrusts you through exotic caves, lush greenery, and, finally, through a clear tunnel under a shark-filled lagoon. A calmer experience can be had drifting through perfect blue waters on a Lazy River float or traversing primitive-looking rope suspension bridges over pools and waterfalls.

Purely adult fun centers on the casino, world renowned for its setting above a seven-acre lagoon and filled with one-of-a-kind sculptures, including the colorful, brilliant glass art of Dale Chihuly. We were dedicated on this project to original ideas and forms, to creating what might have been.

Atlantis is the best of all worlds – mythological, past, present, earthy, decadent – and a nearly indescribable wonderland of the exotic aquatic. It's the sort of place where you can be as relaxed as you want, or as dressed up as you want, waiting to experience all vacation fantasies Atlantis affords.

BOOK TO PACK:
Islands in the Stream by Ernest Hemingway

The Atlantis Casino is designed with panoramic windows, skylights and brilliant glass sculptures by Dale Chihuly that infuse the gaming action with light and energy.

ATLANTIS

Paradise Island, Bahamas
Tel: 242-363-3000
888-528-7155
www.atlantis.com

FRÉGATE ISLAND PRIVATE

Frégate Island
Republic of Seychelles

ocated in the Seychelles Islands in the Indian Ocean – 1,000 miles south of India, 1,000 miles east of the African continent, and 1,000 miles northeast of Madagascar – Frégate is a very private resort. Our enviable task was to design a hotel resort that would provide camaraderie for guests who desired it, and seclusion for those who didn't.

Guy Courtney, our Design Architect in charge, focused on guest seclusion, so much so that our design and building placement would allow guests to walk around in their private villas unclothed yet entirely unnoticed. We also took care to design with sensitivity to both the history of the Seychelles and the extreme delicacy of the island's ecosystem.

Left: Guests enjoy spectacular views while dining on their private villa terrace.

Right: With only 16 villas and as many as seven beaches, Fregate Island Private guests can experience a true Robinson Crusoe tropical island getaway.

Frégate shares the Seychelles Islands' history and folklore, from piracy to privacy. Frégate's first visitors were indeed pirates who discovered refuge, fresh water, food, and secret hideouts on the hidden island. French seaman Lazare Picault named the island in 1744 for the colonies of Frégate birds nesting on its cliffs.

By a blessing of geography and history, the Seychelles are some of the most beautiful and hospitable islands of all the world's oceans. The landscape is lush, the beaches are pristine, with white, talc-like sand, and the water is clear, jewel-like azures and turquoises. During the day, birdsong fills the cliffs and vegetation, and at night, the sky is packed with stars and silence reigns.

The 16 tropical villas are set on the island's cliffs giving both ocean and beach views. The architecture is post-and-lintel construction in rich African Chamfuta teak. Inside the villas, we evoked the feeling of living in a very large, luxurious castaway's hut, with a ceiling of thatching lashed to bamboo and merbou timber rafters. Poster beds were tented in canopies and mosquito netting. Each villa can be opened entirely to the outside to take advantage of those magnificent views, or enclosed by tall, sliding glass doors if air conditioning is required on still days.

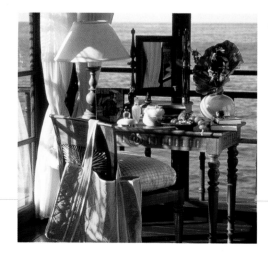
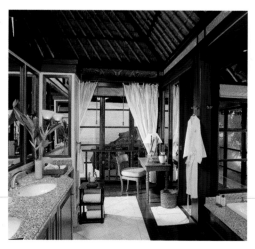
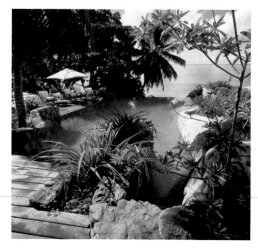

Each villa features a private and hidden daybed and cool-water Jacuzzi.

For the main resort building, we wanted the look and feel of a hillside pavilion with a welcoming atmosphere. The wooden structures sit atop stone plinths, which look like the walls of an old pirate hideout. On approach, the effect is dreamy, like discovering a remote village hideaway.

When creating the interiors, our design boards resembled an explorer's journal. We incorporated the natural colors and textures of island life — of leaves, shells, spices, bark, and grasses. For the main pavilion, we had a chandelier hand carved in Mauritius. It makes for the only adornment in the center of the eye-catching alang-alang ceiling of Balinese origin. And we made getting to the pavilion fun: you take a stone pathway that traverses the center of a lily pond.

Natural beauty, fresh fruits, delicious cuisine, great massages, sparkling seas, starry nights — this is Frégate, and while there, you feel it is all yours.

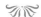

BOOK TO PACK:
Robinson Crusoe by Daniel Defoe

Top Left: Villa living area features Balinese and African inspired furniture for an elegant design in a relaxed atmosphere.

Bottom Left: A tropical paradise, guests can relax in their villa, on the beaches, or stroll the island looking for tortoises.

Bottom Middle: Luxury bathroom with a deep tub overlooking ocean and beach. The resort is known for its privacy and dramatic views of the Indian Ocean.

Bottom Right: A refreshing "infinity" pool is nestled into the granite rock.

FRÉGATE ISLAND PRIVATE

P.O. Box 330
Victoria, Mahe
Republic of Seychelles
Tel: 248-324-545
www.fregate.com

FOUR SEASONS RESORT HUALALAI

Ka`upulehu-Kona, Hawaii U.S.A.

*A*t historic Ka`upulehu, the Four Seasons Hualalai is every bit old Hawaii, with a notion of serenity so sorely lacking in the resort strips developed in the 20th century.

The key to this wonderful property is the words intimacy and innocence. Here on the Big Island, Four Seasons Hualalai captures the magical, tropical promise of a Hawaii undiscovered by the masses. It's all about mana, which is Hawaiian for life force. It's about the view, about the welcoming comfort, about the idea of having your own haven. Even the lifeguards have their own monikers: "stewards of the shoreline."

Left: The Kona-Kohala Coast offers seclusion without isolation.

Right: The pool lounging area takes full advantage of the breathtaking panorama provided by Hualalai, Hawaii's third-largest extinct volcano.

Four Seasons Hualalai is more a series of low-slung beachfront bungalows than resort hotel. At just 243 rooms and suites, it has no corridors. Every guest comes and goes on a pathway, with guest bathrooms overlook private gardens. There is something special about walking into a beachfront room where nothing comes between you and the sand. A ground-floor suite assures my getting a huge outdoor shower, shielded by leafy banana plants and lava-rock walls.

The lava-rock walls and hipped roofs follow the inventive style of Hawaiian architect Charles Dickey (MIT-educated, but born and raised on Maui). His work inspired Hill Glazier Architects, with whom we collaborated on this project. Charles Dickey designed the famed cottages at the Halekulani Hotel on Waikiki, a trendsetting resort completed in 1932. Four Seasons Hualalai incorporates Hill Glazier's take on Dickey trademarks: the "Dickey roof" and incredible landscaping among them. Since the roofs are open at the ridgeline and under the eaves, trade winds aid deep overhangs in providing cool comfort year-round.

Top: Sensual bathrooms with outdoor showers overlook the lush tropical landscape.

Bottom: Romantic bungalows are located just steps from the beach.

Facing Page: The lobby of the resort commemorates the spirit of old Hawaii.

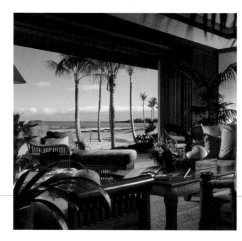

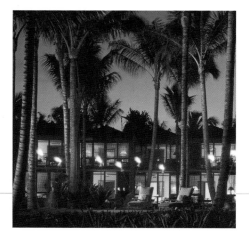

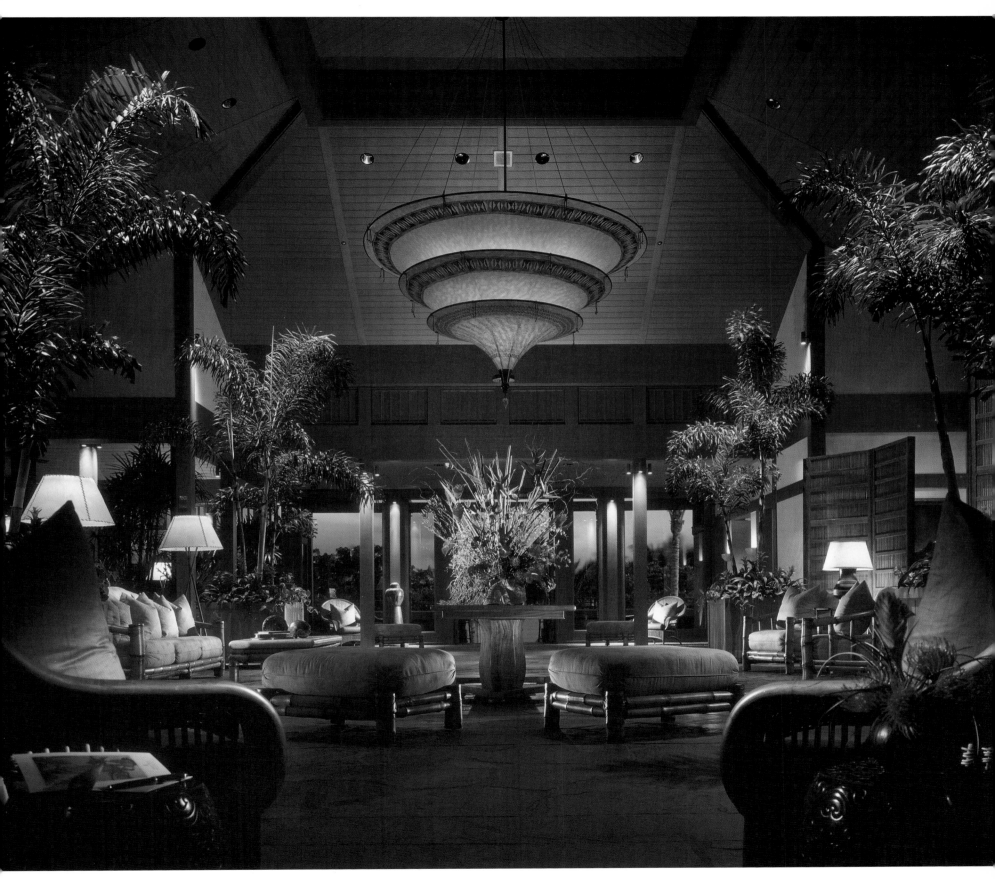

The site itself is extraordinary: the resort sits at the foot of Hualalai, Hawaii's third-largest extinct volcano. Hill Glazier followed traditional kipuka design, meaning a landscaped (lushly so) oasis contained by lava flows. Hill Glazier and Four Seasons appropriately settled on clusters of two-story buildings with dramatic ocean views. On the rugged Kona Coast, it is perfect. A high-rise building would be, quite simply, totally overwhelming.

In keeping with architecture blissfully suited to its site, we carefully crafted the interiors to avoid uniformity or blandness. The style is decidedly Hawaiian, but quite luxurious. Art is local and elegant, rich woods are reminiscent of local species, furniture is comfortably cushioned rattan. Underfoot, the simplicity of sea grass and sisal appears as just the right touch.

We oriented the guestroom furnishings toward oceanfront views in all rooms and suites. Thanks to a system of shuttered pocket doors, guests can open entire walls to the sea breezes and salt air. We liked muted, natural colors here since that keeps the focus on the look of old Hawaii. Everywhere — in the lobby, in the restaurant — we stayed with natural materials and low-key colors. The emphasis is on that spectacular view.

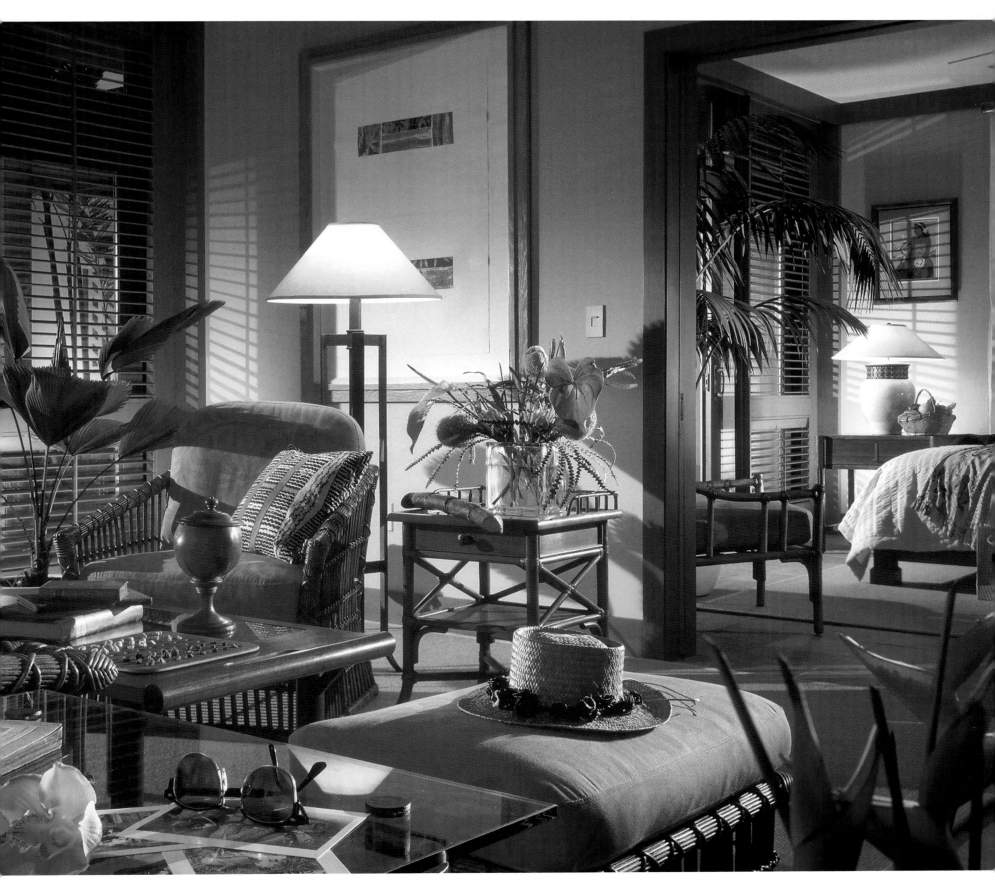

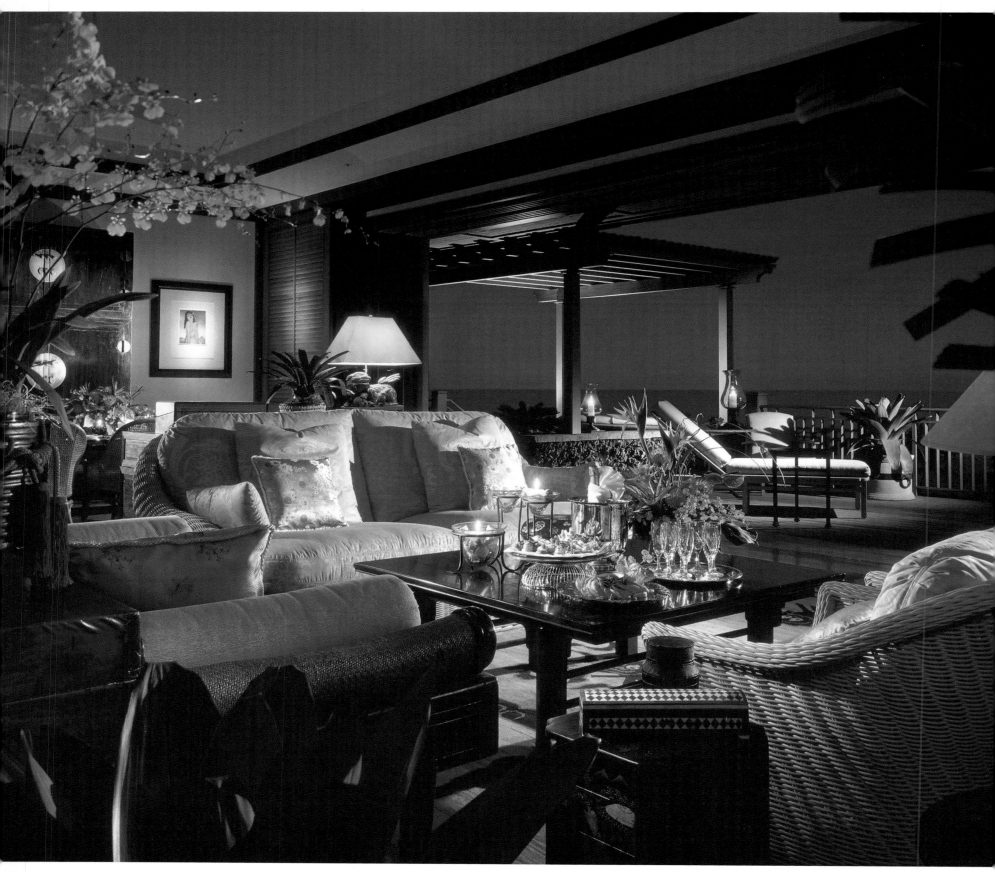

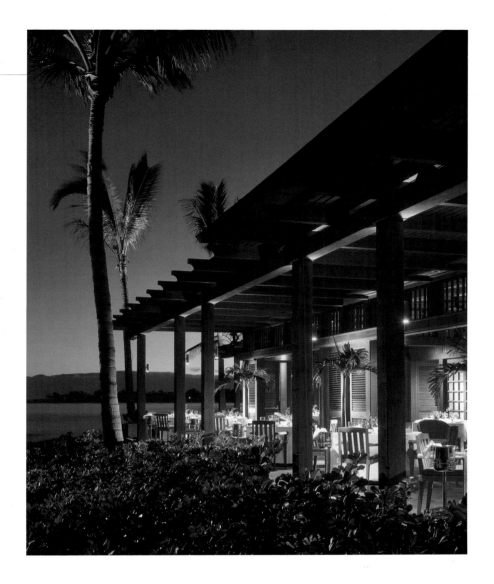

Sweeping ocean views and brilliant sunsets provide the backdrop for award-winning Pacific cuisine at Pahui'a.

The Four Seasons Hualalai offers the most complete island experience no matter what your taste in activities. Not being a very aquatic person, I tend to head for the spa and luxuriate in some of the most remarkable treatments, many of which have spread from these islands to become common in spas around the world. Afterward, retiring to your own hooded chaise on the beach outside your room is the ultimate in relaxation. While I am so engaged, my husband represents the family in the outdoor activities, snorkeling in the mind-boggling Kings Pond, a man-made lava rock aquarium with over 3,500 tropical fish, game fishing in the best charter boats in Hawaii, organized by the concierge, or taking out one of the hotel's classic Polynesian Wa'a Hau'oli, or happy canoe, a trampoline-and-outrigger sailing vessel that is easy to handle. After a fabulous day such as this, sitting outside and having dinner under the stars at the Hualalai may be one of the most romantic and peaceful memories I have.

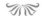

BOOK TO PACK:
Hawaii by James Michener

The Presidential Villa offers a romantic ambience, not to mention spectacular sunsets from your private lanai.

THE FOUR SEASONS, HUALALAI
100 Ka`upulehu Drive
Ka`upulehu-Kona, Hawaii 96740
Tel: 808-325-8000
Fax: 808-325-8200
www.fourseasons.com

Credits

AMANDARI
Architect: Peter Muller
Interior Designer: Neville Marsh
Photography courtesy of Amanresorts International

ATLANTIS
Architect: WATG Architects and HKS, Inc.
Interior Designer: Wilson & Associates
Photographers: Macduff Everton, Len Kaufman, Peter Vitale

THE BLUE TRAIN
Architect: Wilson & Associates
Interior Designer: Wilson & Associates
Photographer: Francki Burger

CAESARS PALACE
Architect: WATG Architects
Interior Designer: Wilson & Associates
Photographers: Glenn Cormier, Peter Malinowski

CONRAD BANGKOK
Architect: Palmer & Turner
Interior Designer: Wilson & Associates
Photographer: Peter Mealin

FOUR SEASONS HOTEL CAIRO AT THE FIRST RESIDENCE
Architect: Smallwood Reynolds Stewart Inc.
Interior Designer: Wilson & Associates
Photographer: Robert Miller

FOUR SEASONS HOTEL GEORGE V PARIS
Architect: Richard Martinet
Photographer: Jaime Ardiles-Arce

FOUR SEASONS HOTEL HONG KONG
Architect: Rocco Design Limited
Interior Design: Wilson & Associates
Photographer: Michael Wilson

FOUR SEASONS HOTEL NEW YORK
Architect: Pei Cobb Freed & Partners; Frank Williams & Associates
Interior Designer: Chhada Siembieda Remedios, Inc.
Photographer: Peter Vitale

FOUR SEASONS RESORT HUALALAI
Architect: Hill Glazier Architects
Interior Designer: Wilson & Associates
Photographer: Robert Miller

FRÉGATE ISLAND PRIVATE
Architect: Wilson & Associates
Interior Designer: Wilson & Associates
Photography courtesy of Unique Experience Touristik GmbH

THE GRAND HOTEL A VILLA FELTRINELLI
Architect: Alberico Barbiano di Belgioioso (original),
Giorgio Rovati (consulting arch.), James Darcy (project arch.)
Interior Designer: Babey Moulton Jue & Booth
Photographers: Oberto Gili, Ottavio Tomasini

HACIENDA BENAZUZA
Architect: Javier Bethencourt
Interior Designer: Manuel Gavira San Juan
Photographer: Fernando Sanchez Covisa

HOTEL CIPRIANI & PALAZZO VENDRAMIN
Architect: Gerard Gallet
Interior Designer: Gerard Gallet
Photography courtesy of Orient-Express Hotels

INN OF THE ANASAZI
Architect: Aspen Design Group
Interior Designer: Wilson & Associates
Photographer: Lisl Dennis

JAO CAMP
Architect: Silvio Rech, Lesley Carstens
Interior Designers: Silvio Rech, Lesley Carstens
Photographers: Dook, David Kays, Trisha Wilson
Photography courtesy of Wilderness Safaris

THE LANESBOROUGH
Architect: William Wilkins (original)
Interior Designer: EAA International
Photography courtesy of Rosewood Hotels & Resorts

LAS VENTANAS AL PARAISO
Architect: HKS, Inc.
Interior Designer: Wilson & Associates
Photographer: Michael Wilson

THE MANSION ON TURTLE CREEK
Architect: Shepard & Partners, Inc.
Interior Designer: HBA, Vision Design
Photographer: Michael Wilson

MONTAGE RESORT & SPA
Architect: Hill Glazier Architects
Interior Designer: Wilson & Associates
Photographer: Scott Frances, NYC

OLD COURSE HOTEL
Architect: RTKL Associates, Inc.
Interior Designer: Wilson & Associates
Photographer: Hedrich-Blessing, Scott McDonald

THE PALACE OF THE LOST CITY
Architect: WATG
Interior Designer: Wilson & Associates
Photographer: Peter Vitale

PARK HYATT DUBAI
Architect: Creative Kingdom, D.S.A.
Interior Design: Wilson & Associates
Photographer: Michael Wilson

THE PENINSULA BEVERLY HILLS
Architect: Three Architecture
Interior Designer: James Northcutt Associates
Photography courtesy of The Peninsula Hotels

RITZ-CARLTON BACHELOR GULCH
Architect: Hill Glazier Architects
Interior Designer: Wilson & Associates
Photographer: Kenneth Redding

ROYAL LIVINGSTONE
Architect: Stafford & Associates
Interior Designer: Wilson & Associates
Photographers: Tim Beddow, Alain Proust

THE VENETIAN
Architect: WATG Architects
Interior Designer: Wilson & Associates
Photographer: Peter Malinowski

YOKOHAMA ROYAL PARK HOTEL
Architect: Mitsubishi Estate Co. Architects
Interior Designer: Wilson & Associates
Photographer: Robert Miller

ZIMBALI LODGE
Architect: Theunissen Jankowitz SA Inc.
Interior Designer: Wilson & Associates
Photographer: Francki Burger, Craig Fraser

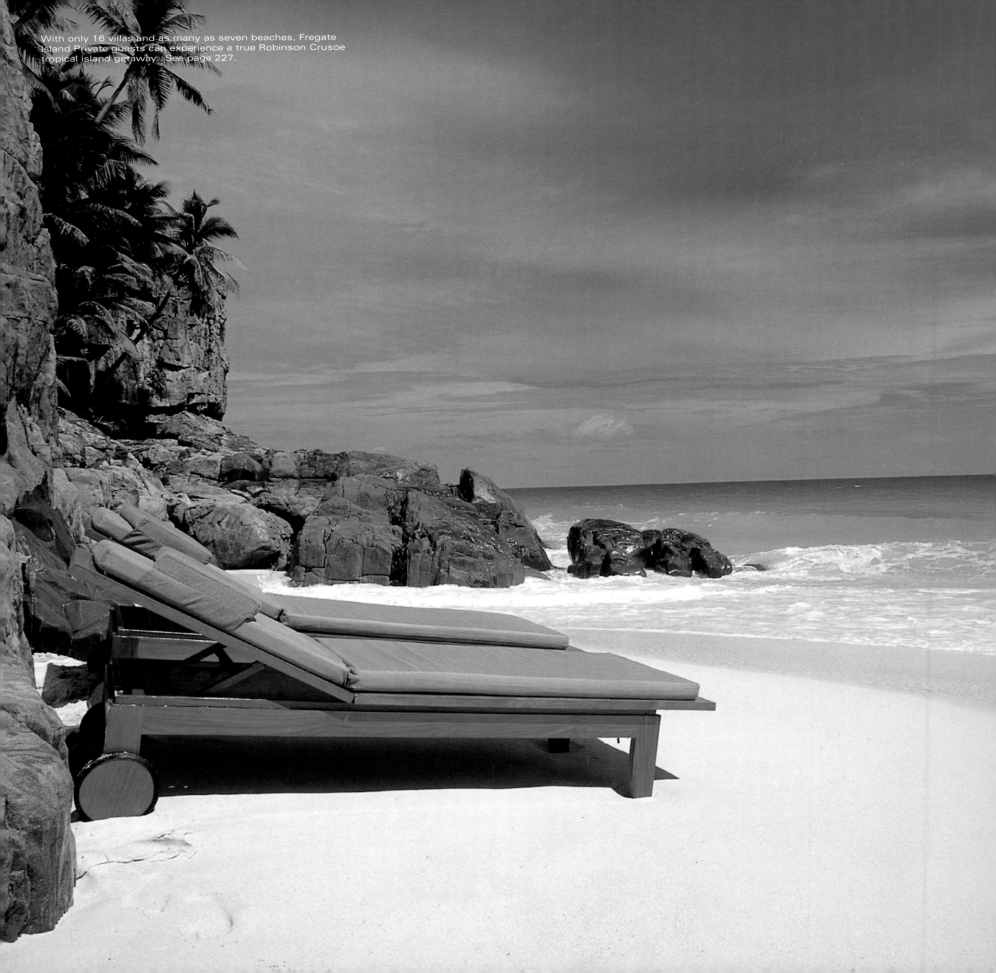

With only 16 villas and as many as seven beaches, Fregate Island Private guests can experience a true Robinson Crusoe tropical island getaway. See page 227.